A Camera, Two Kids and a Camel

My Journey in Photographs

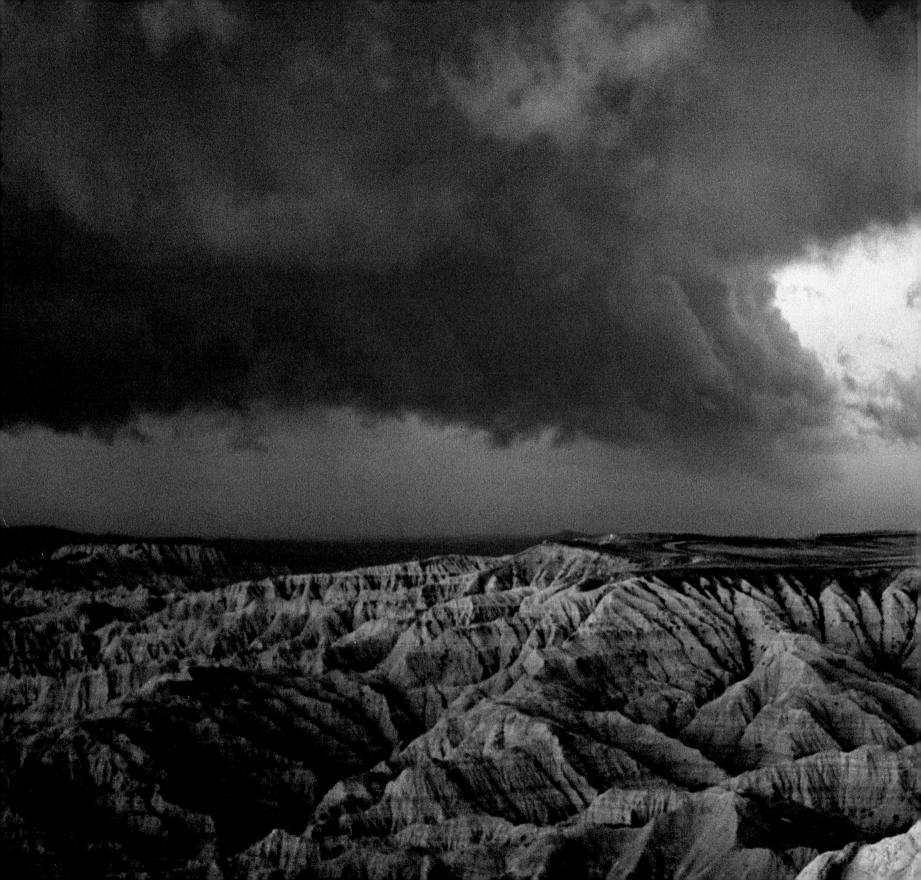

A Camera, Two Kids and a Camel

My Journey in Photographs

Annie Griffiths Belt

NATIONAL GEOGRAPHIC

Washington, D.C.

"Ring the bells that still can ring
Forget your perfect offering
There is a crack in everything
That's how the light gets in"

Leonard Cohen
"Anthem"

For Mom

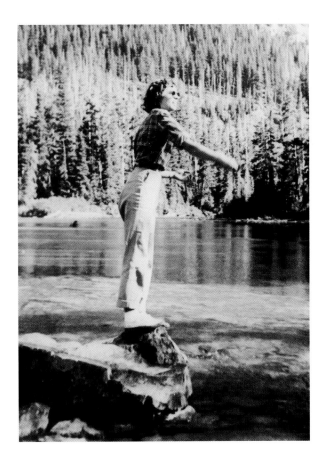

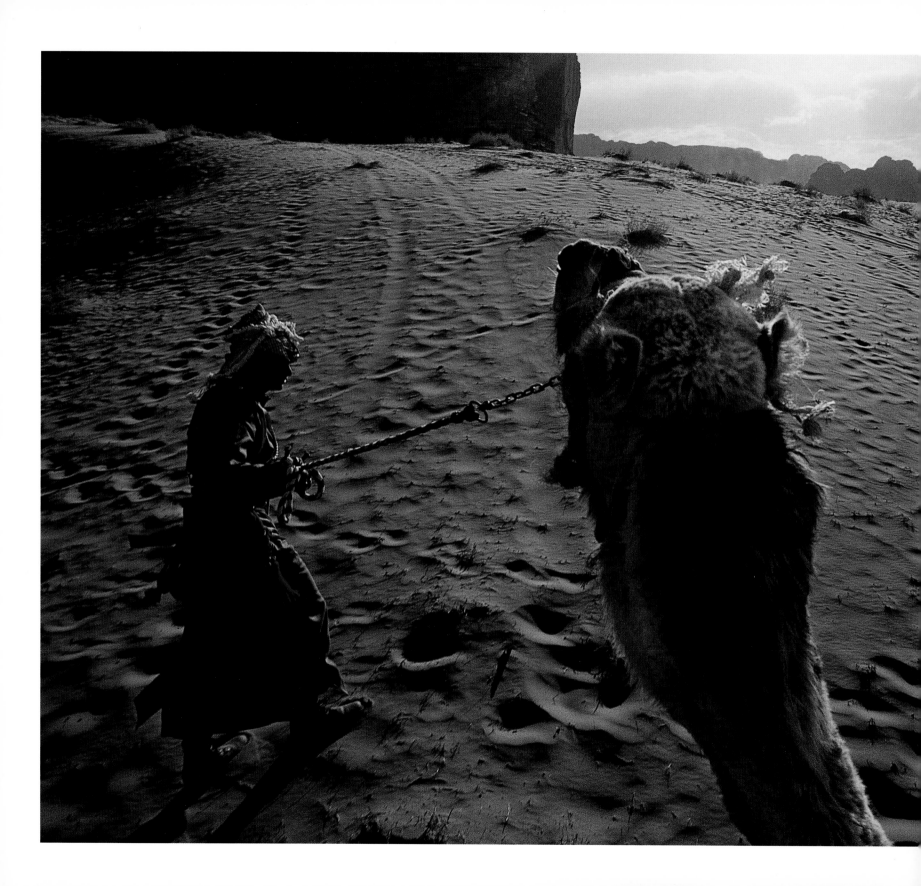

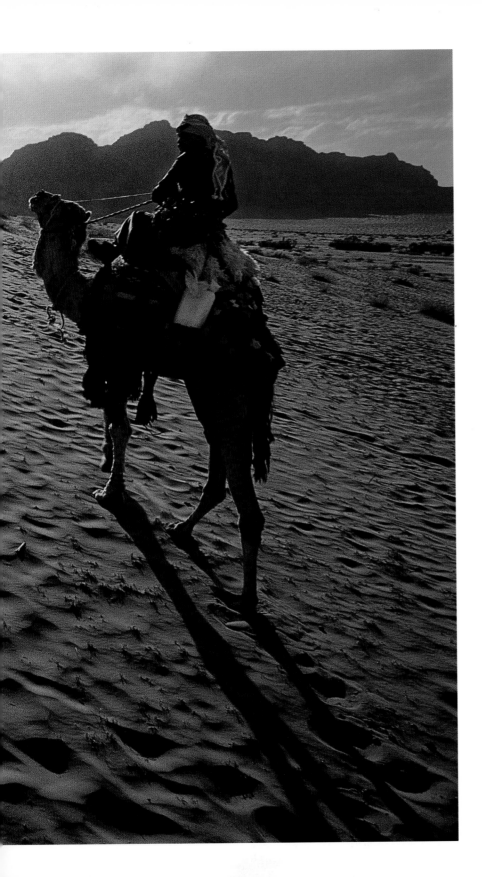

Contents

My Journey in Photographs 18

Early Days 34

Crossing Jordan 82

Shifting Continents 126

Giving Back 176

Afterword 220

Acknowledgments, Credits 222

BADLANDS NATIONAL PARK, SOUTH DAKOTA Prairie storm *(pages 2-3)*
WADI RUM, JORDAN Bedouin police *(pages 6-7)*
WORTHINGTON, MINNESOTA Farm wagon *(pages 8-9)*
LONDON, ENGLAND Taxi at Westminster Abbey *(pages 10-11)*
ZAMBIA Swimming hole at the top of Victoria Falls *(pages 12-13)*
BADLANDS NATIONAL PARK, SOUTH DAKOTA Prairie grasses *(pages 14-15)*
PREY CHAR, CAMBODIA Children celebrate the arrival of a new well *(pages 16-17)*

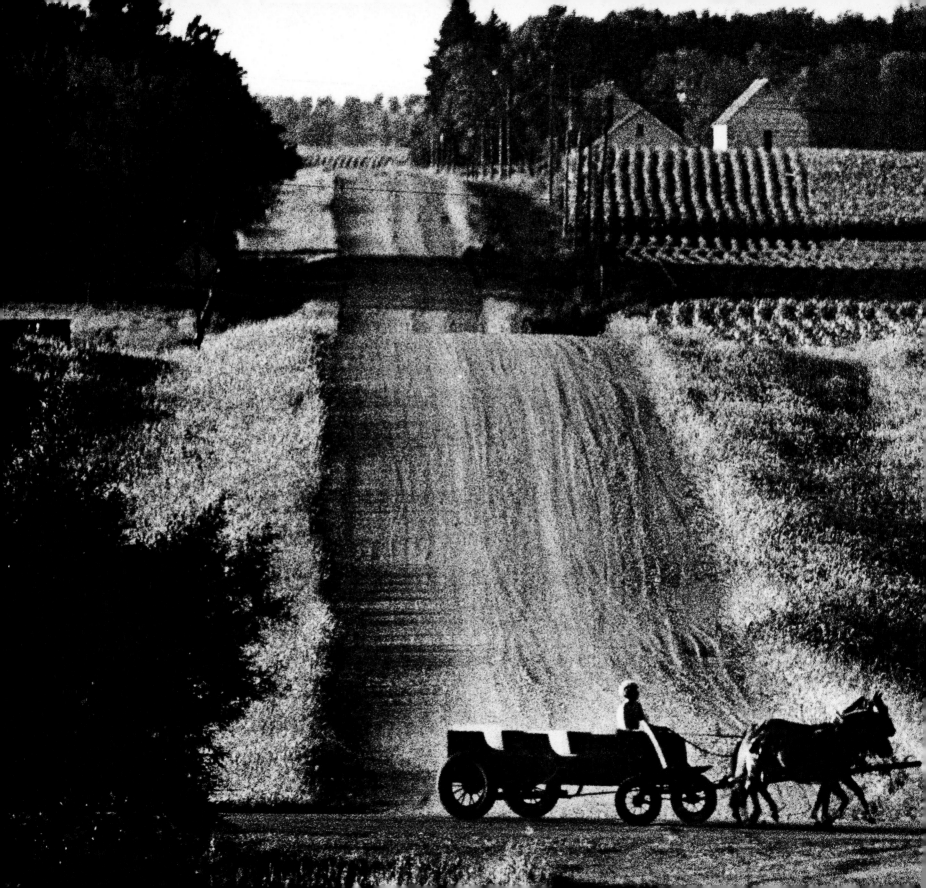

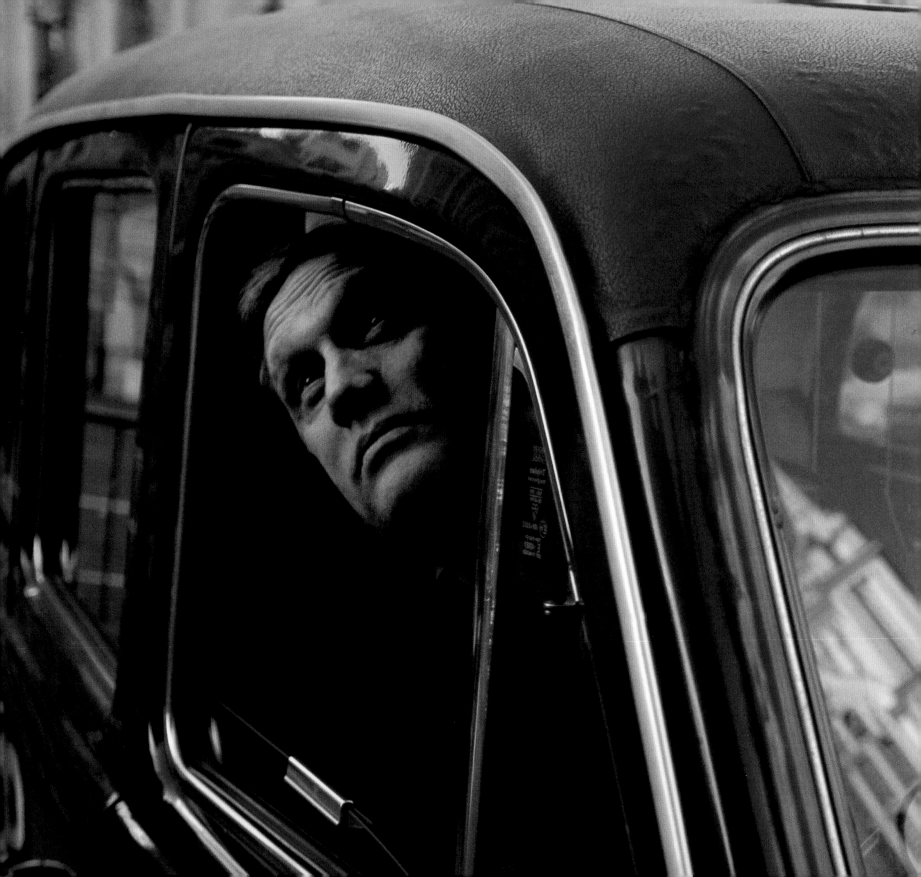

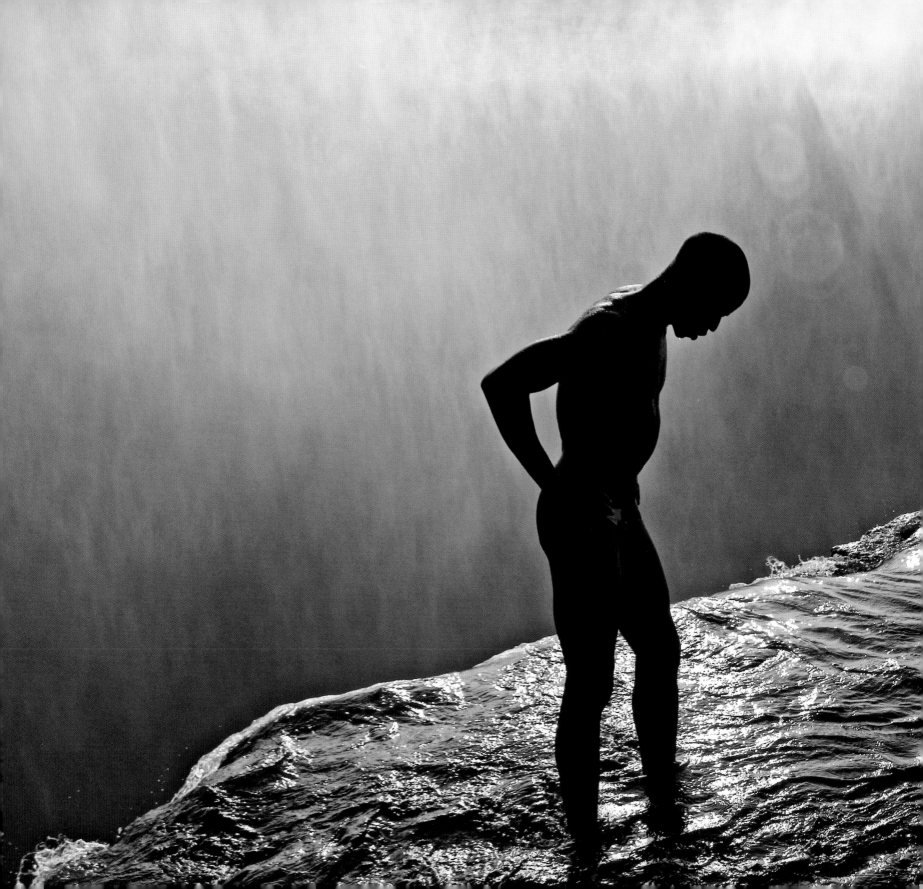

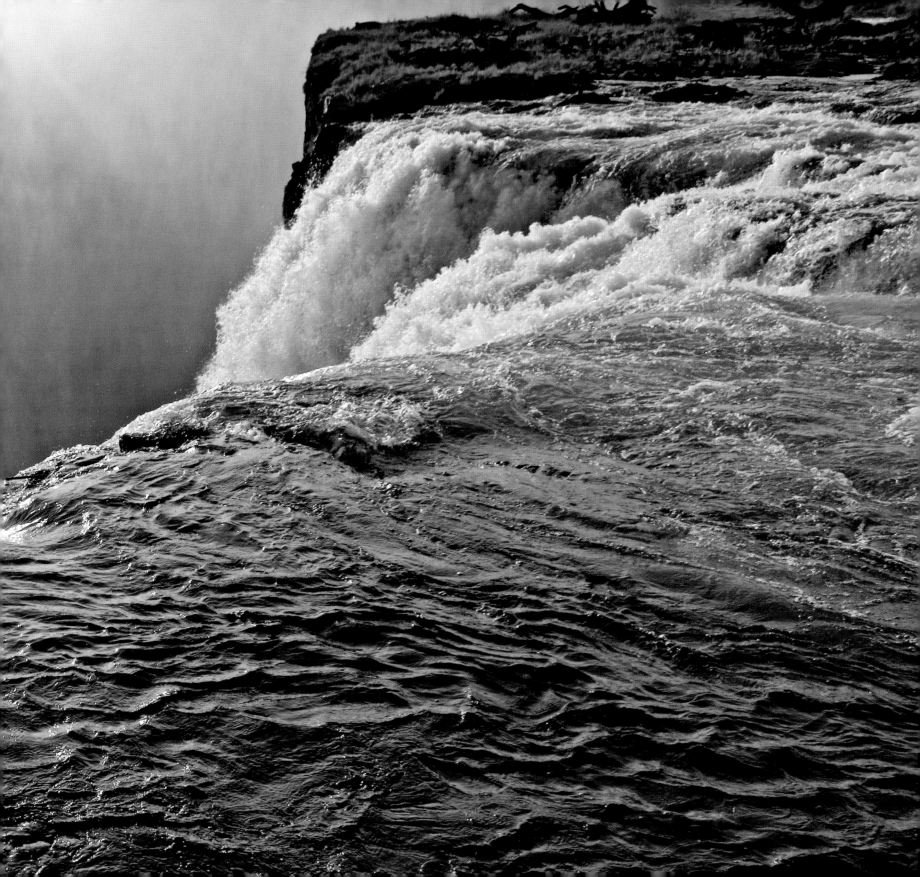

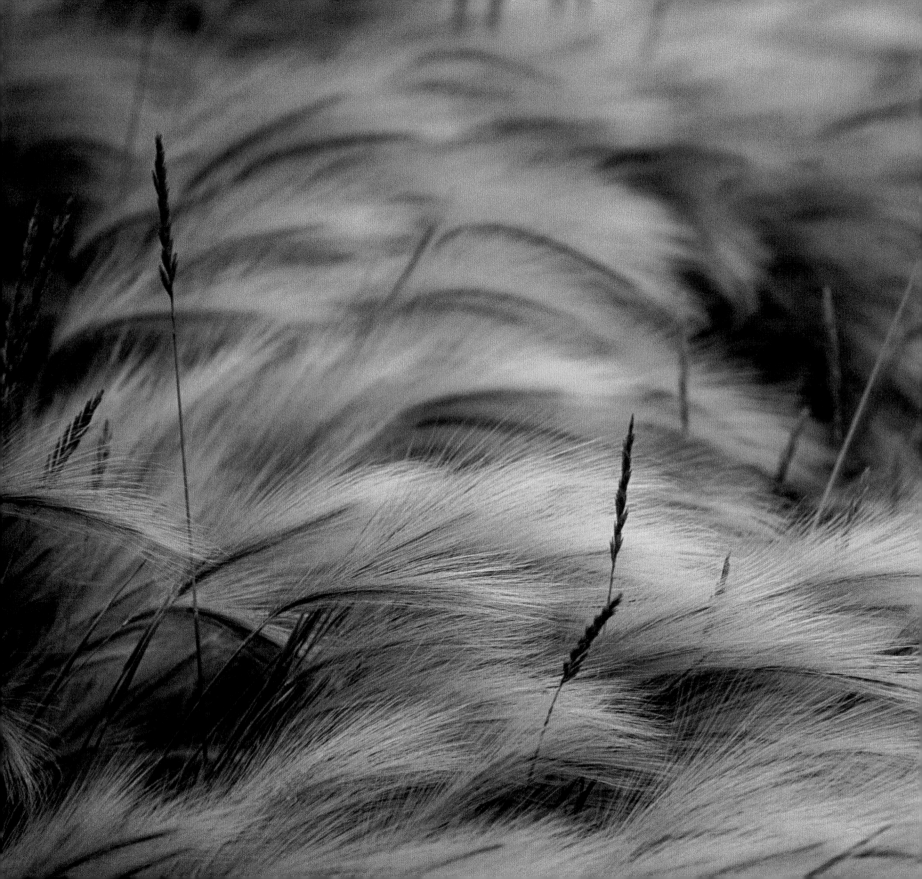

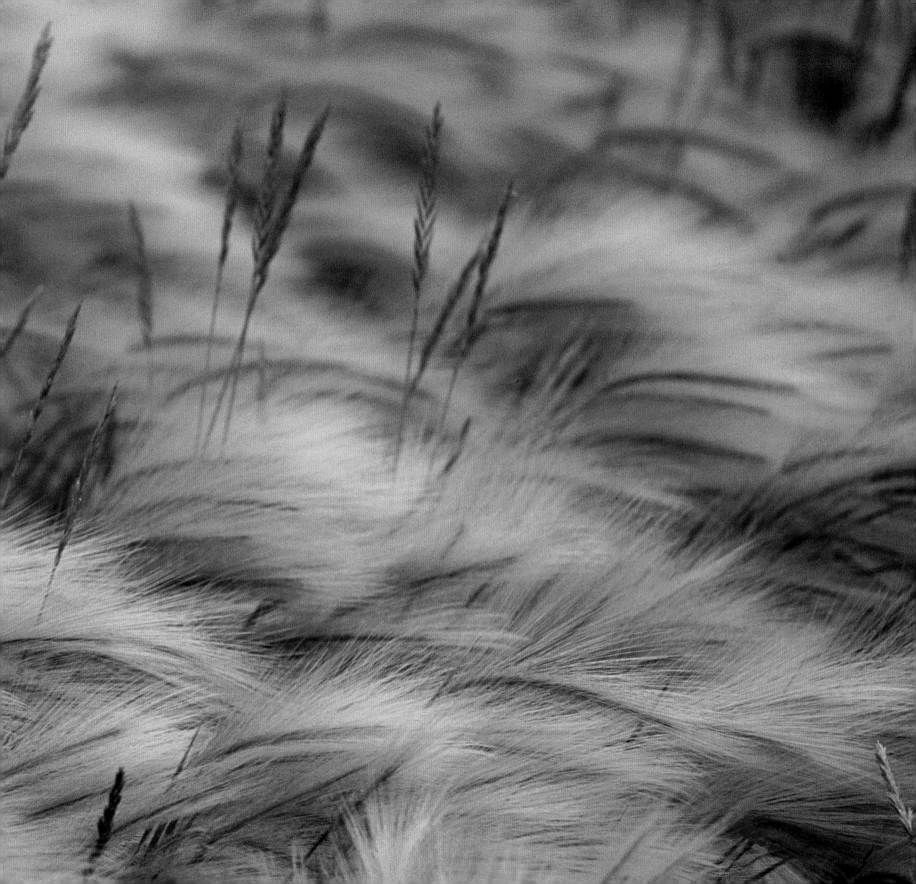

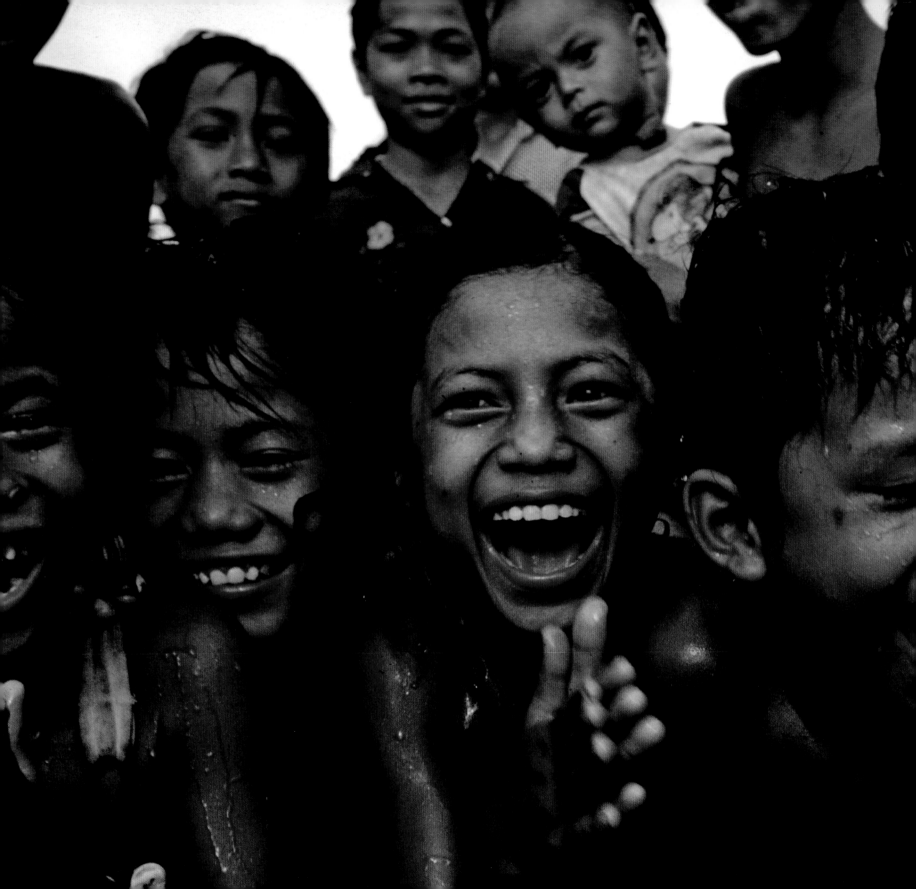

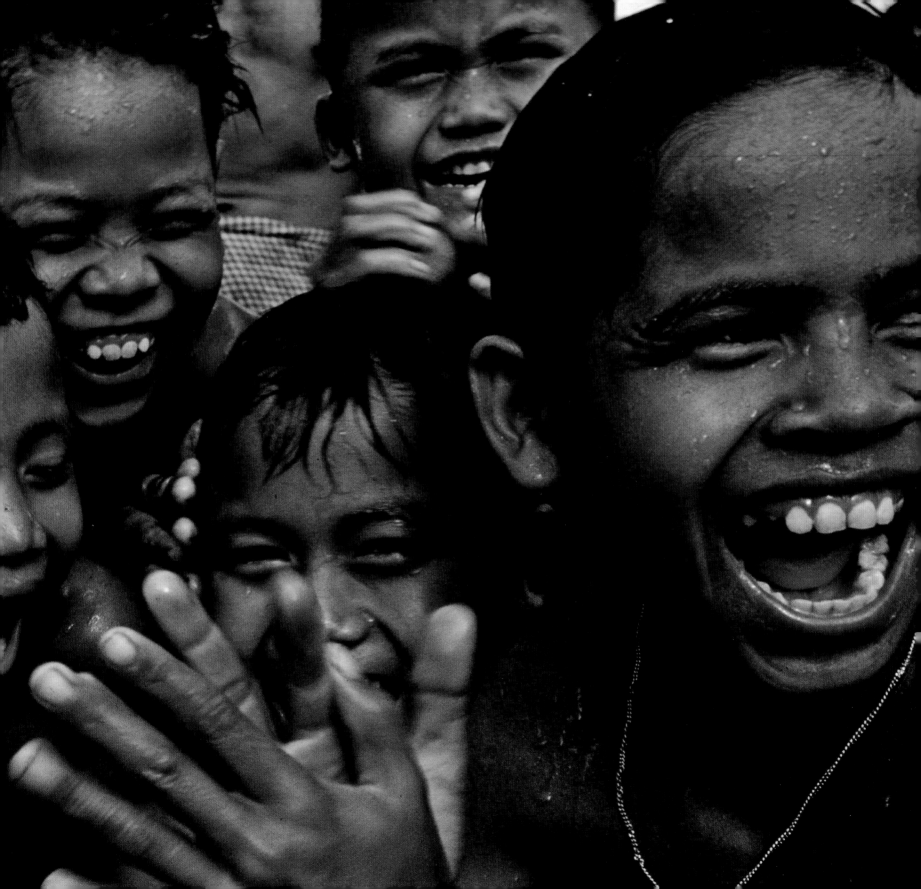

NORTHERN WISCONSIN, 1963
The Griffiths family
Front: David and Mom
Back: Bobby, Sally, a tall friend, and Annie
(photo by Robert Griffiths)

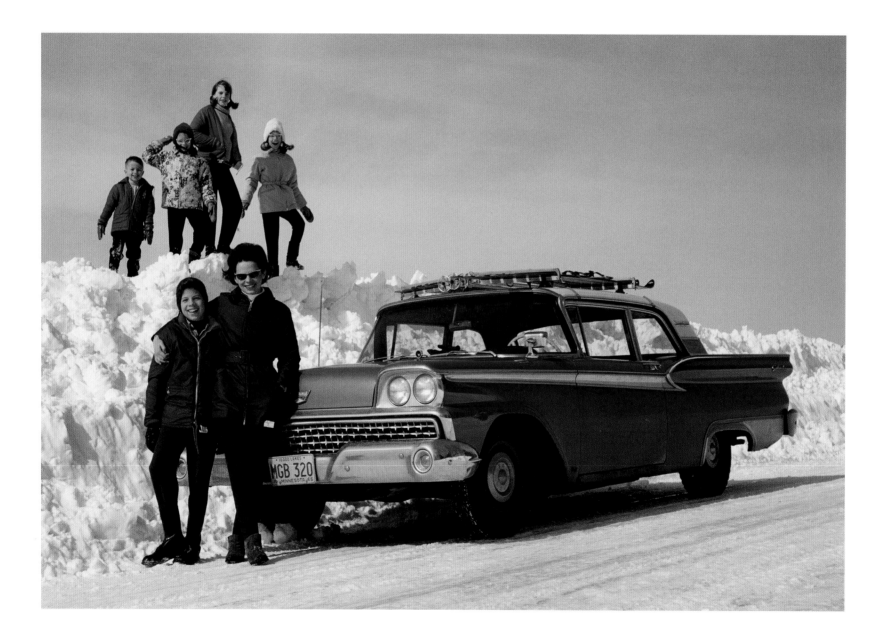

My Journey in Photographs

by Annie Griffiths Belt

N

I am living proof that when plans go awry, wonderful things can happen. When I was ten, I was convinced that I would become a novelist. But as soon as I was old enough to have bills to pay, waitressing looked like the better bet. Suburban, Midwestern Catholic girls tend to be planners, with paths already laid out for us

and personal dreams that get molded to fit the plan. Did I dream of becoming a National Geographic photographer someday? That one wasn't even on the multiple choice. I didn't own a camera until my junior year of college. Yet looking back, I remember poring over copies of *Life* magazine and, yes, *National Geographic*. I remember being astonished by the images of a developing fetus made by Lennart Nilsson. Pictures of the Kennedy funeral are burned on my brain forever. I remember stunning glimpses of the Middle East and Africa and Australia. I recall powerful images of space exploration, Mahatma Gandhi, the Vietnam War. And, although reading and writing were the honored pastimes in my family, it's the pictures that I remember. It just never occurred to me that I could do it.

I grew up in the classic 1950s America: Midwestern, suburban, Republican, two parents, four kids—two boys and two girls. We went to church on Sunday and were surrounded by relatives and grandparents. In summer, Mom kicked us out the back door

after breakfast and we often didn't come back until dinner. My very best friend back then was Mary Beth Stringer. She and I had no time for dolls. We rode bikes and jumped rope and built forts and played "kick the can" with the neighbors' kids, who seemed to number in the hundreds. In winter, we flooded our backyard to make a skating rink and spent hours conquering the world's greatest sledding hill. Mary was game for any adventure and was also the one you wanted on your team in a mudball fight. We caught caterpillars in jars and wished on ladybugs. We dissected cattails and milkweed pods. We spent days mothering an injured bird with eyedroppers of warm milk.

When I wasn't rescuing wildlife, I pretty much lived at the library. It was just one block away, in an old English Tudor house, where each room housed a different collection: history in the dining room, geography in the parlor, fiction in the master bedroom. The rooms had old, deep threadbare chairs, where a child could get lost for hours with the right stack of books.

Books offered a world beyond my world. And my world, for all its lovely simplicity, was beginning to feel a bit claustrophobic. Meanwhile, my mother, who had put her dreams in mothballs to raise a family, was whispering in my ear to fly away, to see the world and follow dreams of my own making.

I got my first real job at age 12, as a waitress. I am convinced that I learned more as a waitress than I ever did in a classroom. It certainly was more interesting. And when I went on to college, it paid for tuition and housing and, eventually, a camera. It allowed me to rent an apartment and feed myself (chicken pot pies, four for a dollar!). But best of all, being a waitress taught me to quickly assess and relate to a wide assortment of humans. I learned the gift of gab and how to quickly put people at ease—great training for a journalist. Waiting tables also taught me teamwork and service and humor. For the first eight years, I loved it. For the final two years, I just wanted to be a photographer.

From the moment I picked up a camera I was a goner. My other studies faded away and all I wanted to do was shoot assignments for the university newspaper, the *Minnesota Daily*. The paper at that time had one of the largest circulations in the state and was produced by young journalists who went on to work at every major publication in the country. In six months I was able to create a credible portfolio. The week I finished college I was contacted by the *Worthington Daily Globe,* a regional daily in southern Minnesota with a history of excellence in photography. I had seen the paper for months as I browsed the Journalism School library. It was a gloriously printed broadsheet with fantastic photographs. By some miracle I was hired, and the two-year experience that followed was like a master class in photojournalism.

Among the most important things I learned at the *Globe* was that if you can befriend a shy Norwegian farmer and make it to his kitchen table, you can probably navigate any culture on Earth. I made it to the kitchen table many times during my early years working at the *Globe,* usually in the company of my favorite accomplice, an exquisite writer named Paul Gruchow.

The *Globe* was a regional daily whose readers spread across much of southern Minnesota, northern Iowa, and eastern South Dakota. Despite its range, there were few assignments, but top-notch expectations from our visionary publisher, Jim Vance. With little or no direction, staff writers and photographers were expected to fill the paper with stories that were important to our readers. I didn't know it at the time, but this independent reporting was perfect training for my future career at National Geographic, where I would need to be exceedingly enterprising.

After meeting the 10 a.m. deadline each day, Paul and I would often take off in search of stories. Paul was the most sincere and least intimidating newspaperman I have ever worked with. Having grown up on a farm himself, and lived through personal tragedy, he was able to project warmth and empathy to anyone he met.

If the topic of the day was drought, Paul and I would head to the hardest-hit county and find farmers who were out walking their broken beans or corn or wheat. If it was a slow news day, Paul would know of a guy who was experimenting with crop rotation, or honeybees, or draft horses, and we would seek him out. Invariably, after making it to the kitchen table, the interview would extend far beyond the chosen topic. With hot coffee and

a warm fire to lubricate their thoughts, farmers would eventually wander into more personal terrain. The lesson I learned during these precious years in the company of a master listener was patience—how important it was to give each subject time and sincere attention. The real stuff was always so much more interesting than what we'd expected to find.

~

It was while I was at this marvelous newspaper that I happened to answer the phone in the darkroom one morning. A gruff voice asked, "You a photographer?" When I replied that indeed I was, the voice responded, "This is Bob Gilka. National Geographic. I need a hail damage picture. You guys get a big hail storm last night?" I managed to pick my teeth up off the darkroom floor and stammered, "Yes, sir." When he asked if I could run out and make the picture for him I responded with a second "Yes, sir." Thus began one of the most important relationships of my life, with the legendary Director of Photography at National Geographic, Bob Gilka.

Bob was a lion in those days, with a drill sergeant's demeanor that masked his wit and tenderness. He had an officer's code of honor and a genius for finding his own talented photographers. He was not easily impressed. Bob always used to say, "I'm knee-deep in talent, but only ankle-deep in ideas. I want people with ideas!" He was a man of very few words, so every word was heard. A pat on the back from Gilka after a story was finished meant as much to most photographers as a Pulitzer prize.

Bob scared the hell out of half the photographers he hired, but those who took a good look into his eyes knew he was there for them. I was one of the lucky ones who looked early. Everyone in the organization, from the president to the janitors, respected Bob. Now in his 90s, he is still a celebrity at National Geographic and remains my favorite dancing partner.

My little picture of hail damage in southern Minnesota was well received, and a year later, I was working for Bob on a full-fledged assignment. I was the youngest photographer at the Society when I arrived in 1978, and I spent at least a decade just trying not to screw up. As a very young photographer, I was blessed with opportunity before experience. While I'm grateful for every break I got, I paid for it in terror. With each new assignment came the fear that this was going to be the one where they figured out that I couldn't do this job—that I was over my head and had simply slipped under the radar. Somehow I muddled through, but my first decade at National Geographic was very lonely. Then I met Don Belt.

Behind every fortunate woman is someone who believes in her—someone sitting in the bleachers, quietly applauding every success, shouldering each disappointment, waiting in the twilight or the drizzle after everyone else is gone, loving her. If she is really lucky, that person is her husband.

Don was a writer at the Geographic when we met in 1987. He was dark-Irish delicious, a maniac for soccer, a would-be geologist, and a poet. I had no chance.

Don was the first man who ever took me fly-fishing—and he didn't even care if I fished. After our first date, he left a

copy of *A River Runs Through It* at the front desk of the hotel where I was staying. He was the first man to draw me a bubble bath, refer to me as "my gal," listen to me lose all professional composure and sob on the phone after three weeks of nonstop rain on an assignment in the goddamn Loire Valley. Don was the first person who ever said to me, in response to my apology for some shortcoming, "Hey, don't apologize. That's just who you are." Such simple and liberating words for a Midwestern Catholic girl to hear. A year to the day after our first date, we were married. And a year later, we became parents. Lily arrived in 1989, and Charlie landed in 1992.

Traveling with children can be complicated, but the rewards far outweigh the hassles. And the younger they are, the easier it is. Lily accompanied me to 13 countries before she was born. Apart from causing recurring nausea, she was remarkably well behaved. Charlie also traveled a bit in utero, but halfway through the pregnancy he tried to arrive three months early and wound up sharing bed rest with me for the rest of his incubation.

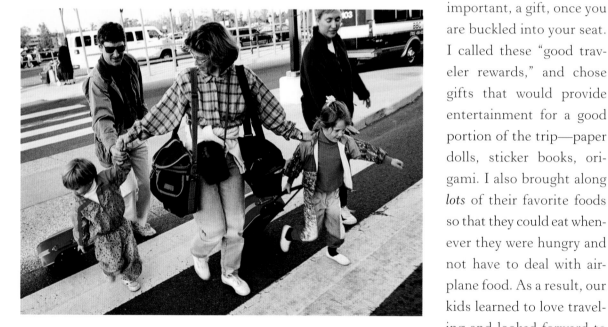

The trick to traveling with kids is to think like a child. As long as they are fed, rested, and entertained, children are remarkably flexible. So my travel plan has always been to meet all those basic needs and spice it up with a liberal dose of bribery.

When they were young, the message to the kids was: If you are a good traveler, you'll receive lots of praise and, more important, a gift, once you are buckled into your seat. I called these "good traveler rewards," and chose gifts that would provide entertainment for a good portion of the trip—paper dolls, sticker books, origami. I also brought along *lots* of their favorite foods so that they could eat whenever they were hungry and not have to deal with airplane food. As a result, our kids learned to love traveling and looked forward to all of our trips. They still do.

Kids also need a kitchen. I had a dream when I was pregnant with Lily that I returned from shooting one day to a grand hotel room where my demon child was ordering room service and watching MTV. I took it as a sign that hotels should be the housing of last resort on assignment. We needed something

homier—something with a kitchen and a neighborhood. So the Belt family has stayed in beach houses and apartments, in Bedouin tents and on an Israeli kibbutz, but rarely in a hotel.

We traveled with the handful of things that made the kids feel at home: pillows and favorite stuffed animals and books. We had them create artwork to decorate the walls of each temporary home. We celebrated important holidays no matter where we were. I remember one Palm Sunday when Charlie asked me, "Mommy, do you think the Easter Bunny will find us in Aqaba?" I headed for the local souk and shopped for Bedouin trinkets, making sure it was an Easter morning to remember.

I have often been amused by how oblivious children are to the things that cause adults tremendous stress in traveling. Most kids are not the slightest bit thrown by delayed flights, passport control, or surly ticket agents. On one particularly horrible travel day, we flew from Washington, D.C., to Jerusalem via Frankfurt. The customs agent in Frankfurt proceeded to tear apart our carefully packed luggage (he even unscrewed the toothpaste!) and roughly pushed each of our ten pieces back toward me to repack. We nearly missed our connection because of the delay, but as we boarded, the flight attendant for Lufthansa handed each of the kids a toy puppet.

That night in Jerusalem, we arrived to find that the apartment I'd rented—which looked so good in the real estate photos—was a disaster. It had one working light bulb, no hot water, no heat, and a serious cockroach problem. Jenn, our nanny, and I tried our best to hide our horror from the kids. As I tucked Lily into her bed she sighed, "I wish we were going home tomorrow." I

gulped and tried to put a happy face on our predicament. "I know, sweetie," I said, "But this is going to be a great trip with lots to do." Lily clutched her new puppet to her chest and smiled, " I know, Mommy. But I just *love* Lufthansa!"

Although our children traveled with me constantly during their first ten years of life, they were rarely with me while I was actually shooting. The ringmaster of this traveling circus was our nanny. We had three amazing nannies—Angela Trittin, Jenn Goff, and Heidi Keir—during our travels, and they remain part of our family to this day. Two are now mothers themselves to very lucky children.

Each of these women brought her own special skills to caring for our kids. And although I had great respect for the wonderful teachers my kids learned from in their classrooms back home, my philosophy on the road was not to let school get in the way of our children's education. So, in addition to keeping them up with their schoolwork, I challenged our nannies to get the kids out and active in any culture we were visiting.

In Jerusalem, when Lily was five and Charlie was two, Jenn set up a chart to see how far they could walk in the two months we would be there. She marched them all over the Old City, visiting their favorite falafel maker and picking flowers to brighten our dreary apartment. We had quite a little celebration when the chart revealed that Jenn and the kids had walked one hundred miles together through the streets of Jerusalem.

Angela hauled the kids to countless agricultural shows while we were working in northern England. She had them shearing sheep and tasting local puddings and rolling down the endless green pastures of the Lake District.

Heidi taught them to body-board in the Tasman Sea and to run the luge in New Zealand. She expanded their vocabularies with colorful Australian slang.

It must be said that, although I was the first woman photographer at National Geographic to take my kids on most assignments, I did have role models. Some of the guys had been quietly bringing their families along for years. Dave Harvey told me that he'd packed a kid or two along whenever possible. He often mentioned how crucial those trips were in bonding with his sons, Brian and Erin. Cary Wolinsky and his wife, Barbara, trotted little Yari all over the world with them. Cary told me that Yari was the finest passport he ever took to China. Sisse Brimberg traveled quite a bit with her first child, and I remember Sisse telling me, when I asked about the difficulties of traveling with her son, "Oh, it is very difficult traveling with Caulder," she sighed. "It's almost as difficult as traveling *without* Caulder."

❧

And then there was my mother. Mom was born on May 20, 1927, the day Charles Lindbergh flew the Atlantic. Somehow, being born on that day kindled in her a lifelong fascination with flight. As soon as she was old enough, Mom applied to become a stewardess but was rejected because she wore glasses. So she became a pilot. In 1977 she joined a group of women in an aviation race across the country called The Powder Puff Derby.

Mom was the oldest of three girls, raised by a harsh Irish-Catholic mother and a sainted German father in St. Paul, Minnesota. The Becker girls were, and are, a loveable bunch. All three inherited their father's sweetness and their mother's beauty. My mother was born restless. But as the oldest daughter in a very conservative home, she needed to use both her will and her wits to pursue any dream of travel. Still, she managed to wriggle free to spend two summers as a waitress in Glacier National Park. There, away from the iron will of my grandmother, she camped and hiked and fished, and met the handsome man who would become her husband. Those summers in Glacier may have been the happiest time of her life.

Although my mother faced more obstacles than opportunities in her life, her irrepressible spirit has always inspired me, especially as I felt the weight of trying to break new ground for other women. When I quietly began taking our kids on assignment, I was meticulous about expense accounting and paying our own way, fearing that someone might accuse me of taking advantage. In fact, I know now that I was the cheapest date the Geographic had for years. We never stayed in expensive hotels, and I passed on business class to ride back in steerage with my kids. I never talked about the children in business meetings. But after five years of proving that this could be done, I came out of the closet and, I hope, helped open the door for other photographers to follow.

As our kids got older, they were able to accompany me, nanny-free, on some amazing shoots. Among the indelible memories of traveling with my children was a trip Charlie and I made together to the Galapagos Islands. I am convinced that the islands were designed by 13-year-old boys. They are crawling with bizarre lizards and rock formations and ancient tortoises,

with blue-footed boobies, ruby-throated frigate birds who dazzle with courtship displays, and with albatross who soar above on seven-foot wings.

A favorite memory is the afternoon that Charlie and I spent together snorkeling off Floreana Island. We had drifted for some time with sea turtles and manta rays when suddenly Charlie grabbed my hand and pointed. A boisterous gang of sea lions was headed our way. They swirled around us like ricocheting bullets, sometimes stopping to stare directly at us, whiskers to face mask, then diving between our legs to tug at our flippers and dive again. As I floated, holding hands with Charlie, surrounded by this tornado of sea lions, I could hear my son shrieking with delight through his snorkel.

It is important to note that along with joyful moments, there are risks and even dark days on assignment. When Lily joined me on an eight-day pack trip to Yellowstone, we did see grizzly tracks near camp. In the Galápagos, an occasional shark drifted past. Like all parents, Don and I have had to weigh the risks of each adventure for our children. During our years working in the Middle East, I was often questioned about bringing the children along. We were careful to research any place we took the kids and discovered that the places we were traveling to—including Damascus, Amman, and Jerusalem—were far safer than any large American city.

On many assignments, it is not the subjects who are difficult, but the logistics. Over the years I have traveled by horse and by VW bus, by train and truck and countless road-weary vehicles. We traveled by mule in Mexico, by dinghy in New Zealand, by ship along the Indian Ocean, by fishing boat in the Sea of Galilee, by moped in Bermuda, by sailboat in Sydney. I have flown rotor to rotor with another helicopter, darting grizzly bears in the high Arctic. The five most dangerous days of my life were spent traveling through Cambodia with a driver who drove as though Pol Pot was on his tail. Driving the mind-numbing, horn-blaring roads of Pakistan was a near-death experience. I have been in light planes with two separate pilots who had to make emergency landings far from any runway.

Other modes of travel have been sweeter. In Africa I have traveled by balloon, ultralite aircraft, and elephant. While drifting in a rubber raft on the west coast of Mexico, Don and I were suddenly lifted out of the water by a friendly Gray whale and her calf. Then there is my children's favorite mode of transportation: the camel. In Jordan, Charlie and Lily and their Bedouin buddies spent hours exploring the ancient caves of Petra by camel and donkey. They befriended a baby camel and named him Lawrence. Our kids were quite a hit with the locals, and they would often hitch a ride with passing camel drivers. The sight of my children riding high, often with one or two other kids, in the arms of a Bedouin friend is an indelible memory.

While photographing a story on Lawrence of Arabia, I asked permission to travel with the Bedouin police through the exquisite desert region of Wadi Rum, where T. E. Lawrence had traveled during the Arab Revolt of World War I. My request was met with great concern because, in the Bedouin culture, a woman does not go out into the desert with a band of strange men. Finally, King Hussein himself granted us permission. On

the day we were to depart, the three Bedouin policemen I would be traveling with approached me with great dignity. They were dressed in the magnificent green-and-red garb of their order. One by one, they spoke to me in hesitant, rehearsed English, "You are our mother," they said. Confused at first, it finally dawned on me that they were comforting me. They assumed that I was terrified about taking this journey with them and were assuring me that they would treat me as they would treat their own mothers.

We traveled for three days and two nights along the Saudi border, through fire-red sand and stunning rock formations. They provided me with the least ornery camel and taught me how to ride so that my legs wouldn't cramp. All three were so resourceful that they surely didn't need a mother. Though trees were scarce, they could somehow build a fire and make sweet tea in minutes. I was always given the first cup, the best blanket to sit on, the nicest piece of fruit.

At night we camped in natural cave

shelters, where the men built roaring fires and made amazingly good bread from flour and water and little else. As the sky darkened and the desert cooled, the men laughed and told stories. I fell asleep, full and forgotten, to the timeless music of friends speaking Arabic around a campfire in the desert.

I believe that the Arab culture is the most welcoming in the world, and it saddens me that, because of the extremist acts of a few, there is now such broad misunderstanding of this ancient and exquisite culture. The first word Arab people want to learn in any foreign language is "welcome." Our children remember their time in the Middle East, especially in the Kingdom of Jordan, as the finest adventures we ever had as a family. It was here that they ran wild over rocks and through caves with bands of local kids. They learned to milk goats and draw maps in the sand and eat with their hands. Here, every adult looked out for every child.

When we were staying in Aqaba one spring, Lily met some local fishermen who allowed her to help them haul in their nets. They made her feel so special that, from that day on, she insisted on joining them every morning at sunrise to help, certain they couldn't do it without her.

The kids also befriended a sand-bottle maker. Sand bottles are the most popular tourist trinket in these parts. Artists painstakingly pour sand of different colors into a bottle and create a desert scene. By cleverly painting glue on the inside of the bottle, the most accomplished artists can even create camel herds and celestial scenes inside a bottle the size of a jam jar. Lily and Charlie's friend was a young man named Ayman, who

spoke quite a bit of English. He called Charlie "Prince" and Lily "Leila" and gave them lessons while we waited for our food to arrive. They brought him little paintings and wildflowers. And, of course, he made them each a sand bottle.

On our last day in Aqaba, we went to say goodbye to Ayman. He had prepared a package for the kids. Different colored vials of sand were carefully wrapped in scraps of brown paper along with a handmade tamping tool and a little funnel. He told our children that they could go back to America now and teach their friends how to make sand bottles. This is the Arab culture I know—kind, welcoming, and generous.

In my early years, I was so busy scrambling to succeed in my job while juggling the needs of my family that, like most working moms, I had little notion of giving back to society. Every so often I would donate a picture or speak at a high school, but I felt no great commitment to a cause or an organization or a charity.

However, I had made a commitment to my children that I would never be an absentee mother. And their academic needs were quickly outpacing our ability to keep them up with their schoolwork on long trips. The kids were good students at their public schools, and we had always worked closely with their teachers to keep them on track when we traveled.

But it became increasingly tricky as they headed for high school. I remember one Back to School night in my daughter's calculus class when I found myself asking, "So, what *is* calculus?" Clearly, I needed to make some changes.

Fortunately, I had listened in the early years at National Geographic when Bob Gilka urged all of us to have a Plan B. Bob knew that publishing was about to undergo many changes, and that none of us could count on a lifetime of magazine assignments. So, being the Girl Scout that my mother raised, I did what I was told and began honing my skills as a picture editor, speaker, and teacher. When it became clear that my days of pulling the kids out of school for a couple of months at a time were numbered, I initiated Plan B. I proposed stories that could be shot in summer. During the school year, I pursued shorter assignments, began lecturing regularly, and started working on book projects.

As these new stars aligned in my career, I recognized inside myself a deep longing to have my work be *useful* as well as beautiful. I wanted my pictures to make a difference in real people's lives. At the same time, my irrepressible brother, Bobby, approached me with a new idea. Bobby had for years found ingenious ways to use his printing business

to create revenue for nonprofits he believed in. He felt that two of his favorite organizations, Habitat for Humanity and Church World Service, had a real need for compelling photographs and personal stories about both the families that were being helped and the dedicated people who were working shoulder-to-shoulder with them.

We began with a calendar for Habitat for Humanity. The following year we launched a similar project for Church World Service (CWS), a non-denominational consortium of churches, synagogues, and mosques to raise money and distribute it to ongoing partnerships around the world. CWS funds an amazing array of projects, ranging from disaster relief to sustainable agricultural programs. They are particularly committed to women's rights.

Each spring I head off on a whirlwind trip to two or three third-world countries. I usually spend about four days in each country, shooting portraits of those whose lives are better because of the dedicated workers who care about them. The resulting images are used in a variety of fund-raising products.

The other issue that stole my heart was the environment. In 2000, as the chads were being counted in Florida, my friend Barbara Kingsolver and I realized that the environment was at risk. We resolved to make a difference. With a grant from the National Geographic Expeditions Council, I set off to document the last one percent of wilderness left in the United States. I traveled from the Arctic National Wildlife Refuge to Hawaii to the Okeefenokee Swamp to give a glimpse of what the continent had looked like before Europeans arrived. I shot the images on black-and-white infrared film and hand-colored the resulting prints. Barbara, who is a biologist as well as a celebrated novelist, wrote an exquisite text. The Last Stand project became a book, a traveling exhibit, and, most important, a fund to support grass-roots conservation projects in the United States.

Recently I was listening to a talk by renowned photographer Duane Michals. Duane is as free a spirit as I have ever known. At one point in his talk he stopped and asked the audience, "What ever happened to *wonder*?" With that simple question, Duane reminded me that it is wonder that really matters…and wonder has been my mother's greatest legacy. She has never turned away from a sunset, never failed to exclaim when a humming-bird visits her feeder, never tired of the reincarnations that each season brings. Mom's sense of wonder has always been alive and well in me and in my children.

I recall a day years ago when Charlie tiptoed off the kindergarten bus, beaming. In his hands he carried a small black plastic gardening pot. Its precious cargo was a single, delicate seedling. Like Houdini, he announced that his corn seed had magically taken root at school and that his teacher had allowed him to bring it home for planting. After motherly minutes of exclaiming over the precious cargo he held, I told him by all means, take it out and plant it in the garden. I assumed that he would dump the pot in our large back garden and thought no more about it.

Two weeks later I noticed a new plant sprouting in a small patch of garden directly outside the front door. It looked remarkably like a small corn plant. As I bent over to ensure this was

PETRA, JORDAN
Lily Belt, age six, with a Bedouin shepherd

APPALACHIA, KENTUCKY
Daniel Boone Forest (*pages 30-31*)

LITTLE ROCK, ARKANSAS
High school baseball (*pages 32-33*)

not a weed, out came Charlie with a sippy cup full of water that he proceeded to lovingly drizzle over the little plant. He beamed. I nodded.

In the way that wonder triumphs and inspires, Charlie's corn plant continued to grow. By June, it was three feet high. By September it fully blocked our front door. When it reached its full height of seven feet, Charlie decided it was time to harvest. For all its grandeur, the corn plant produced only three malformed ears. We thought of using the opportunity to explain to Charlie all about plant fertilization, but this seemed like a little too much reality to lay on a small boy's miracle. Besides, the corn looked lovely to him. Instead we decided to hold a mini-Thanksgiving. We boiled

his corn with a little sugar and exclaimed over all 33 delicious kernels.

These days Charlie is in high school and Lily is headed for college. Lily has her heart set on becoming a doctor. Charlie, like his dad, is a beautiful writer. This year I will be working in Australia and South Africa, and the kids, once again, will be coming along. It amazes me to think that this will be the first time that Lily and I will travel together as adults. My life continues to be both hectic and humbling. I expect that Don and I have raised a couple of gypsies and that we will be chasing *them* around the world one day. The truth is, we can't wait. We just hope they will let us come along some of the time.

As a photographer I have learned that women really do hold up half the sky; that language isn't always necessary, but touch usually is; that all people are not alike, but they do mostly have the same hopes and fears; that judging others does great harm but listening to them enriches; that it is impossible to hate a group of people once you get to know one of them as an individual.

The spirit of wonder that was born in our family on the day that Charles Lindbergh flew his plane across the Atlantic lives on, I hope, in the photographs I have been privileged to make—and, certainly, in the two good travelers named Lily and Charlie, who have fledged and are now discovering worlds of their own to explore.

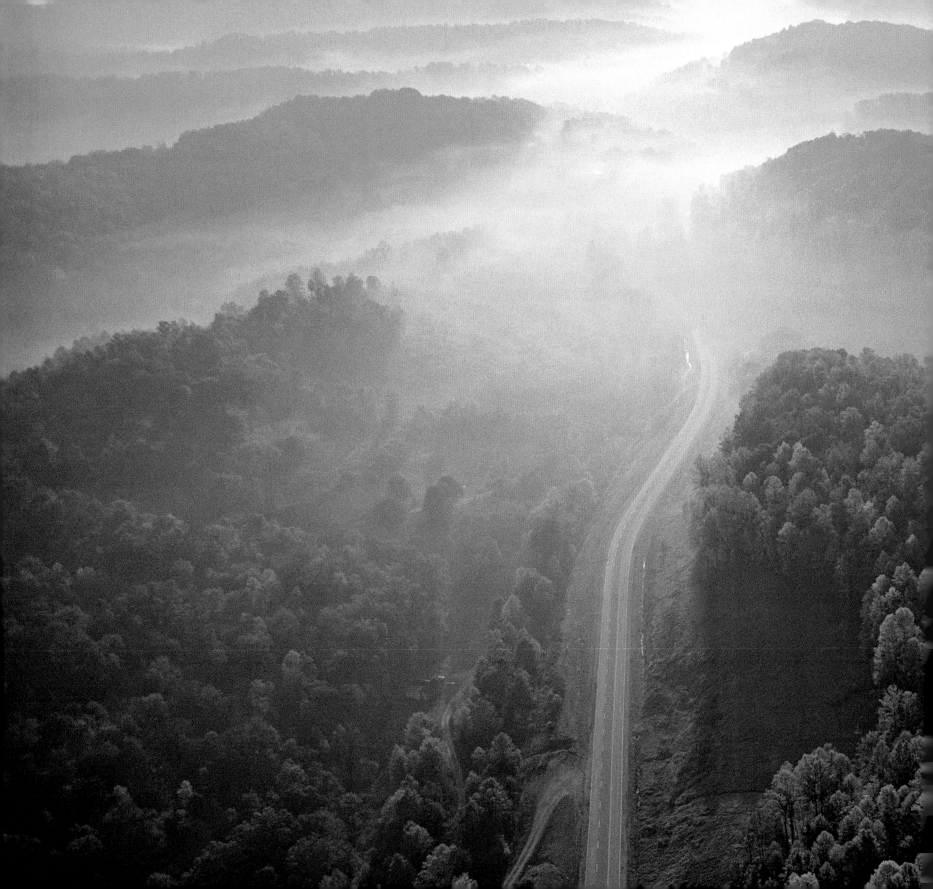

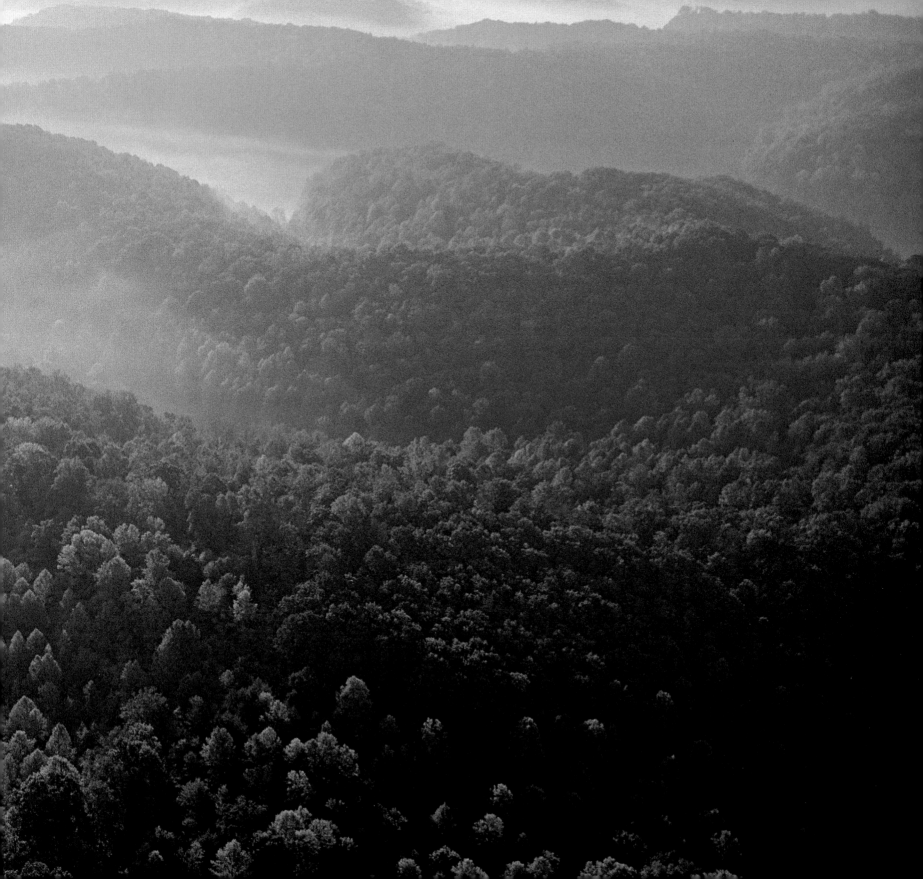

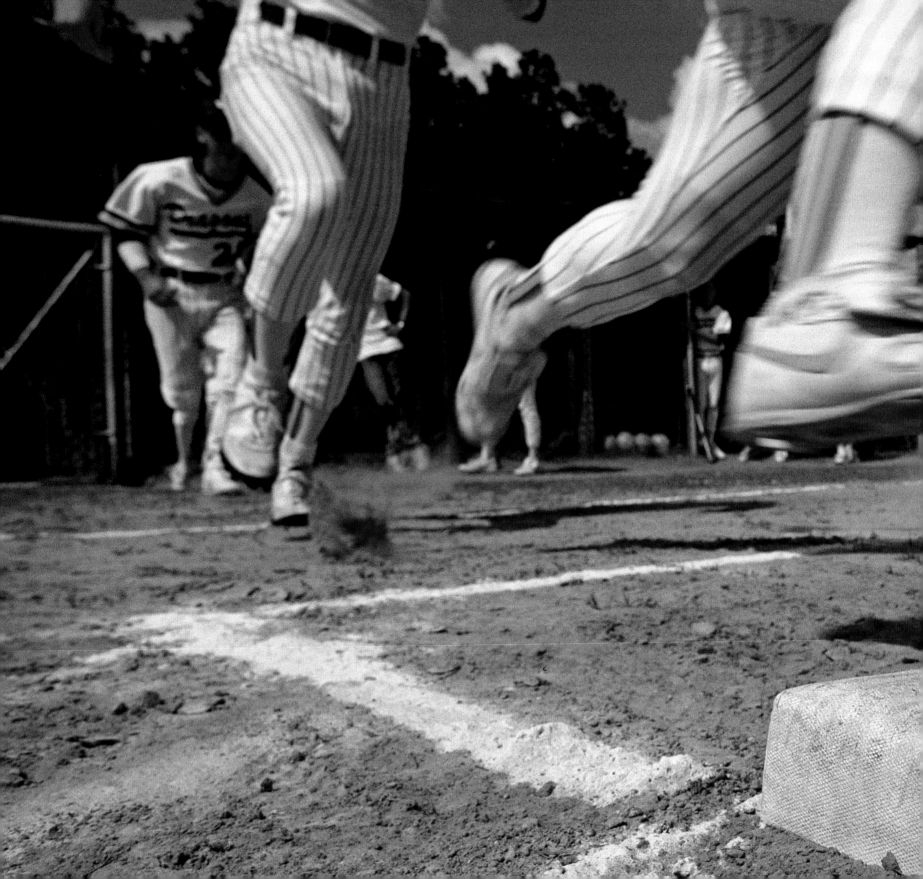

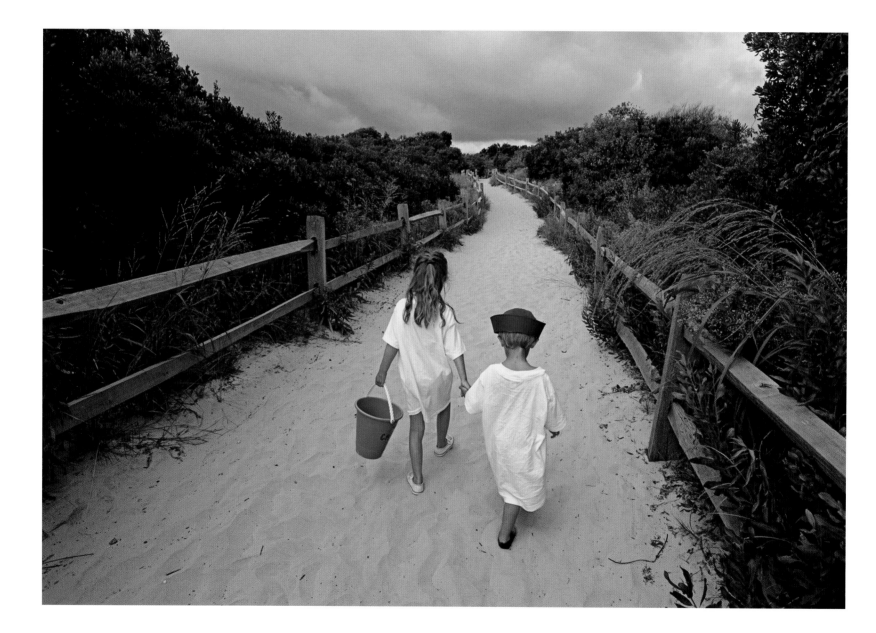

Early Days

It is terrifying to be 25 years old and find yourself catapulted to the top of your profession. When it happened to me, I felt a combination of euphoria and vertigo. The realization that I'd been granted the opportunity of a lifetime—a photo assignment for National Geographic—was thrilling for about 15 minutes.

Then the fear kicked in. I would be walking a high wire without a net, and I sure didn't want to fall.

I got my first full assignment while standing in the rain at a pay phone in northern Minnesota. I had sent in a black and white portfolio, along with a story proposal about a canoeing trip, to National Geographic's legendary Director of Photography, Bob Gilka. At the time, I'd left my newspaper job and was spending the summer camped out in the Boundary Waters of northern Minnesota, leading a group of high school kids who were building trails. I had absolutely no idea what I would do at summer's end. When I got a message that Mr. Gilka was trying to reach me, I hopped in the camp bus and drove out to the only pay phone I knew of, 20 miles away. It turned out that Bob liked my portfolio, and he liked my spunk in proposing a story. He asked if I could start shooting the following week for a National Geographic book about wilderness canoeing.

I remember walking away from that pay phone on wobbly knees, in the pouring rain, and letting out a yell that could be heard all the way to Winnipeg. I was two years out of college, had never been east of Ohio, and had never shot a color transparency. I just hoped that nobody at National Geographic knew that I was in completely over my head. But I did what I always do when I'm afraid: I took a deep breath, worked my butt off, and prayed that I wouldn't blow it.

I didn't know it at the time, but I was being eased into the process gently by a guardian angel named Bob Gilka. The first few assignments he gave me were in the United States—so at least I could speak the language and make a phone call now and then. He also assigned me shorter term Geographic book projects at first, rather than the more intimidating magazine assignments. Behind his gruff exterior, Bob Gilka was a very kind man, and he was taking it slowly, grooming me for bigger things.

My lifelines on those early projects were Bob's elegant assistant, Lilian Davidson, and the two patient editors who looked through my film whenever I sent in a batch, Guy Starling and Susan Smith. Over the phone, they walked me through the confusing logistics of captioning and shipping film, expense accounting, and other basics of working for the Geographic. More important, they assured me that the pictures were fine, and that I need not fall on my sword just yet. After endlessly

scouring the north shore of Lake Superior for photographs on my first assignment, I remember Susan finally telling me over the phone, "Annie, you've got it. Go home!" If Susan hadn't released me, I might be there still.

❧

In those days at National Geographic, we were given our assignments with very little fanfare. "Annie, this is Bob Gilka," he'd say. "I need you to go to London (or Namibia, or Tulsa)." After a discussion lasting about five minutes—and a five-minute phone call with Bob was a *long* call—the photographer was expected to take over. We were on our own to research, budget, organize, and execute each assignment. Photographers usually tried to coordinate with writers, but often went on assignment alone. I worked on stories where I never met the writer, but I also worked on a memorable assignment where I *married* the writer. Assignments in those days averaged three to six months. No assistants. No shot list. No excuses.

This was heady stuff for those of us who loved independence, but it did require tremendous self-motivation. The folks back at the office never knew if we slept until noon or worked 18-hour days—they just expected us to come back with an accurate story and great pictures. So each of us became, essentially, our own worst boss. We were keenly aware of how talented and hardworking our colleagues were, and that knowledge caused most of us to push ourselves to the limit on assignment.

For months at a time, our only real connection back at the office was the assigned picture editor, who waded through hundreds of rolls of film and gave us feedback over the phone. This was long before e-mail and cell phones, so those calls were our only yardstick in judging whether we were getting the pictures or going up in flames. I would make each call with my heart in my throat, certain that this was the assignment where they would find out that I was in over my head. Early in my career I had the great fortune to meet picture editor Kathy Moran. She became my friend and trusted compass. When Kathy was on the other end of those phone calls, I could relax a bit. Kathy coached me through countless projects ranging from Lawrence of Arabia to the Badlands of South Dakota. She is the finest picture editor I know.

Photographers are notoriously eccentric and insecure. (Kathy once described herself as the highest paid babysitter in Washington D.C.) The team that Gilka built was manned with characters and wild men, scientists and artists and nutbars. To a person, they were highly creative, adventurous, committed, and brilliantly resourceful. And boy, did they know how to have a good time.

One of the perks of working at National Geographic is that you rarely have a dull lunch. The level of energy and intellectual stimulation in this crowd has always been priceless to me. When we meet back at the office, everyone is either just back from somewhere amazing, or just heading out on his or her next adventure. In the early days, the assignments were longer, so the reunions were even more fun. Gilka called us all back once a year for a raucous two-day seminar that always stretched into three or four days of celebration and misbehavior. I recall one seminar when a group of photographers donned tuxedos and press

CHAPEL HILL, NORTH CAROLINA
Aqua aerobics class for pregnant
women *(following pages)*

passes, rented a limo, and proceeded to crash diplomatic parties all over Washington. I must say, we were well received at every stop.

But the mother of all reunions came when Bob himself retired. Every department at National Geographic wanted to do something special for this kind and legendary man. Photographer Bruce Dale volunteered to take up a collection for a parting gift. The response was so generous that he briefly considered buying Bob a hardware store near his cabin in Maine. In the end, we threw a picnic bash that will never be matched, complete with a world-class fireworks display. Photographer Chuck O'Rear, who grows wine in Napa Valley, even bottled a special vintage called Chateau Gilka, and brought cases of it to the party.

About the time that Bob retired, other people came into my life who made it richer than ever. I married author Don Belt, and gave birth to our children, Lily and Charlie. Balancing marriage and children with a career on the road has been the biggest and best challenge of my life. When Don and I realized we were about to become parents, we made some promises and set some boundaries. We pledged that in every career choice we made, family would come first.

I was determined not to be an absentee mother, so I made a commitment that I would take the kids with me on any assignment longer than two weeks. I also recognized that it was up to me to propose stories to the magazine that were compatible with our family's happiness. I knew that if I kept my dance card full, I wouldn't have to turn down stories that were too difficult or dangerous for the kids to come along. Whenever we could, Don and I proposed stories together, and traveled in the field as a family.

I kept my personal life out of the office and never let the logistics of traveling with kids become an issue.

That does not mean, however, that there weren't logistics—far from it. In addition to being a photojournalist, I needed to juggle a nanny and two kids on the road, so I became a manager, a travel agent, and a pack mule. Flight attendants would see me coming and weep. Camera bags, strollers, car seats. I may be the only photographer in history who packed her camera gear in Pampers.

Fortunately, the kids were born travelers. They actually enjoyed our marathon travel days, and learned to go native wherever we landed. Rather than come to where I was shooting, they instead settled into the local community with their nanny, exploring the culture and learning more about human geography than they ever could in school. Lily and Charlie continue to treasure a world of memories and landscapes in their hearts: the summer freedom of America's Barrier Islands; the dusty, desert world of the Bedouin; the pristine grandeur of British Columbia; the amber grasslands of Montana and South Dakota; the sacred geographies of Jerusalem; the ancient, winding alleyways of Fez.

The kids taught me a lot on these journeys. Because I came home to them at the end of each shooting day, I learned to put the camera down and be present in my life. It may sound strange, but as much as I love photography, I celebrate any sunset that I don't have to shoot, any bit of light that dances on my day. Some of the things I love best, I rarely photograph: dying roses, new ice on our little backyard pond, family, and friends. Maybe it's because they're so precious to me that I want nothing between me and my connection to them—not even a camera.

MISSISSIPPI DELTA, LOUISIANA
White pelicans

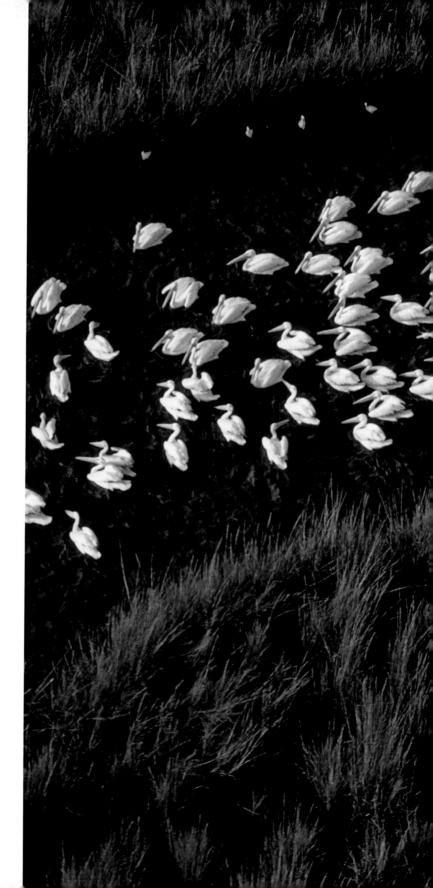

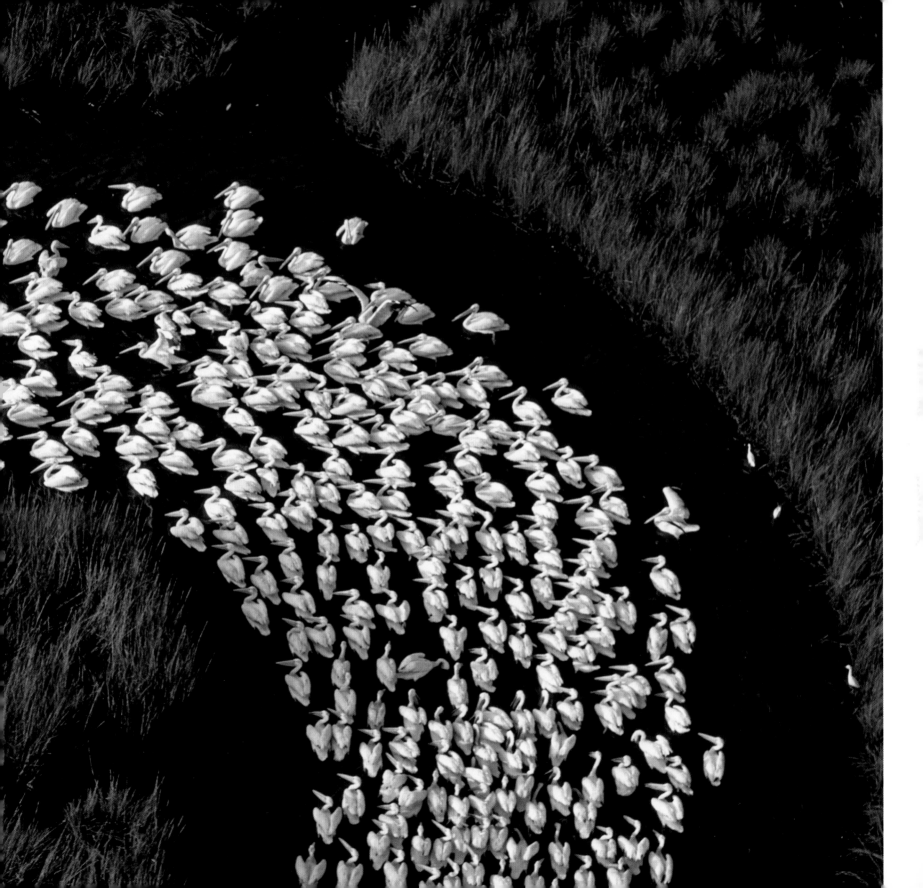

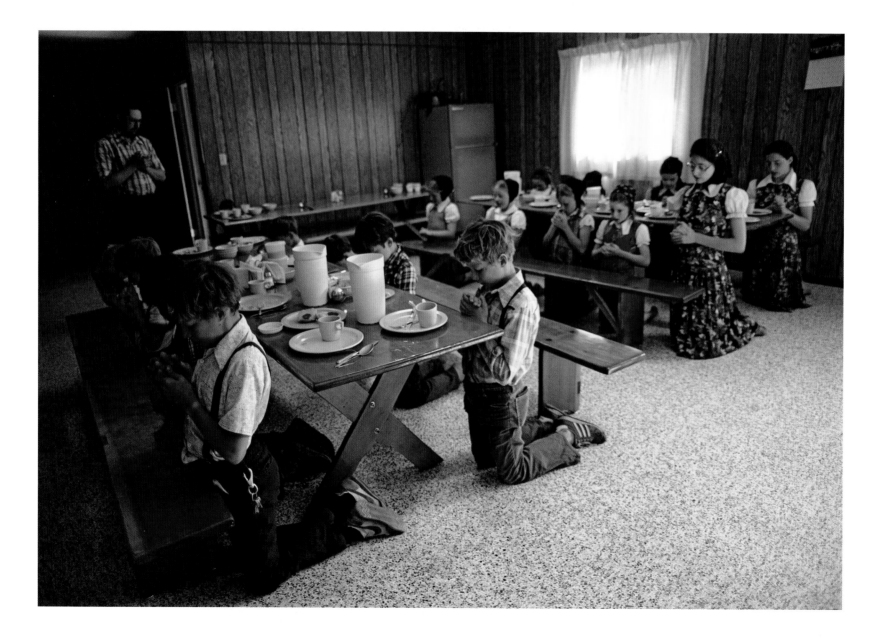

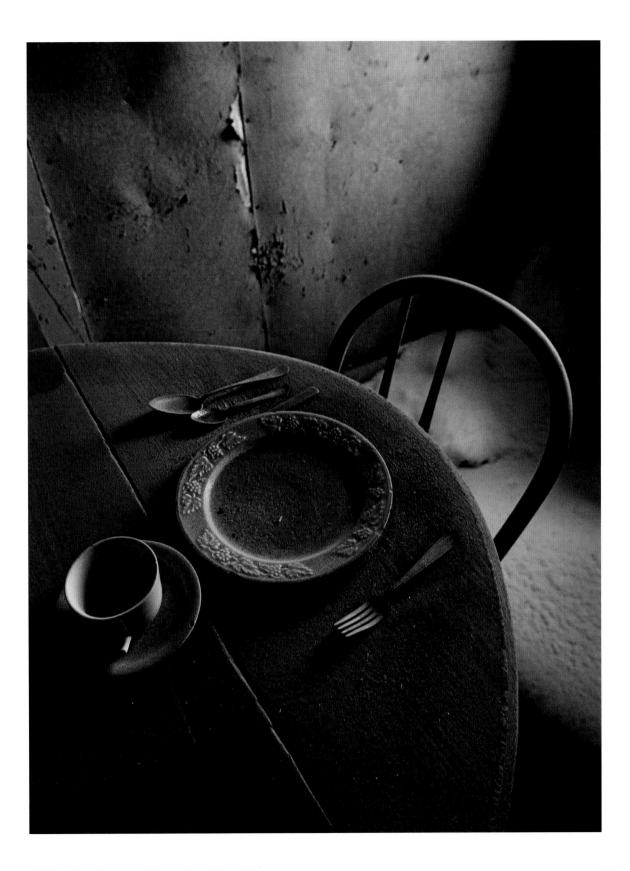

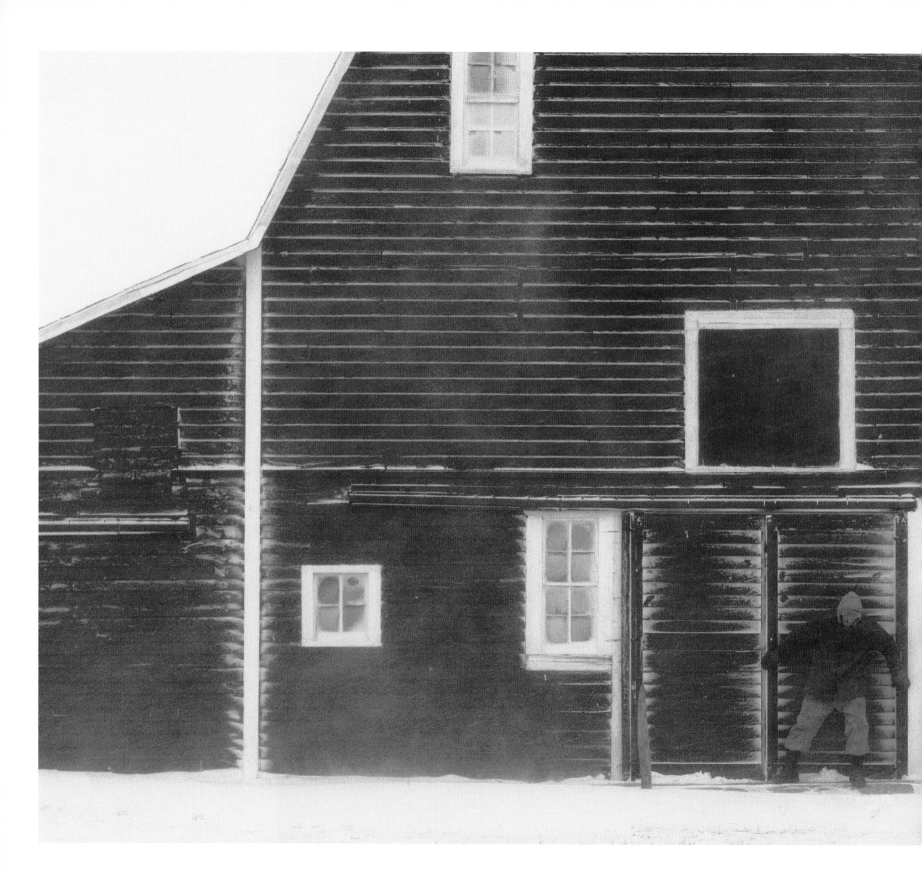

MCGREGOR, NORTH DAKOTA
Farmer Helge Holte wrestling with barn
door during blizzard
ARCTIC, ABOVE THE BROOKS RANGE
Midnight during the summer solstice
(following pages)

NORTH DAKOTA BLIZZARD

In 1988 I proposed a story to the magazine on the vastly underappreciated state of North Dakota. There is no time in North Dakota quite as brutal as January, so the author and I decided to head north to get a sense of how serious winter could be. I was a Minnesota girl, but author Cathy Newman was from Miami and had never seen snow. Poor Cathy. As luck would have it, we were met by a full-blown, in-your-face, take-no-prisoners North Dakota blizzard. I had spent years covering nature's wrath, but Cathy was terrified. So I packed our four-wheel-drive car with shovels and sleeping bags, food and water, and assured her that we would not die. The wind chill was -60°F as we set out from Minot.

We ended up at the farm of Helge and Amy Holte. The Holtes had farmed together for nearly 50 years on land that Helge's parents had homesteaded. Amy welcomed us with hot chocolate as Helge stoked his woodburning stove. Shy at first, the way all Scandinavian farmers seem to be, Helge was slowly drawn into our conversation. Eventually he told us the harrowing story of his own childhood, when his immigrant parents headed out by wagon to the Dakota Territory to homestead a piece of land.

The family reached their land in the middle of winter. As we listened to the blizzard outside, it was hard to imagine anyone wintering over here without a sturdy house for shelter. Helge spoke softly and rotated his cup of coffee as he told us about other blizzards—about prairie fires and drought, and the backbreaking work of turning over virgin prairie. In the early years, he said, when people died in winter, families had to wrap and store the bodies until May, when the ground thawed.

As we listened to the blizzard howling outside, Helge began to get restless. Earlier in the day, he had gathered his livestock in the barn to keep them safe from the weather, but as the storm worsened, he stood up and began putting on his boots. Photographers must follow, so I reached for my gear. I took this picture as Helge wrestled the 40 mph wind to open the barn door and check on his cattle.

Sadly, Helge Holte died before this picture was published. When other farmers in the area were contacted to get a sense of what kind of man he had been, one of his old friends said, "Well, let me put it this way. In my next life, I wouldn't mind coming back as one of Helge's cows."

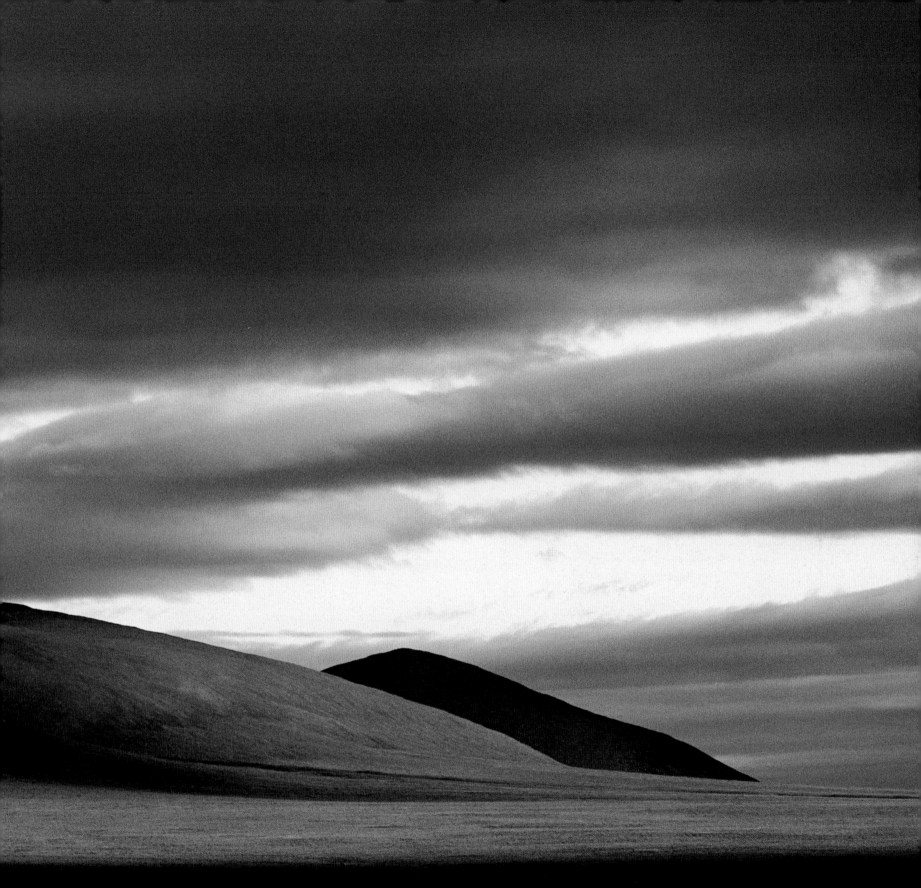

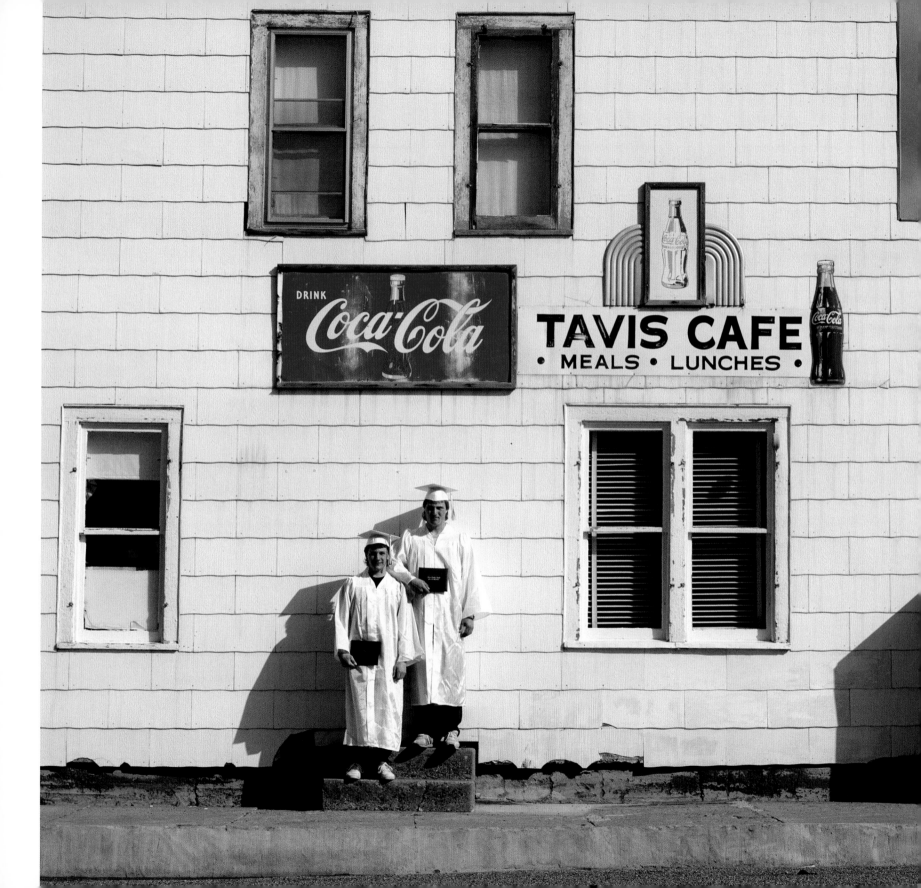

MELISSA

Every so often in my work I meet someone who touches me and teaches me a life lesson. Melissa Riggio was one of those people. She appears in the composite image at right, which is the only picture in this book that has been digitally altered. I made it while working on a story for *National Geographic Kids* magazine about Melissa, who is a poet, songwriter, and singer. She was also born with Down Syndrome.

I grew up with a cousin, Mary Jean Martin, who also has Down Syndrome, and I had come to realize over the years how sensitive and perceptive she was. Melissa, like my cousin, was blessed with a loving and supportive family. But she'd reached an age, 18, where she longed for more. Melissa was painfully aware that she was different from other girls, yet she wanted the same things that most teenage girls do.

My two days with Melissa proved to be two of the most challenging and rewarding of my life. I had been cautioned that Melissa was painfully shy with new people and was nervous about being photographed. But she also longed to express herself—to perform and to have her voice heard—and to feel pretty. Our first day was spent with Melissa hiding in her room, trying to work up the courage to meet me. Eventually, with some coaxing, she came out and by that evening we were baking cookies together and having fun. Like Mary Jean, Melissa had a lively sense of humor that she kept hidden from strangers. We planned to make pictures the next day. But overnight her fear returned. The next morning, Melissa was even more withdrawn than before and seemed filled with dread.

The day passed without a single comfortable photograph. By late afternoon, I was concerned that I might be upsetting this terrific kid. I knelt in front of her, took her hands, looked her in the eye, and told her that she absolutely did not have to be photographed if she didn't want to. She asked quietly if I'd be angry with her if she declined. When I just smiled and shook my head, she said she needed to go to her room. She returned ten minutes later in her prettiest pink dress. This was a young woman struggling to be in control of her own life. She even had ideas about how she wanted to be photographed.

What Melissa taught me to do was to listen on a deeper level. At one point, after we'd done a variety of portraits, she went out in the yard and began to dance. This is Melissa dancing.

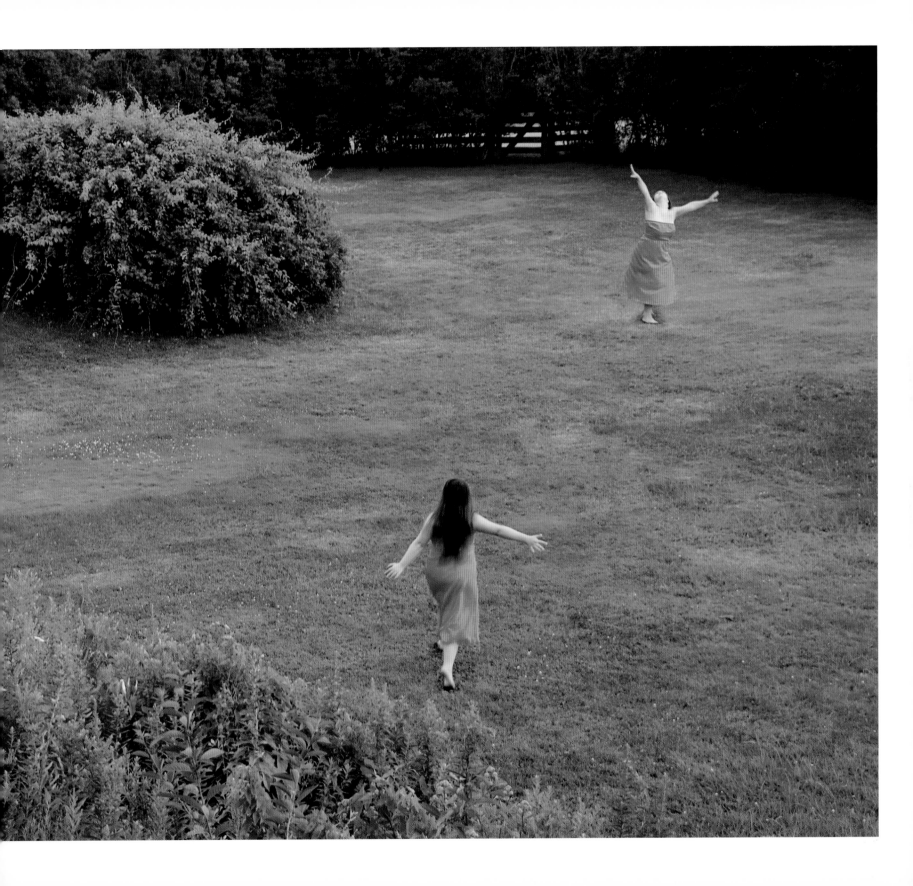

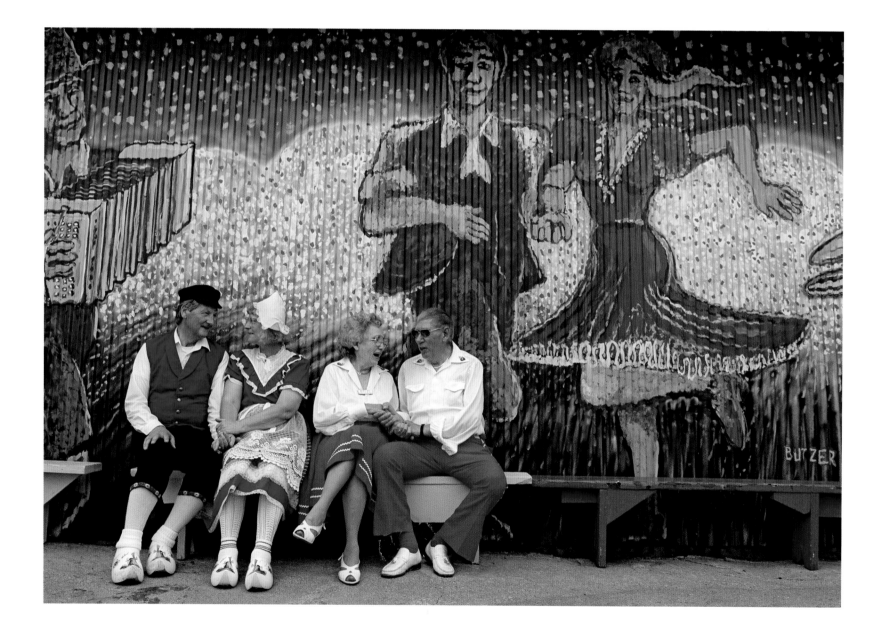

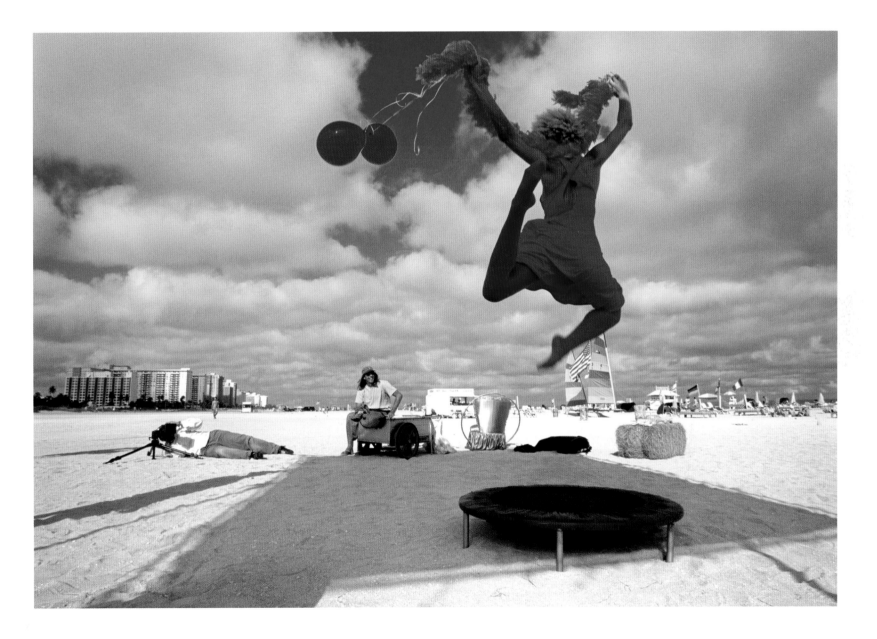

MIAMI, FLORIDA
Models wait at a fashion shoot

WESTERN SOUTH DAKOTA
Trucks at twilight along Interstate 90
(following pages)

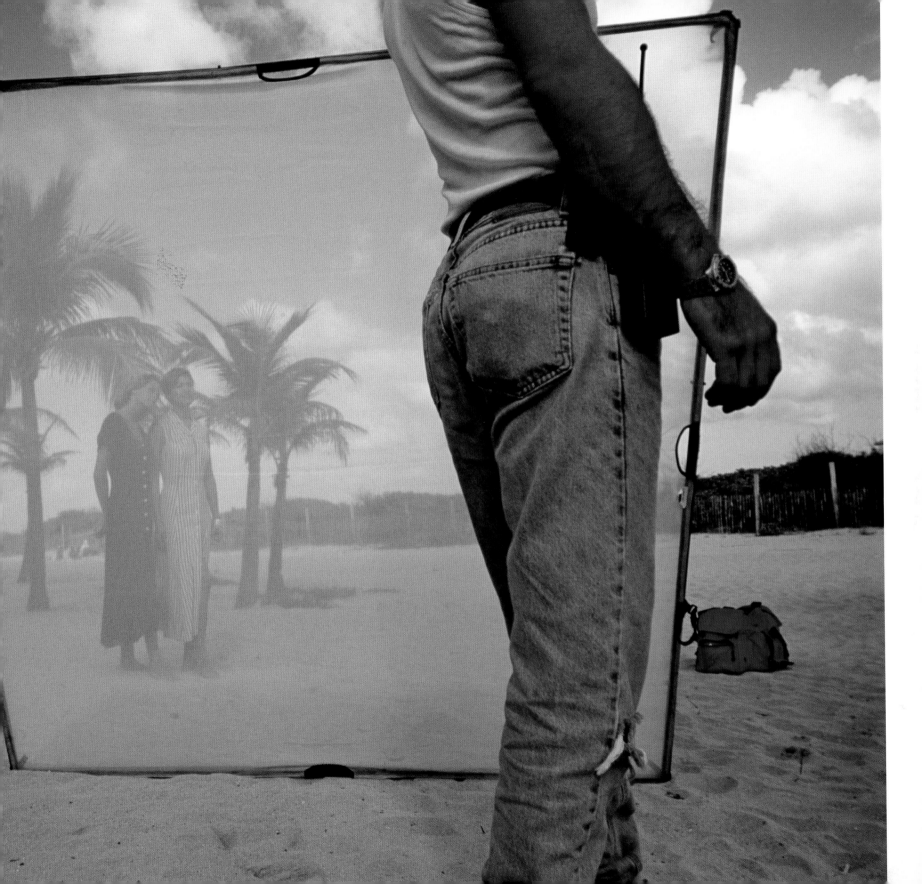

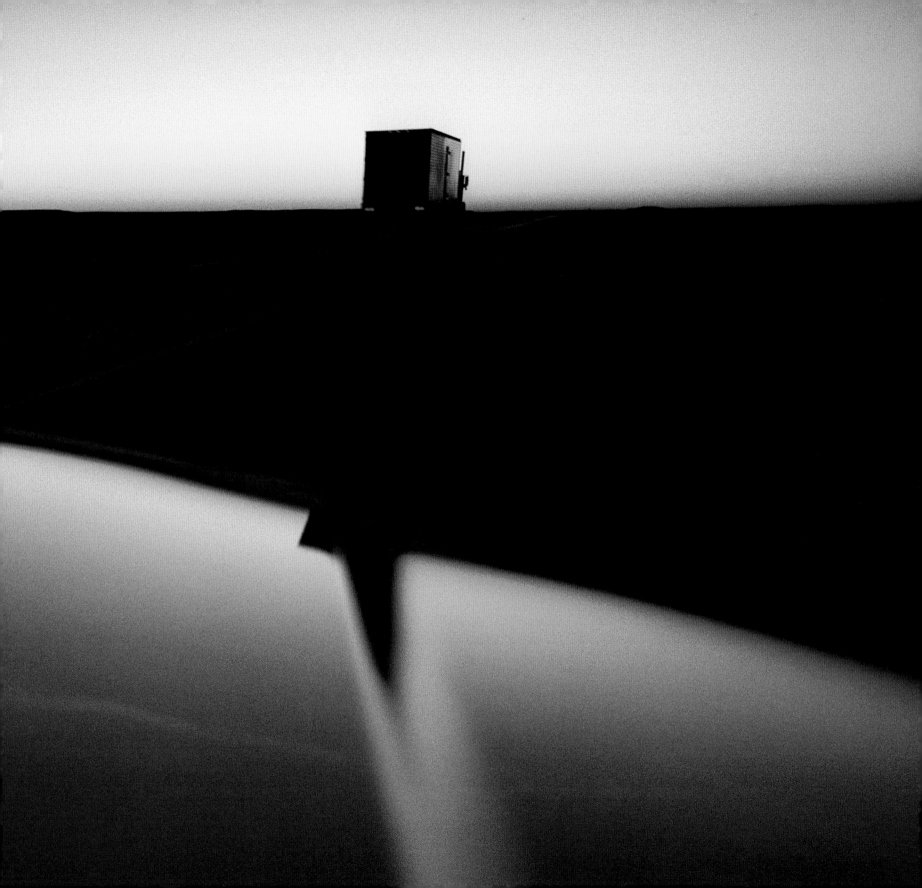

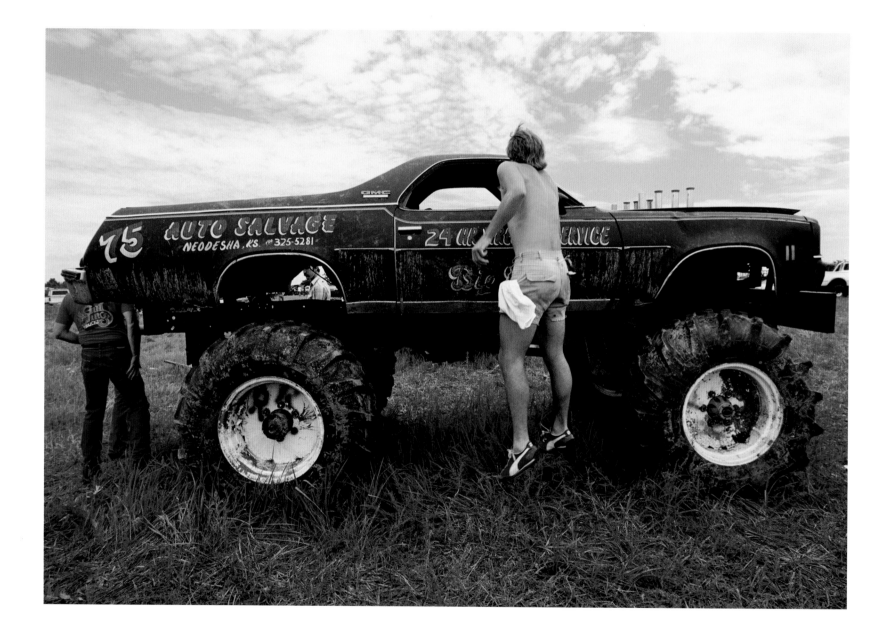

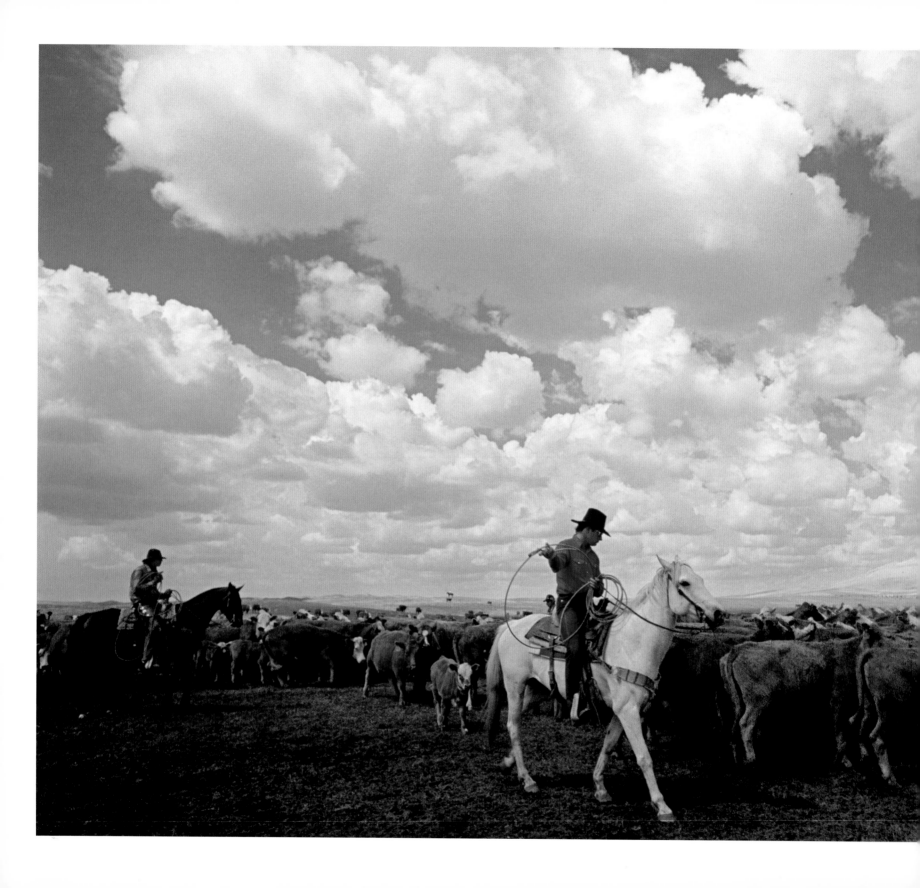

FAMILY BRANDING

There is nothing in American culture more romanticized than the life of a cowboy. And although the pressures of modern ranching have reined in the free-spirited life we idolized in movies and ballads, there are still days when genuine, born-to-the-saddle cowboys are pretty darn romantic.

On American ranches, traditions born of necessity have now become a precious remnant. Nowhere is that more apparent than at an annual family branding. Because branding takes a village of volunteers, it has become a raucous social event in the life of any ranch. Well before sunrise, neighbors arrive from surrounding ranches in pick-up trucks loaded with hot food, cold drinks, and sleepy volunteers. The day begins with coffee and biscuits and ends with steak and beer. In between, a hell of a lot of good hard work gets done. And boy is it fun. Shortly after daybreak, the cattle arrive in a whirlwind of dust, wailing and bawling, driven by a dozen or so cowboys on horseback. Like shadows, the horsemen vanish and reappear in the dust as they separate the calves from their mothers. Lariats sail through the air and helpers on the ground wrestle each victim to the dirt for branding, castrating, and vaccinating. Steer testicles are tossed into buckets, which the younger kids carry to the kitchen to be deep-fried. It is both macho and mandatory for any visitor to sample one of these "prairie oysters." Yes, I did!

In 1986 I was invited to a branding at the Vinton family ranch in western Nebraska. Their ranch was so remote that I arrived a day early and spent the night in a guest bedroom. At dawn, I was awakened by a sudden light. I looked out and saw that the sunrise had ignited cornrows of luminous clouds over the horse pasture. I grabbed my camera and tore downstairs and out the door. A dozen horses wandered the pasture, baptized in unforgettable light. I shot as fast as I could, thrilled at the scene in front of me.

As the light faded and the horses moved off, I threw back my head and hooted. It was then that I realized I was not alone. Behind me stood a line of cowboys, leaning against a fence and staring at me with amusement. Consummate professional that I was, I had run out of the house in nothing more than my t-shirt and undies. I wished them good morning and marched what remained of my dignity back inside to put on a pair of jeans.

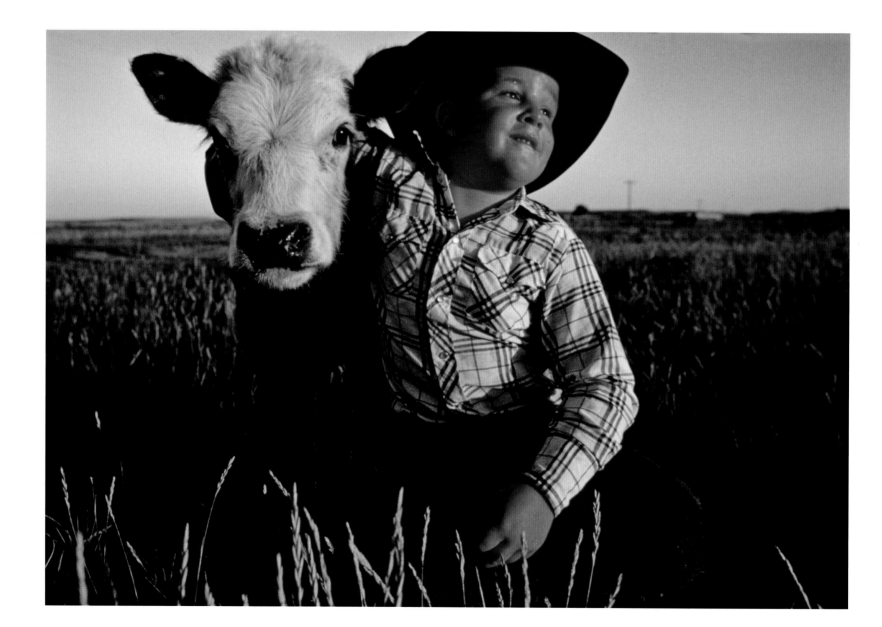

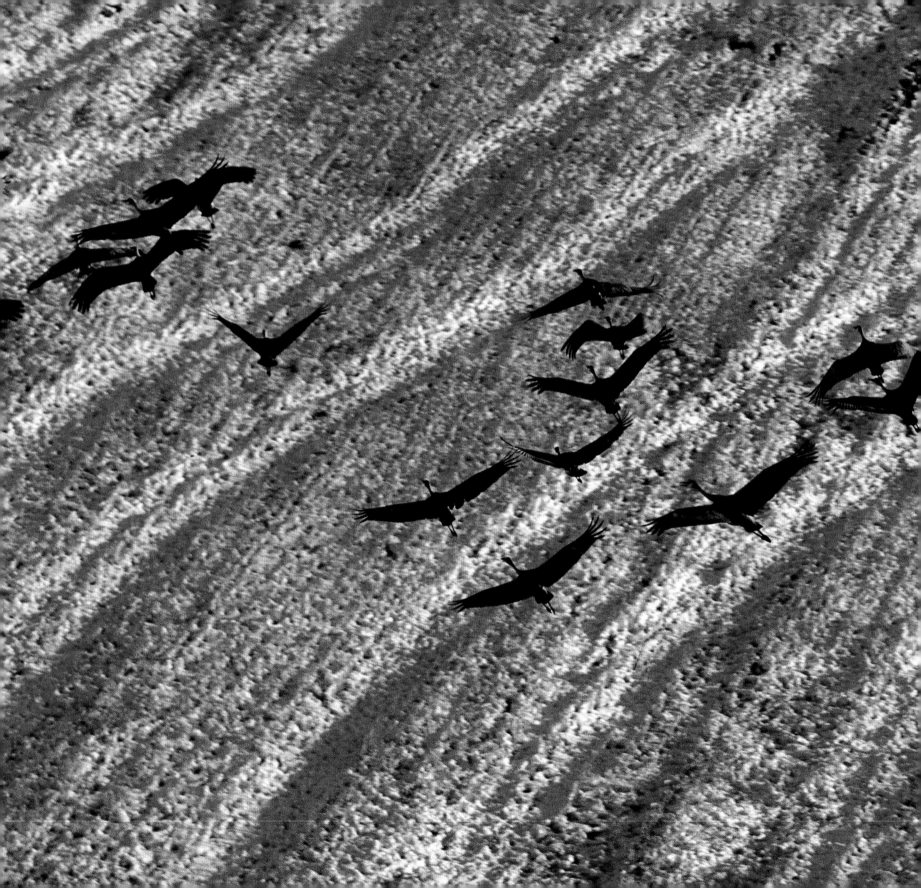

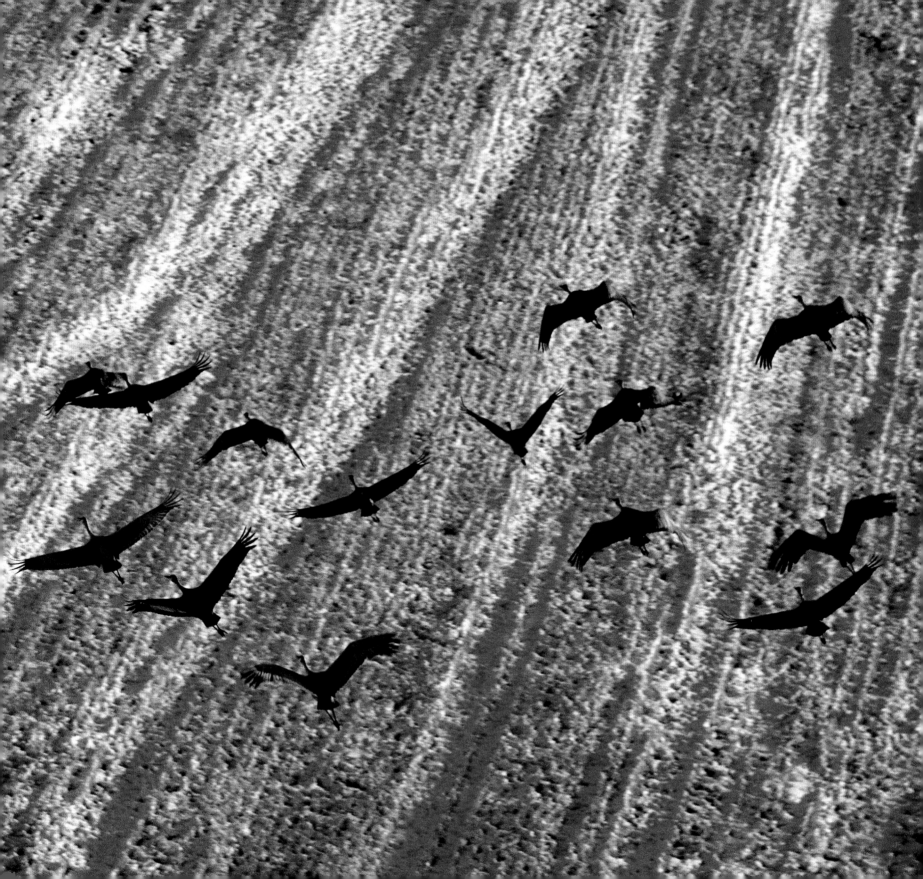

YELLOWSTONE

In 1997 my fearless seven-year-old daughter, Lily, joined me on an eight-day horse pack trip into the remote backcountry of Yellowstone National Park. Our goal was to navigate the wilderness to the source of the Yellowstone River near the Teton range. The rest of the crew included National Geographic picture editor Kathy Moran; our wrangler, Hank; his young daughter, Toria; and a cowboy cook named Lyle. Lily adored Lyle because he supplied her with limitless quantities of bacon and chocolate. I'll never forget the sight of my 40-pound daughter atop the kindest horse that ever lived, urging him on over rivers and up mountainsides. He was a gassy old boy, and since I usually rode close behind Lily, I got the full concert. His name was Dusty, but we christened him "Toot" in honor of his musical talent.

Our journey, already a physical challenge, was complicated by a freak September blizzard. We'd brought only flimsy nylon tents and now we were snowed in. The temperature hovered around 20°F all day and dropped well below zero every night. Yet Lily and I were in heaven. The snowfall was lovely to photograph, and my daughter considered snow an enormous treat. Fortunately I had a great sleeping bag, so at night, when the temperature dropped, I was joined in my tight quarters by my cameras, two pairs of hiking boots, and a seven-year-old. Lily slept like a hibernating bear cub, but I woke every hour or so to make sure she hadn't been squeezed out of the mummy bag like a dollop of toothpaste.

Midway through our adventure we were witness to one of nature's miracles, a total lunar eclipse. We were 50 miles from the nearest light bulb and the night was impossibly black, windless, and very cold. We huddled together in a clearing—two cowboys, two journalists, and two little girls—and watched breathlessly as the Earth passed between solar and lunar and, for a full minute, erased the moon.

As the moon slowly reappeared, we hurried back to our campsite and built a warming fire. Hank pulled out a pipe and asked if we'd ever heard real cowboy poetry. In a sandpaper voice he proceeded to recite epic poems from memory for over an hour. The verses spoke of loneliness and loss, of characters and cowards, of battles with mountain lions and grizzlies, of horses loved and lost. Lily crawled inside my down coat and fell asleep. I could have listened forever.

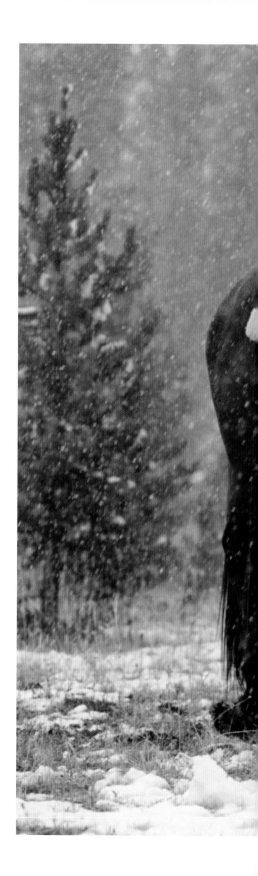

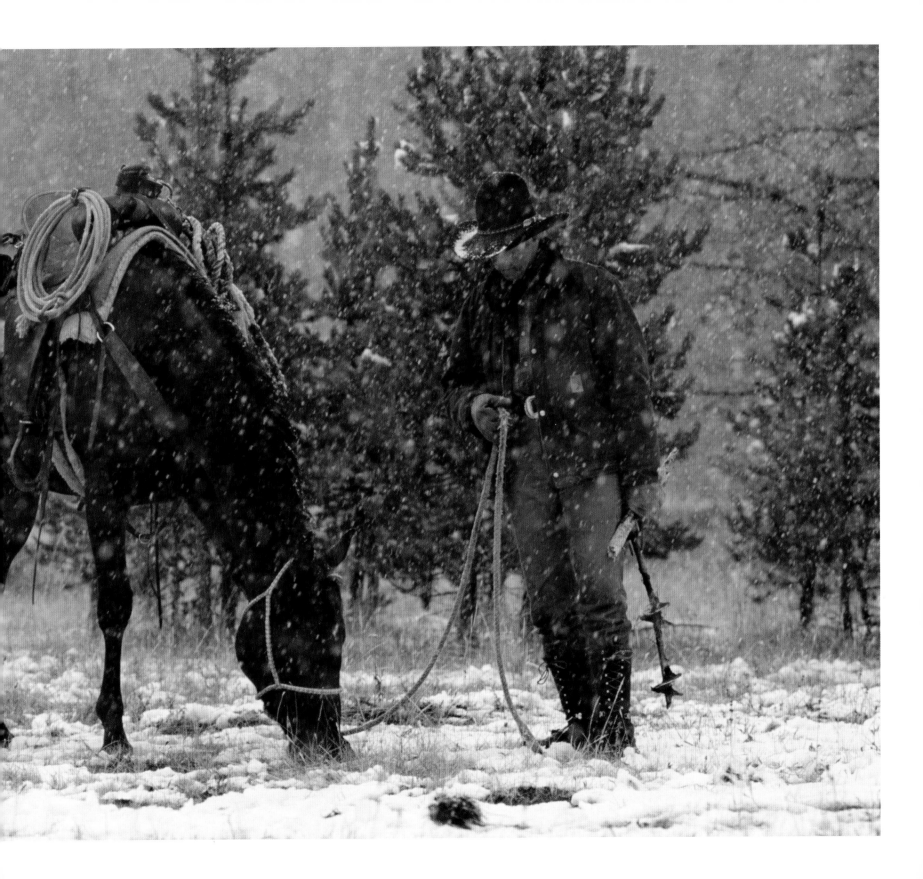

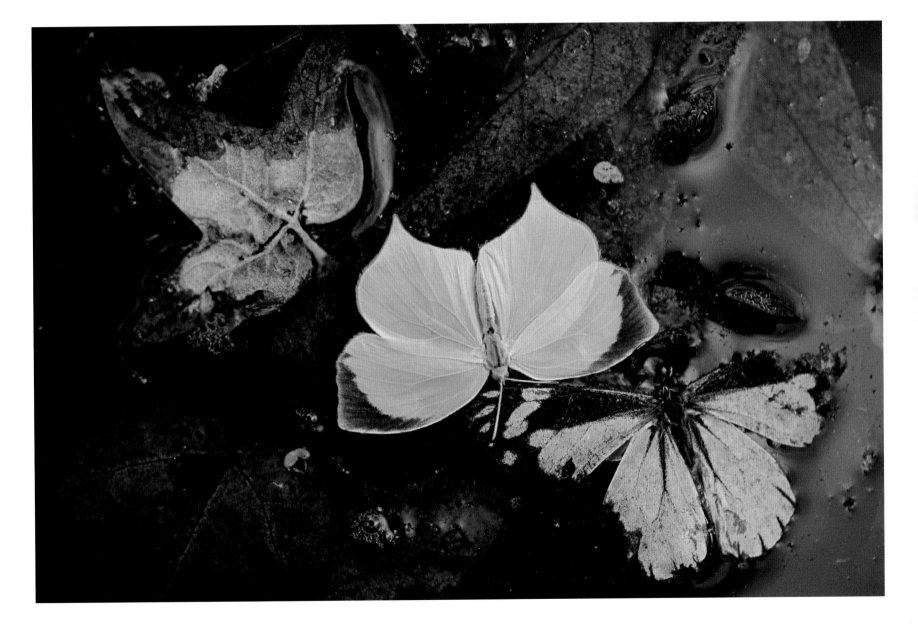

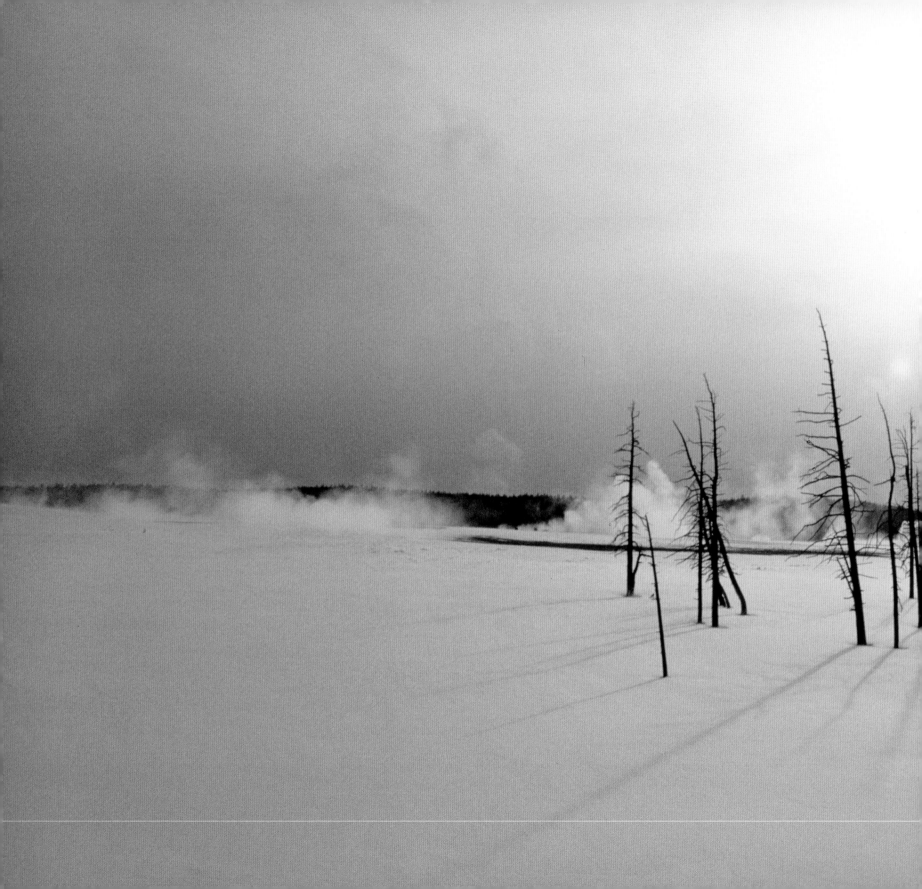

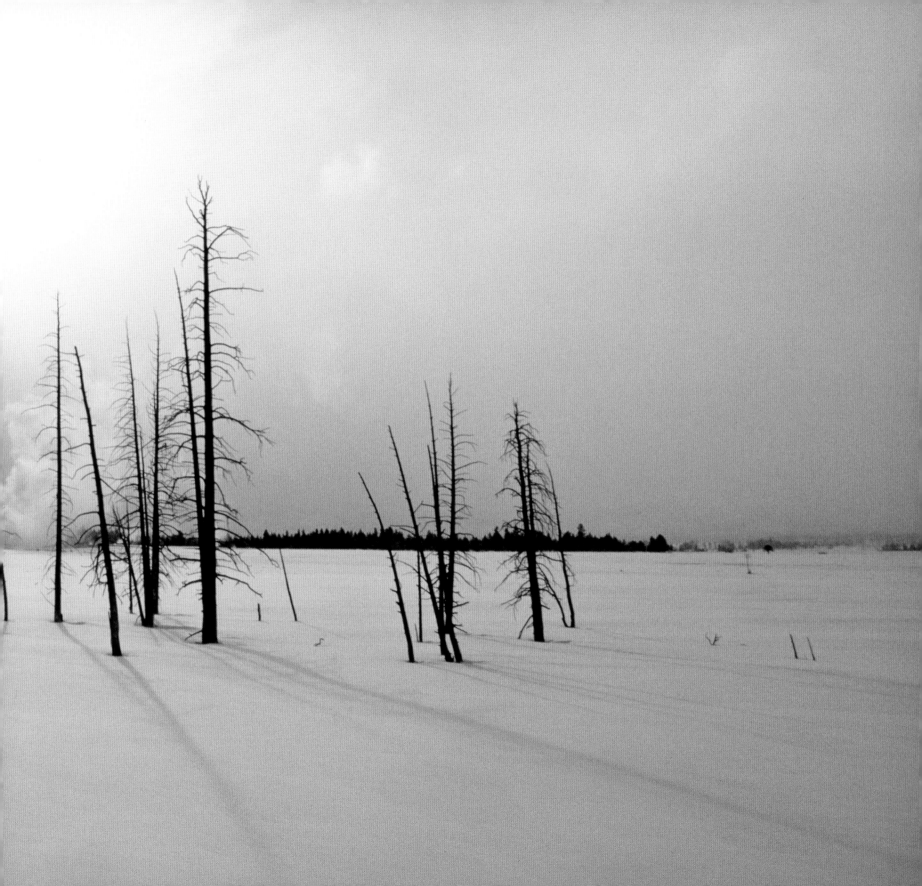

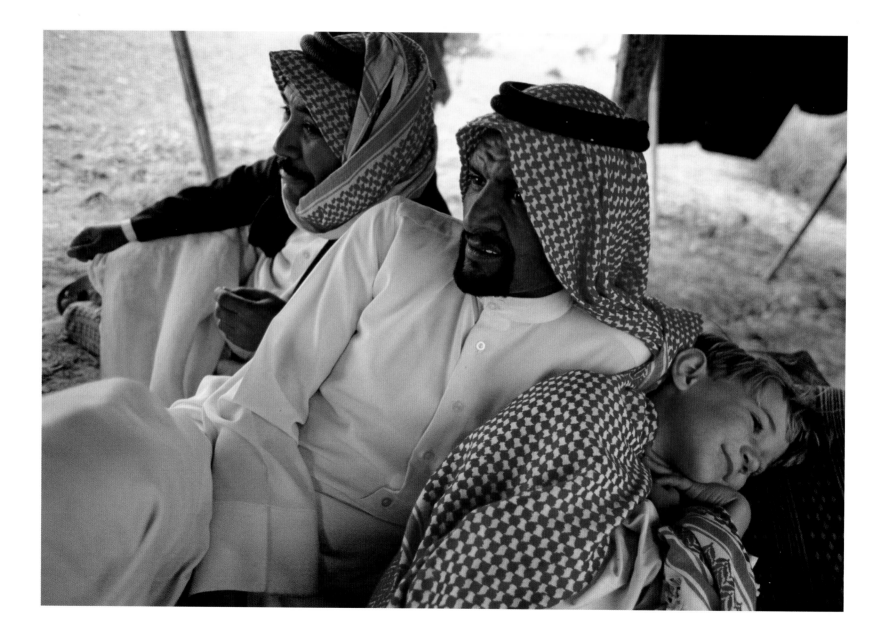

Crossing Jordan

For a period of five years, in the late 1990s, the Geographic assigned me to a number of projects in the Middle East, which took me to Jordan, Israel, Syria, and Egypt. It was one of the most compelling chapters of my photographic life. Working in the Middle East also left an indelible mark on our family.

We set up house in places we'd only dreamed about: an apartment in Jerusalem, a beach house in Aqaba, an historic way station in Petra, a kibbutz in Galilee. We immersed ourselves in ancient and complicated cultures—Bedouin, Hasidic, Palestinian, Druze—and we made dear friends in every community we joined.

I recall one day when I spent the morning photographing a Palestinian family in the Old City of Jerusalem as they made preparations for their Ramadan evening meal. I left them in late afternoon and spent the rest of the night reveling with a Lubavitch family celebrating the joyful Jewish holiday of Purim. It occurred to me that cultural segregation was so ingrained here that, although these two families lived less than a mile from one another, they had never—and probably *would* never—think of visiting one another's home. And yet, as a photographer, I was afforded the privilege to pass from culture to culture, from lunch to dinner, with anyone.

But there were epiphanies. When our children were baptized in Nazareth by our dear friend Riah Abu al Assal, an Anglican bishop, we held a small luncheon. We invited our friends, who came from the diverse communities of Galilee: Palestinian and kibbutznik, Christian and Muslim and Jewish. They all came. There were a few awkward moments, but then the kids began to climb in laps and take friends by the hand and even dance. Soon everyone relaxed and shared a meal, and we celebrated Lily and Charlie's special day.

There is a saying in Israel: "'No' is not an answer—it's just the beginning of an argument." I heard this on the first day of my first assignment in the Middle East, and it made me laugh because I sometimes felt that I'd spent most of my life trying to find a way around the word "no." Gaining trust and access is a crucial part of my job. I usually take a "no" as a creative challenge and try to listen on a deeper level to *why* my request is being denied. Is it fear or tradition or an expression of power—or powerlessness? I then try to come up with a solution that will comfort or compromise or address the concern. I try to find the way to "yes."

I never needed these creative powers more than when I worked in Israel. In Israel the answer is *always* no. No because it is Saturday, No because you are a woman, No because it's Friday, No because it's dangerous, No because it's Sunday!

The answer was an emphatic "no" when I sought permission to photograph a Jewish holiday in northern Israel called Lag b'Omer. Once a year, Hasidic Jews flock to Mount Meron to visit the tomb of the revered Rabbi Simeon bar Yochai, who survived a Jewish revolt against the Romans in A.D. 135. His son, also a rabbi, started the tradition of lighting bonfires at night to mark the anniversary of his father's death, which falls during Passover. Lag b'Omer is a time of huge crowds, spectacular bonfires, and great happiness. But women are not allowed anywhere near the action.

Helping me in Galilee was a delightful Israeli archaeologist and religious scholar named Yossi Buchman. Yossi tried everything he could think of to get permission for me to attend Lag b'Omer. But after days of pleading to the authorities we realized that there could be no compromise. Women were simply not allowed. Yossi, a brilliant and thoughtful man who'd moved mountains for me in Galilee, was deeply discouraged. But an idea came to me that I knew I had to try. "So, Yossi," I said. "What if I went to Lag b'Omer looking not so much like a woman?"

Yossi thought for a moment, and then smiled. "I love this idea," he replied. I dashed off to a local barber to get my hair cut short, like a man's. I borrowed clothes from my husband and pulled a baseball cap down low on my head. And for the first time in my adult life, I was glad that I had the body of a 12-year-old boy. It worked. I escaped detection, and for two days I wandered freely, photographing this extraordinary celebration.

At night the bonfires raged, fueled by holy oils that the men poured in as offerings. At one point I found myself balancing on a wall above the largest bonfire. I have no fear of heights, but I looked over and saw a young man beside me, frozen with fear. I wanted to help him, but I knew that Jewish law would make it offensive for him to take the hand of a woman. So I slipped my hand inside the sleeve of my shirt and reached out to guide him. Relief flooded his face, and for the first time in my life I received the grateful look that one man gives another.

❧

The next morning was a sacred day in the lives of local three-year-old boys. Strict Jewish tradition dictates that an infant boy must not have his hair cut for the first three years of his life, and then only by a rabbi. By mid-morning, dozens of rabbis had gathered in the yard outside the tomb. Next, the fathers arrived with their three-year-old sons. In a tender ceremony, the men carried their sons from rabbi to rabbi. Each rabbi blessed the child, cut a lock of his hair, and gave him a piece of candy. By the end of the morning, every child had been shorn of all his hair, except for the dangling side curls he would keep for the rest of his life.

Normally, I wouldn't go to so much trouble to gain access to an event. But this was such a lovely holiday, and so rarely seen, that I made the effort and luckily it worked. There were two mistakes that would have given me away at Lag b'Omer. The first was speaking. The second was entering a bathroom. So for two days I had to hold my tongue and my water. My husband said he wasn't sure which was the bigger challenge.

In five years of covering stories in the Middle East, my greatest pleasure was spending time in the company of Arab women, who are some of the most misunderstood and misrepresented people on Earth. Because westerners hear terrible stories about abused women in the Middle East, we forget that women are abused in every society, including our own. Somehow we assume that abuse is more sinister in Arab societies, where women are dressed in robes and veils and genders are kept separate. It is widely assumed that Arab women are unhappy. The truth is that in this and many cultures, most women simply become closer to one another than to any men in their lives. The concept of sisterhood is essential in understanding Arab women.

I learned about this at a Palestinian home in northern Israel. Sheik Mohammad was the elderly patriarch of an extensive family, but he still had the mischievous soul of a young man. As he sat with Don discussing recent history in the region, I wandered off with the women of the house, who were busy cooking in the kitchen.

Although I had taken pains to dress modestly, I was still an aberration in their world—far from home, traveling freely—until I showed them pictures of my children. They responded with grins of approval. My children were proof that I was one of them—a mother. They immediately began calling me "Umm Charlie," mother of Charlie, until I teased them and insisted they call me "Umm Lily," mother of Lily. They made me promise to bring the children on my next visit, which I later did. These marvelous women taught me to blend herbs and roll them into little dumplings called *kibla*. We sat on the floor like sisters, molding handfuls of dough and paste into balls, ready to fry. In their headscarves and conservative dress, these women may have looked oppressed to people who didn't know better, but they were animated and smart, affectionate and irreverent, funny and kind. Their kitchen was alive with the lovely complex smells of cardamom and zatar. And although we had few words in common, we laughed and teased, made fun of men, petted one another's children, and drank endless cups of tea. I don't know what the guys were doing, but the gals were having a blast.

A few days later, I arrived very early to celebrate the end of Ramadan with my new friends. The men were off at the mosque, but the women of the family wandered in by twos and threes and greeted one another with tender kisses and embraces. After everyone had arrived, I found myself herded into a Volkswagon beetle with nine other women. I sat on someone's lap, listening to whispers and giggles all around me. We drove for about ten minutes, until we arrived at a small cemetery on a hilltop in Galilee. The chattering stopped and the women became somber. I had no idea where we were, but I sensed that something sacred was about to happen. Without a word, my friends tumbled out of the car. Each went to a different grave and began to pray. It was raining softly, and I could hardly breathe watching the intimate scene before me. The women moved from grave to grave, their silent tears mixing with the rain, as they remembered family members buried there. And they allowed me to be with them.

They allowed me to be with them. That is the constant miracle of my work.

MOUNT MERON, ISRAEL
Hasidic man praying beside bonfires
during L'ag b'Omer

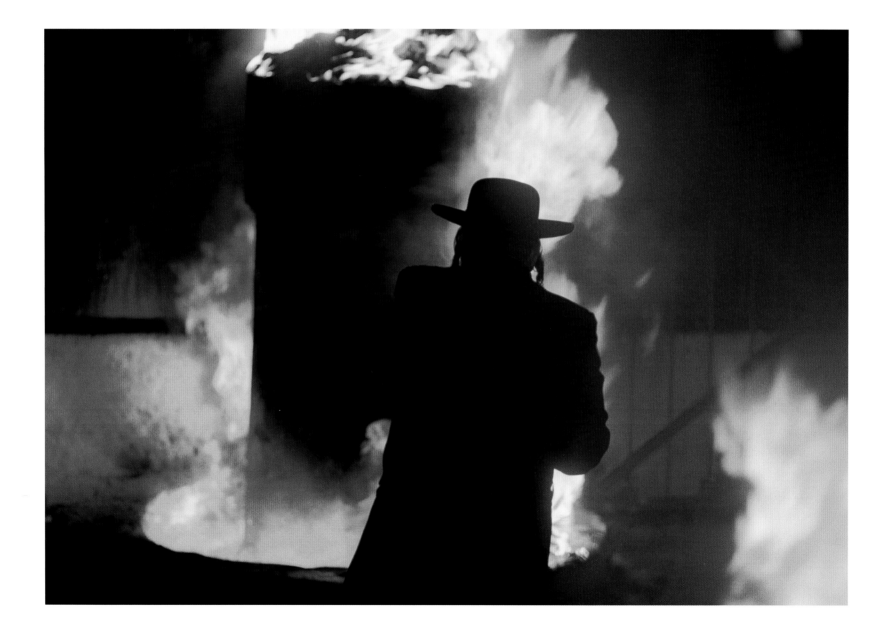

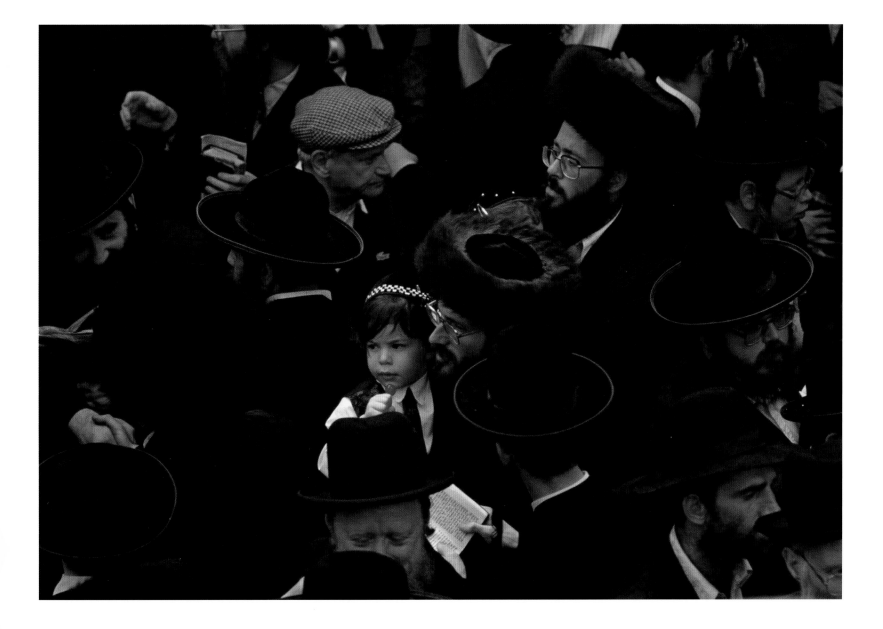

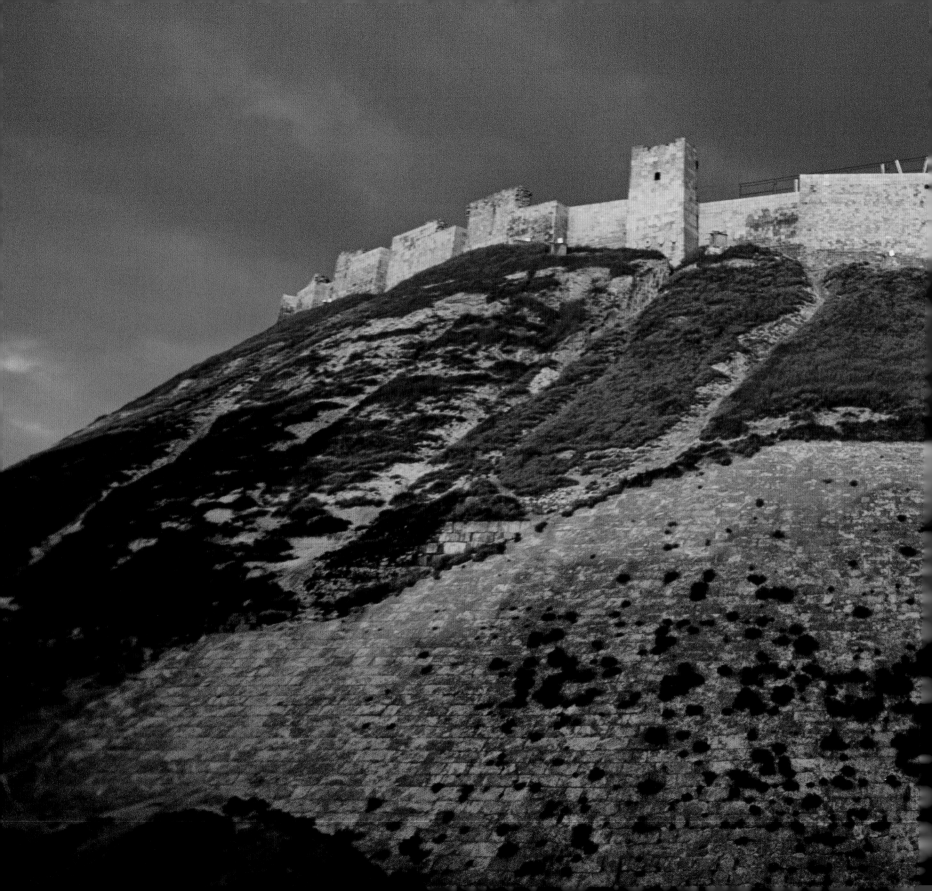

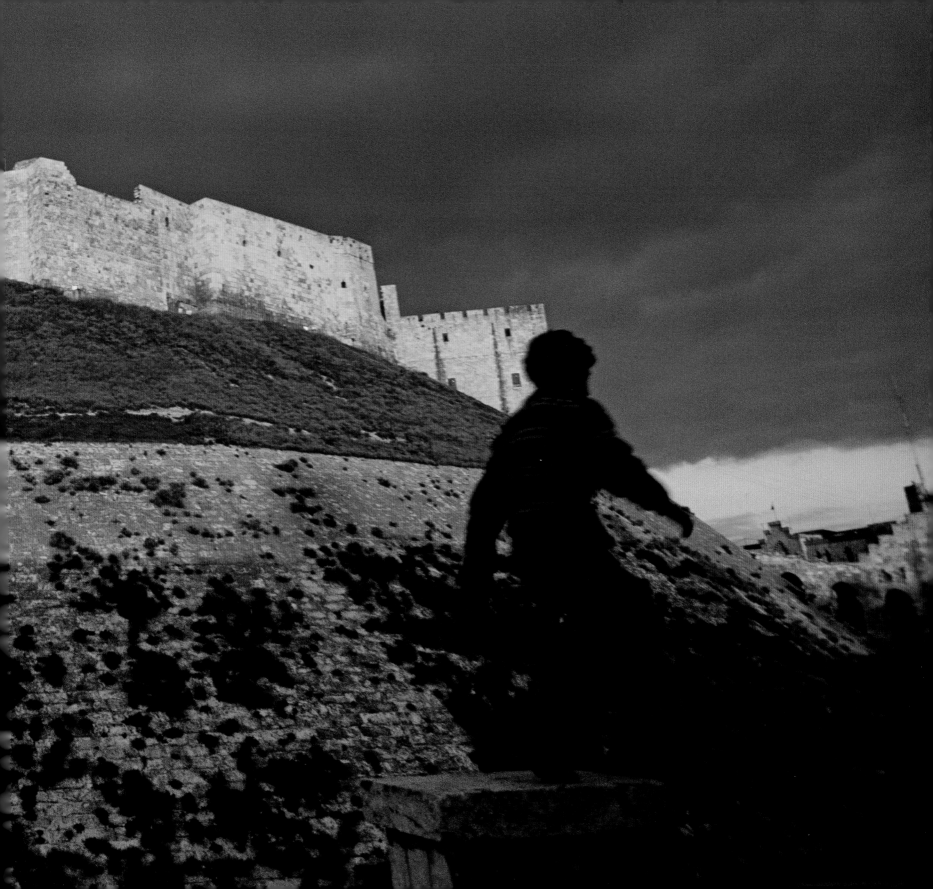

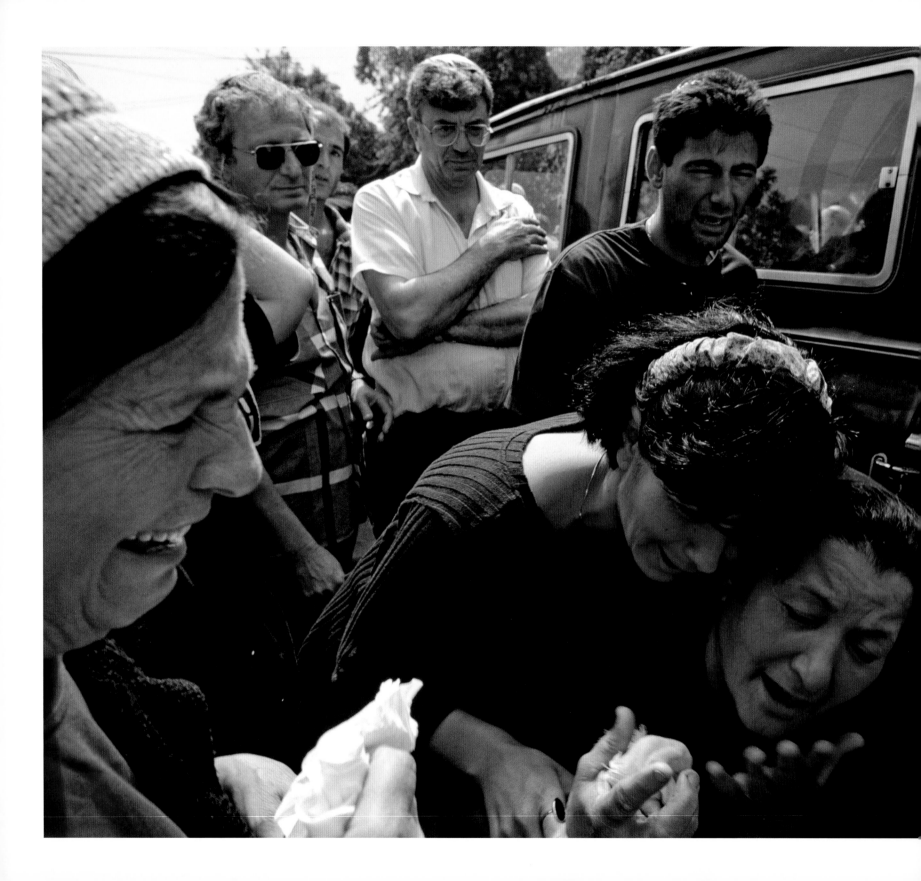

SUICIDE BOMBING

My first assignment in the Middle East was to be a hopeful story about Galilee, the northern region of Israel where Jews and Arabs have been living fairly peaceably for generations. We arranged to stay on a kibbutz along the Sea of Galilee, where the kids could romp with other families and we could pursue our story in peace. But peace is hard to come by in Israel.

Shortly after we arrived, a Hamas suicide bomber blew up a bus in the nearby farming town of Afula, killing eight people and wounding dozens. Don and I sped toward Afula to cover the aftermath, knowing that our story had just changed, along with our own sense of security. The fact that our children were just miles away was unsettling. We suddenly understood the way all Galileans felt, living with the knowledge that random violence could shatter their lives at any time.

In Israel most wounds are remarkably fresh and easily reopened. Spend time with anyone there and you are likely to hear a heartbreaking story about surviving the Holocaust or being stripped of land that had been in a family for generations—about an Israeli daughter serving with the army on the Lebanese front or a Palestinian son being denied a decent education. In Afula that day we found Israeli friends devastated by the bombing and Palestinian friends hiding in their homes, fearing retaliation.

The next morning I went to the home of Asher Attia, the bus driver killed in the blast. His house was surrounded by mourners waiting to accompany his body to the cemetery, and I waited with them. The silent grief outside was pierced periodically by women's cries from inside the house. I was the only journalist there. My camera was visible, but the situation was very tense, and I took no pictures for several hours. Finally, pallbearers brought out the coffin and the family stumbled out of the house.

I took two pictures that day. The first was of the family weeping beside the hearse. The second was of a fist coming into my face. One son, startled by my camera, went after me. The astonishing thing was that the rest of the family immediately came to my aid and apologized, explaining that he was crazy with grief. They wanted me to take photographs so the world would know what had happened. Still, I felt like a dog. The last thing I wanted was to add to the family's grief. And yet I had.

JERUSALEM, ISRAEL
Hasidic neighborhood of Mea Shearim

JERUSALEM, ISRAEL
Jewish cemetery at the Mount of Olives
(following pages)

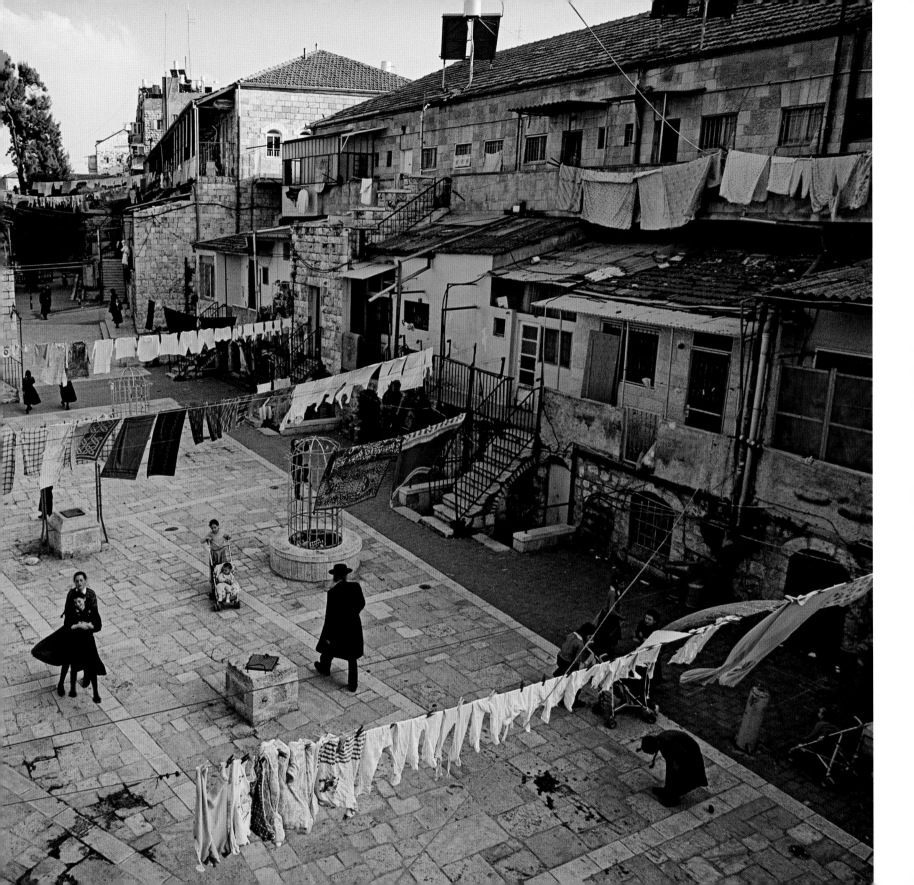

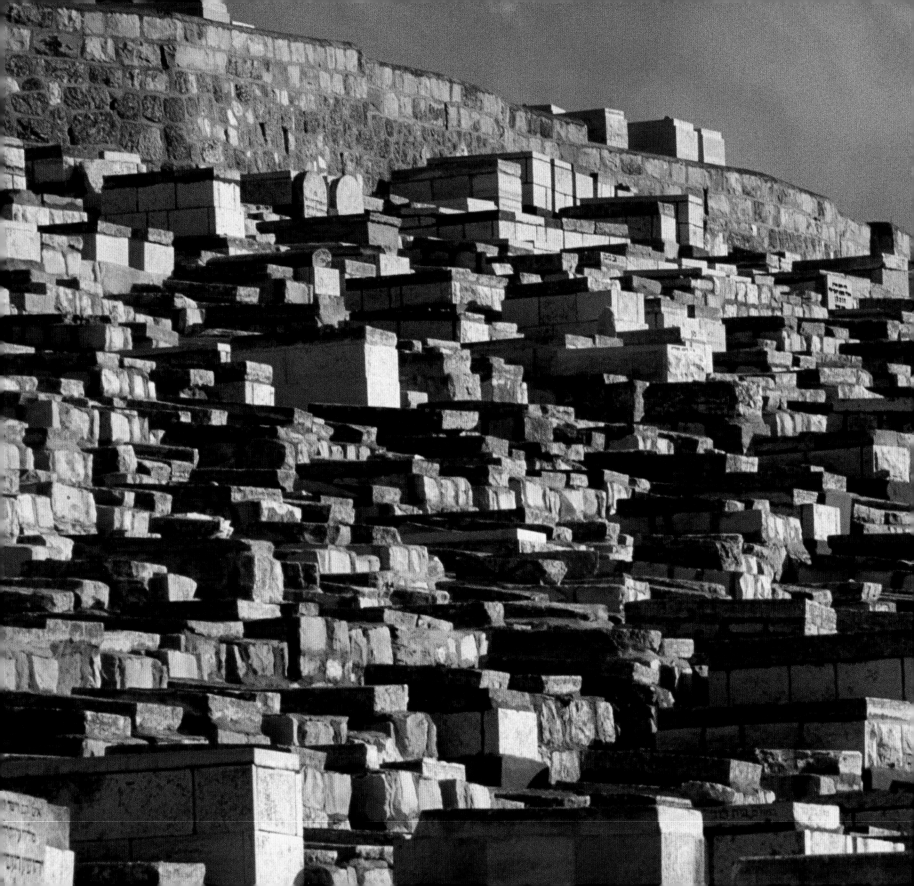

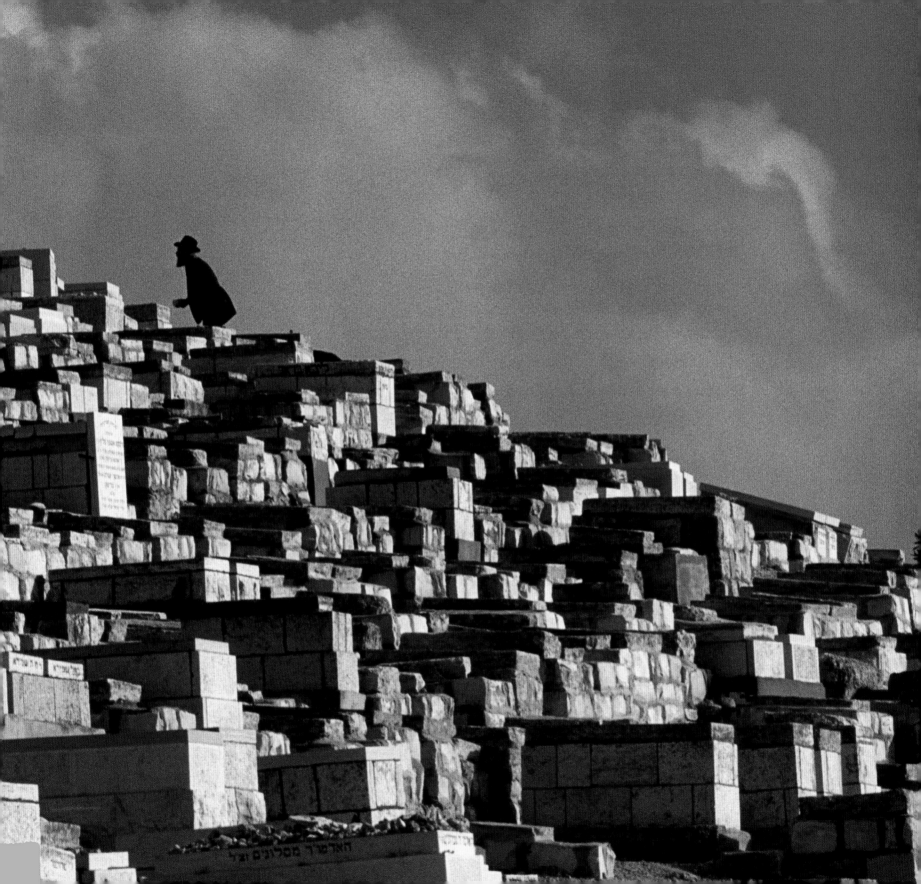

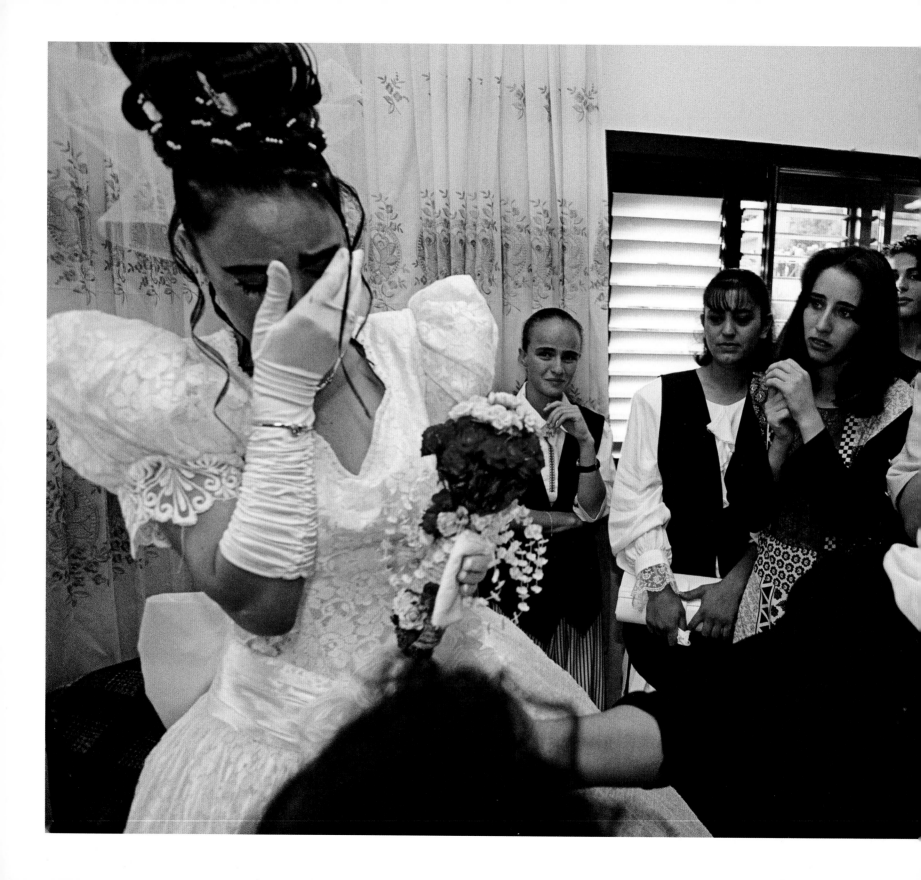

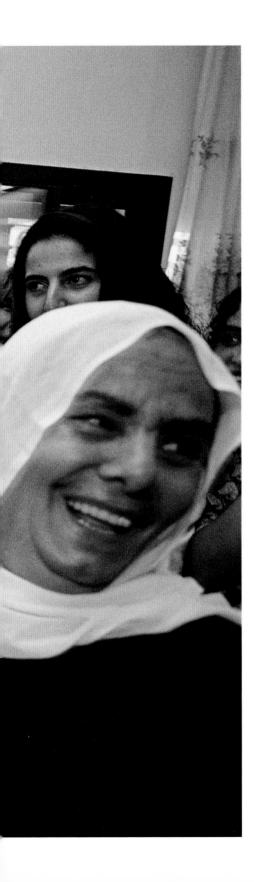

GALILEE, ISRAEL
Druze bride weeping as she
leaves her family home

A DRUZE WEDDING

While working in Galilee, some of my favorite days were spent in Druze villages on the slopes of Mount Carmel. The Druze are an Arab sect whose very private faith has been kept a mystery for many centuries. Neither Muslim nor Christian, the Druze are the ultimate Middle East survivors, living mostly in separate enclaves, avoiding conflict, and maintaining good relations with whomever the ruling power might be. I was particularly touched by the women of this region, who were funny and bright and progressive in many ways. They had recently convinced community elders to allow their daughters to attend college—a real victory in this conservative society. I befriended some of the leaders of this education movement and, to my delight, they invited our family to attend a wedding in their village.

Two days before the wedding, dozens of women gathered in the courtyard of the bride's family home to make traditional Druze bread. Plastic tables and chairs were produced along with enormous bowls of dough. In a joyful free-for-all, the women grabbed handfuls of dough and, in a blur of motion, pulled and punched and spun and threw them in the air until they were impossibly thin. Finally, they stretched the flattened pieces of dough across round cushions and folded them to store for cooking. There is not a pizza kitchen in Italy that could compete with these ladies. Amid this happy chaos, I chatted with two of the bride's aunts about the wedding day. They explained that the women closest to the bride would gather at her home before the ceremony. The groom, meanwhile, would lead his brothers and friends in a parade with bells and drums to the home of his future bride. When she hears the sound of her groom approaching, tradition requires that she burst into tears—both as a sign of modesty and to demonstrate her sadness at leaving her father's home.

On the day of the wedding I placed myself near the bride. Aunts and sisters and girlfriends hovered with sweets and tender preening. It was clear from their girlish chatter that this was a marriage based on love. Even so, at the first sound of the drums approaching, this beautiful bride summoned all her love of family and wept real tears. Grandmother beamed and girlfriends looked on with concern, knowing that this needed to be the performance of a lifetime.

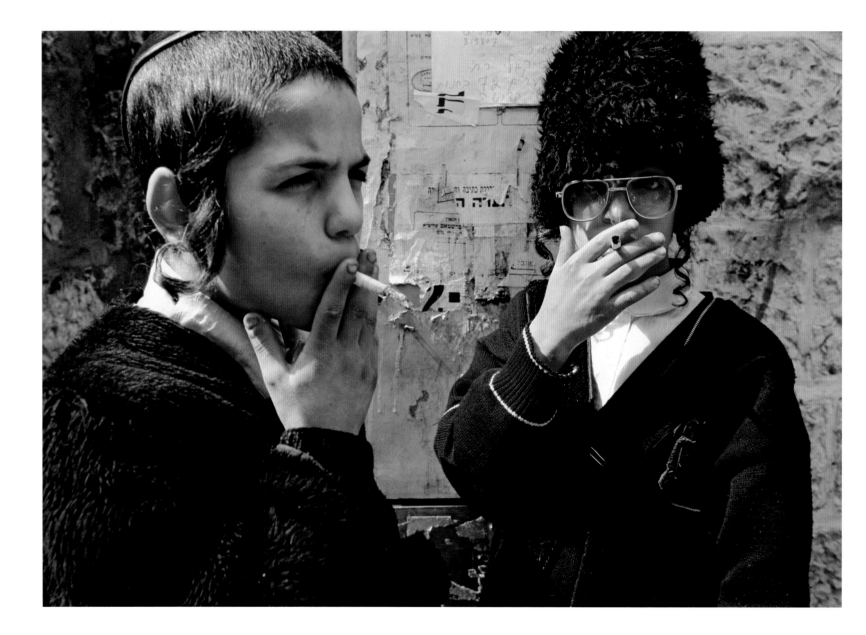

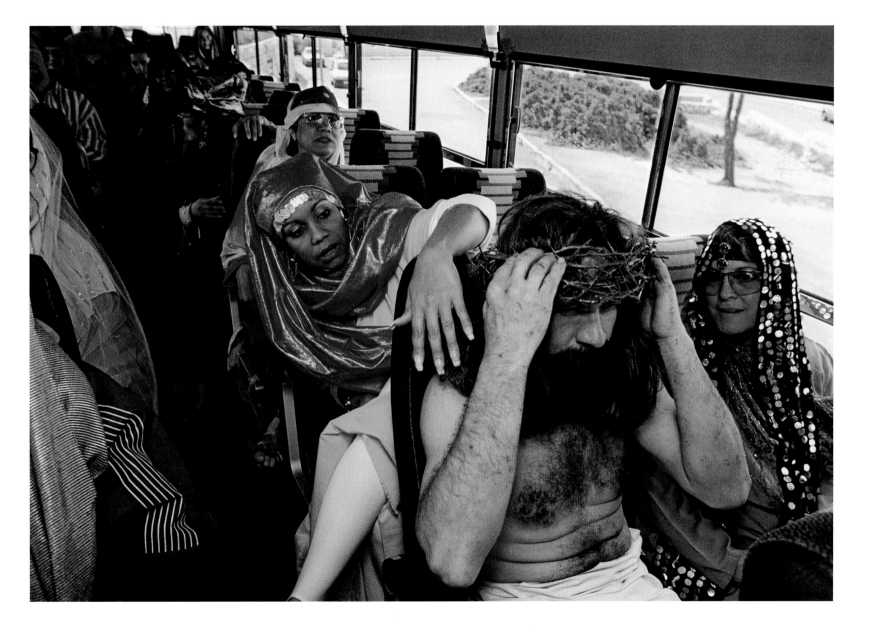

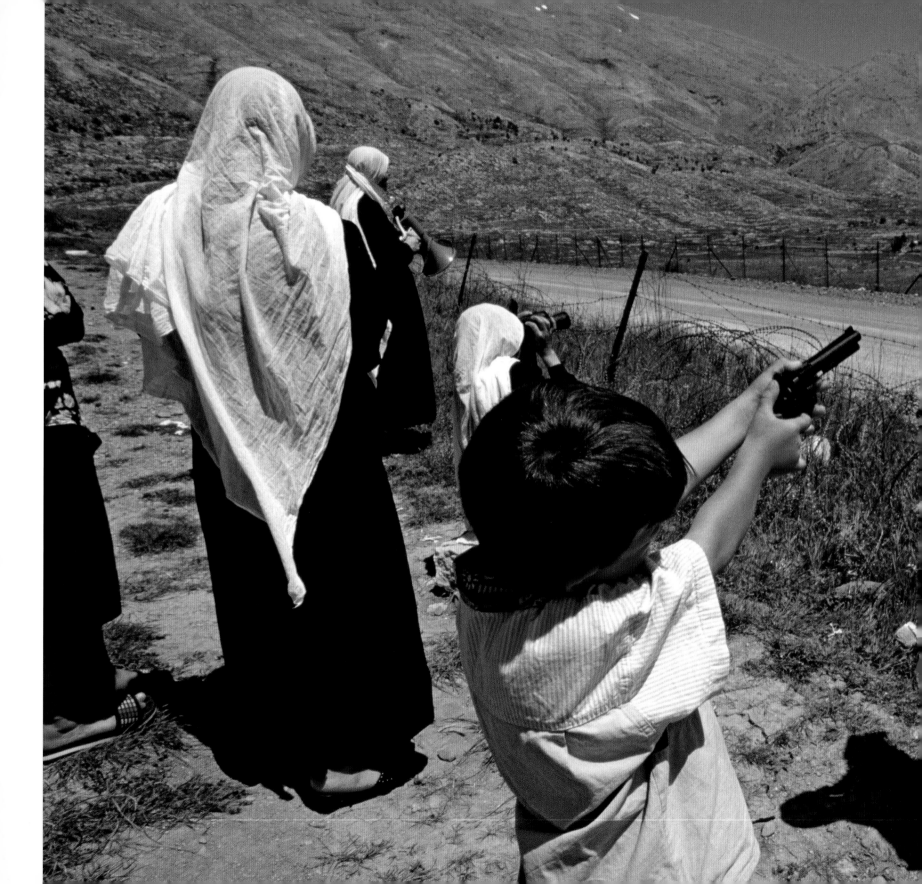

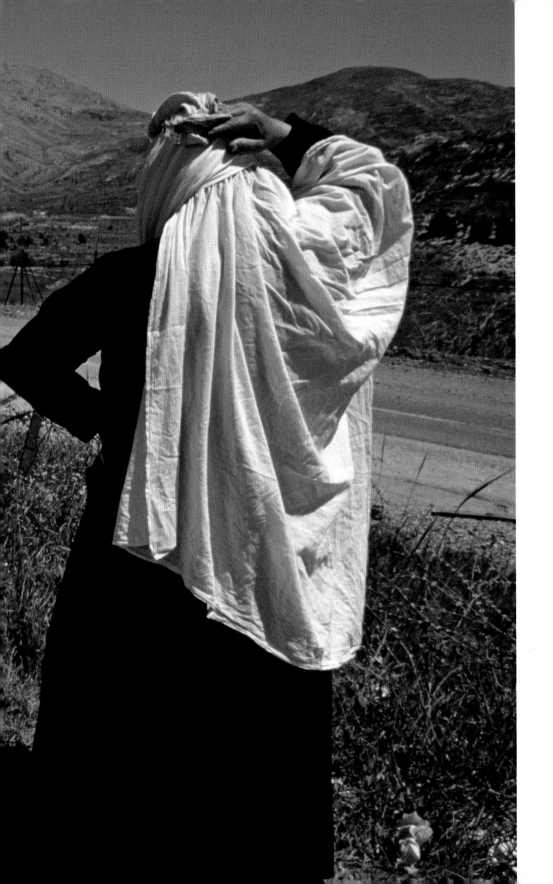

THE GOLAN HEIGHTS, ISRAEL
Druze families calling to one another
across the Syrian border

NAZARETH, ISRAEL
Altar boys on Palm Sunday
JORDAN
Aerial view of the Dead Sea
(following pages)

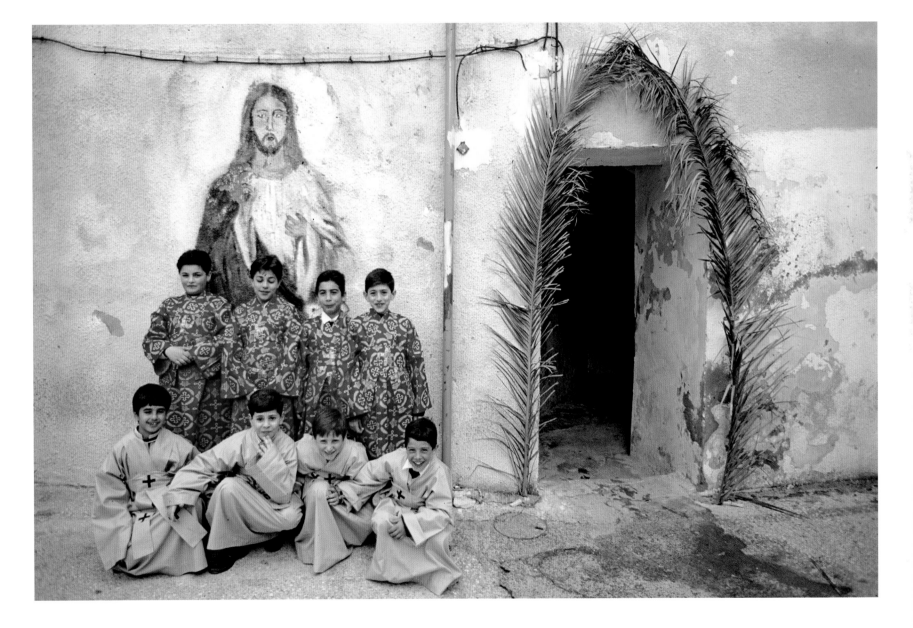

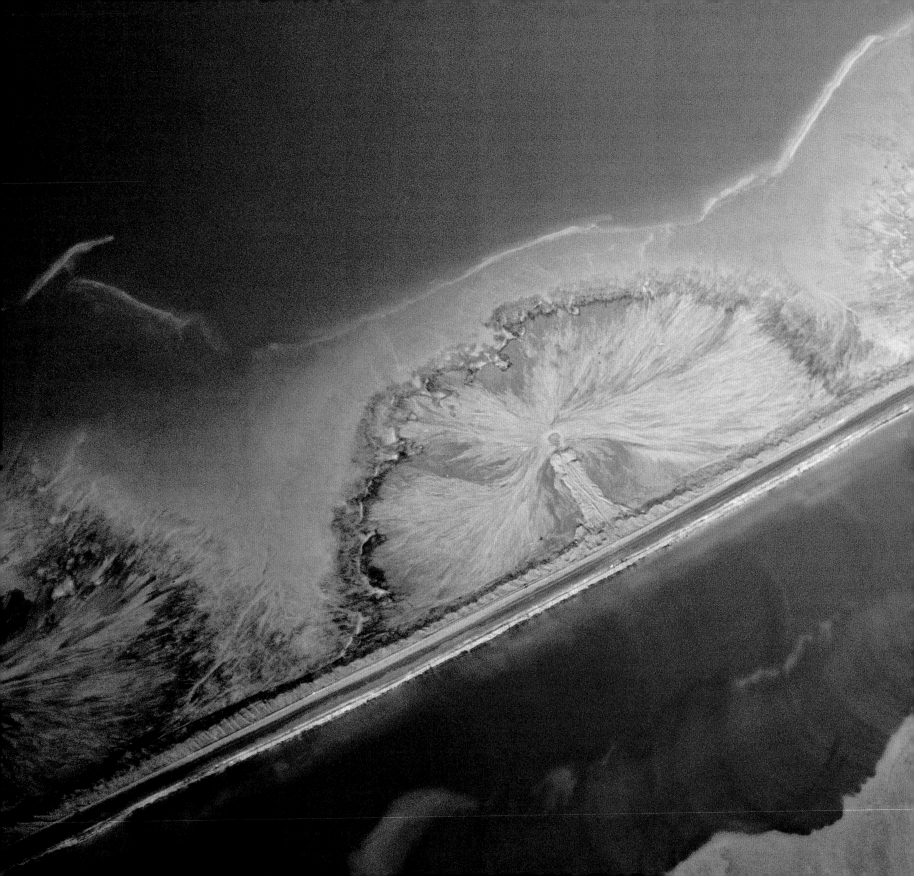

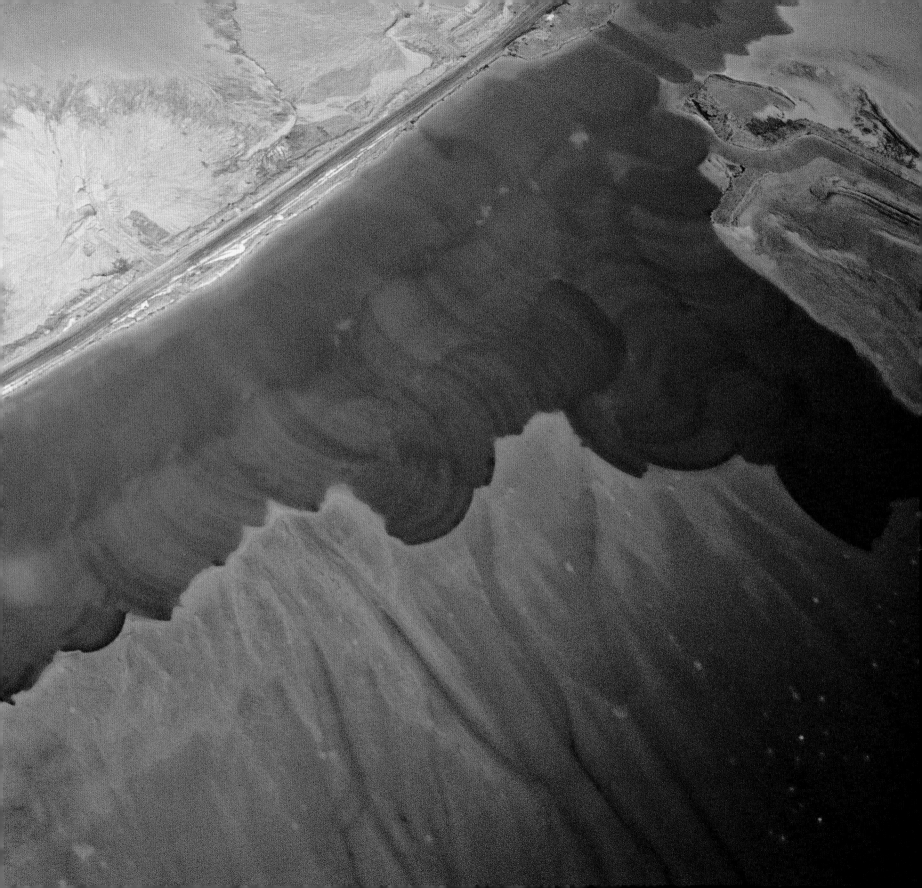

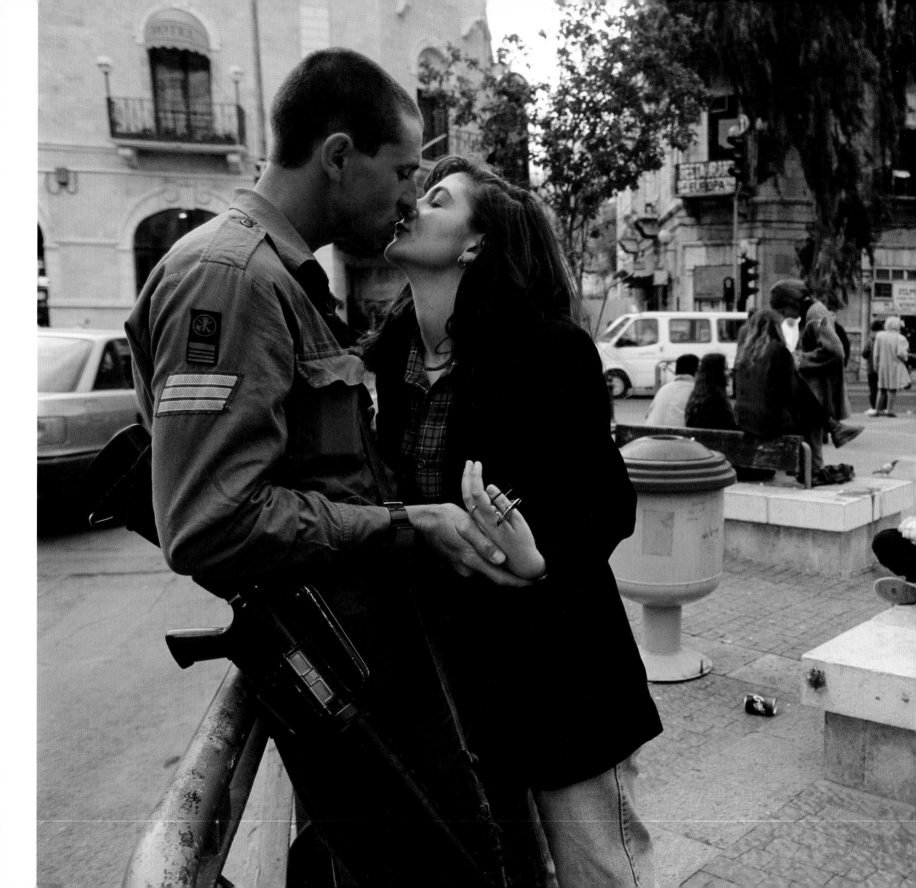

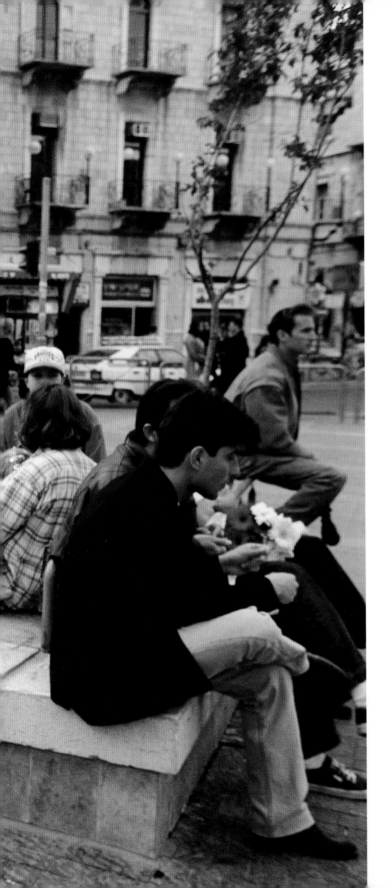

JERUSALEM, ISRAEL
Soldier kissing a friend

JERUSALEM, ISRAEL
Muslim quarter of the Old City
(following pages)

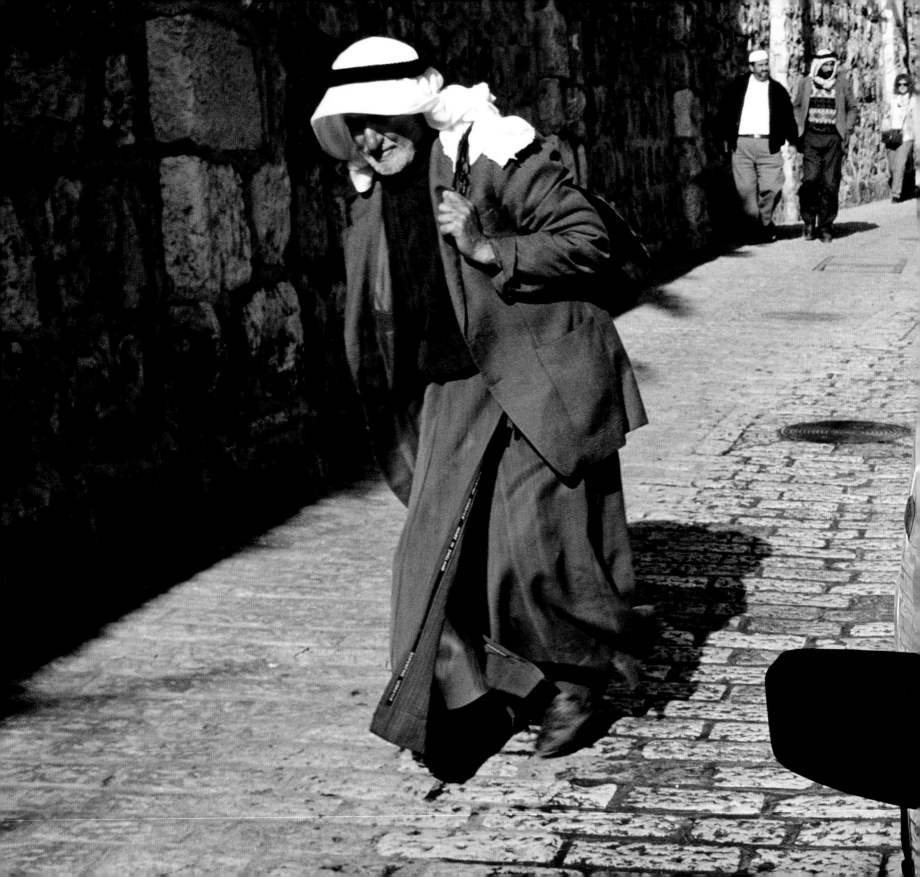

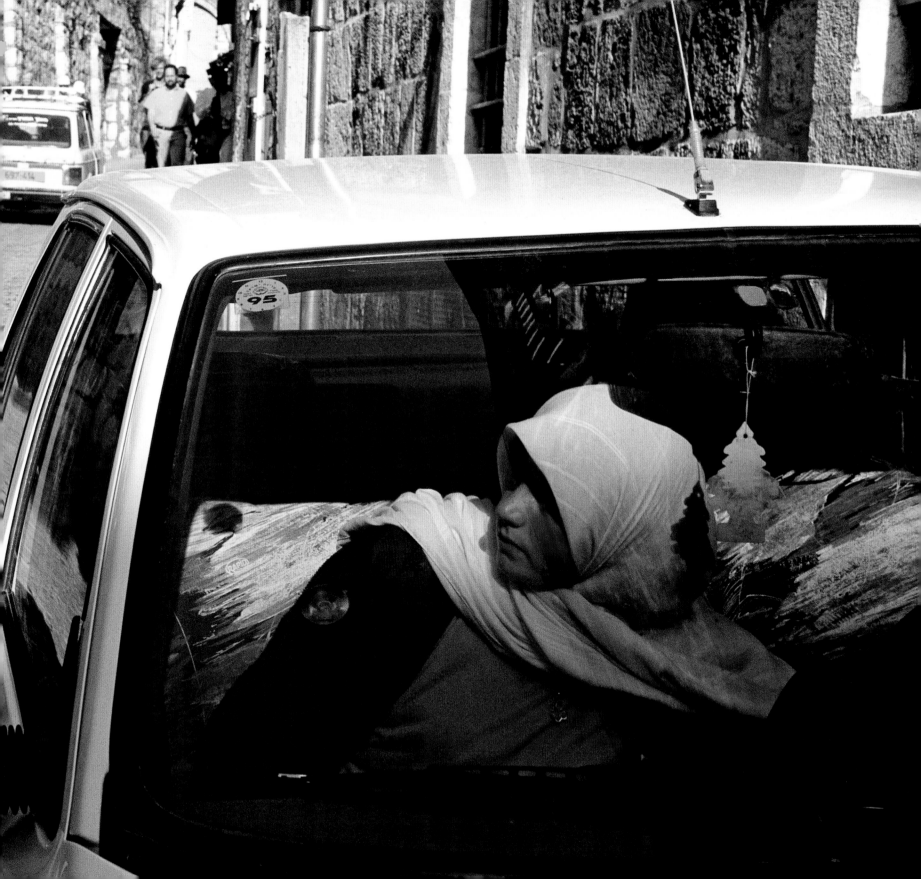

JORDAN
Aerial view of Wadi Rum

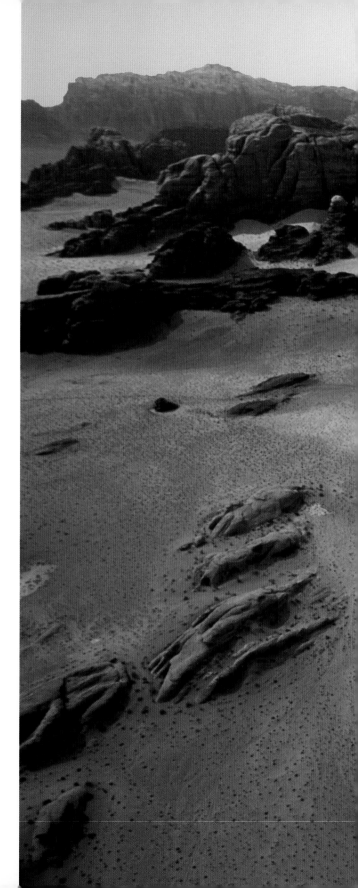

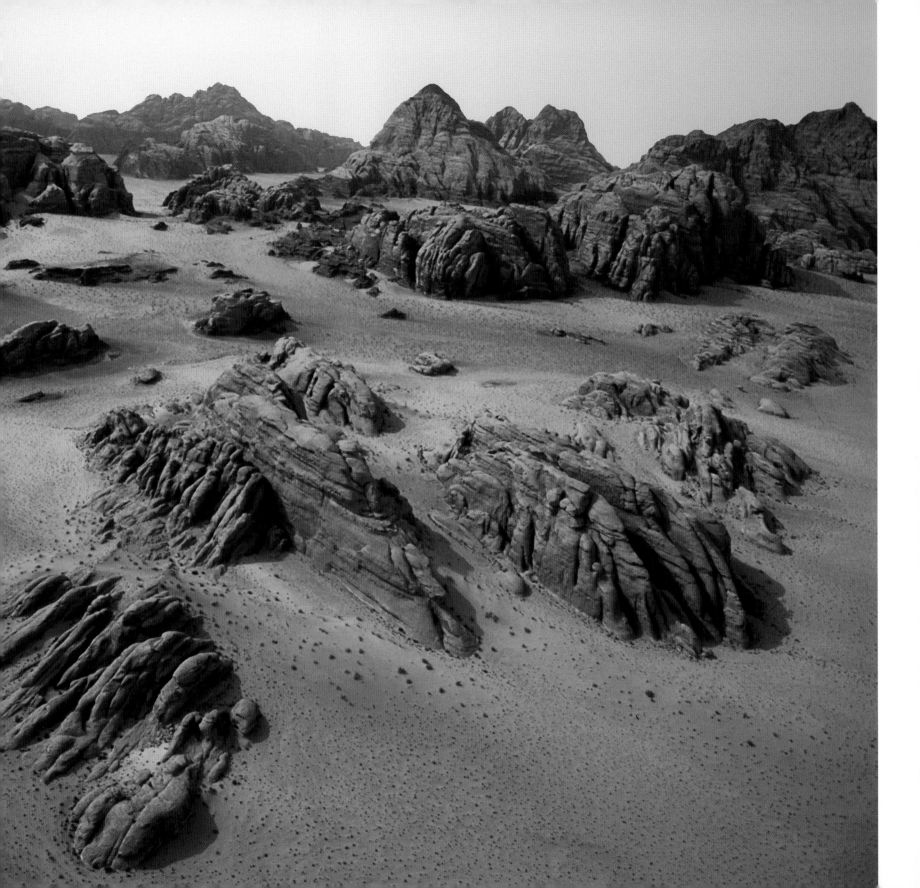

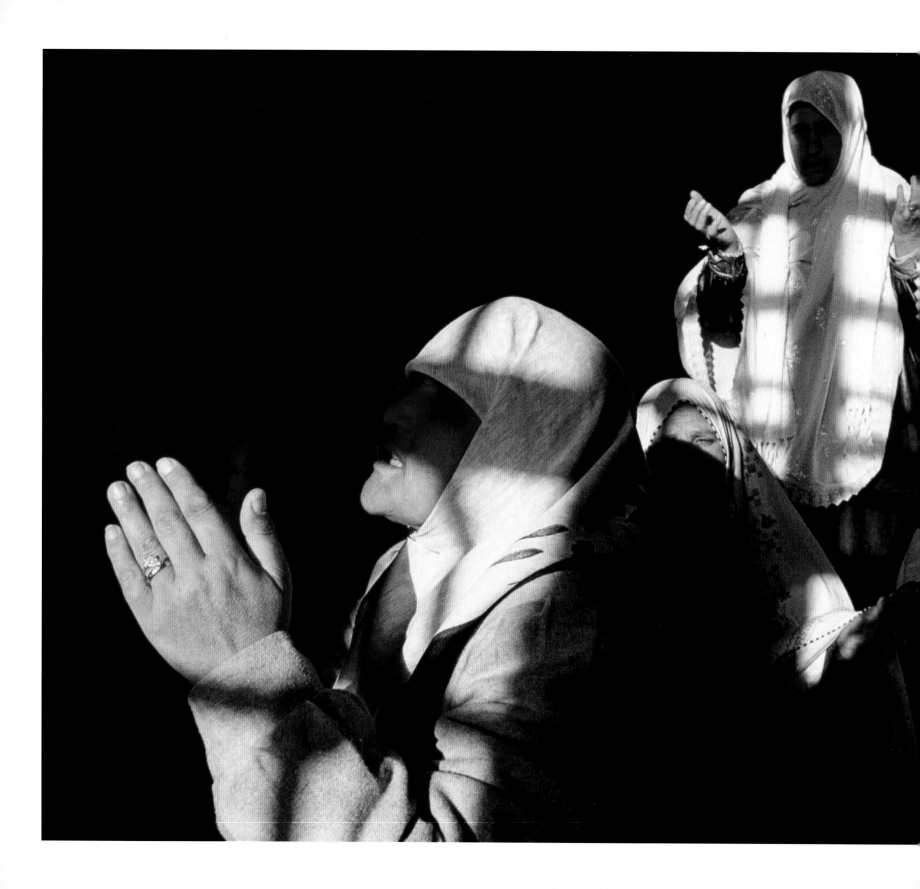

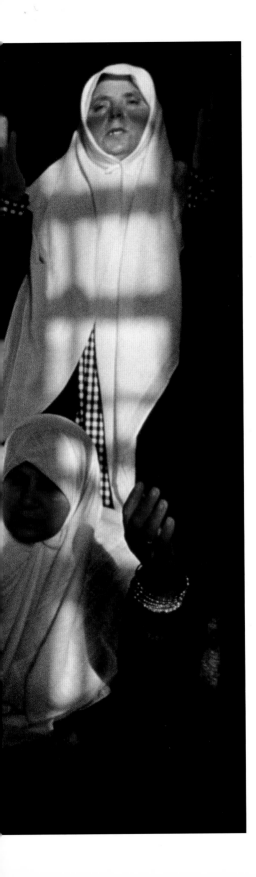

RAMADAN

The final week of Ramadan in Jerusalem is a sacred and breathtaking celebration. Trying to get permission to photograph it is a nightmare. Ramadan is a time of high anxiety for Israeli security as thousands of Muslim worshippers flow into the Old City for prayer at the Dome of the Rock. I spent days meeting with Israeli officials, negotiating for access. Their fear was that 200,000 Muslim worshippers could easily be incited, especially by the presence of a camera. I was finally granted permission to shoot from the air, but only with an Israeli military pilot and only from a height of more than 3,000 feet (very high for an aerial). It turned out to be an extraordinary day. Thousands of worshippers poured into the plaza surrounding the Dome of the Rock. But, unlike the chaotic crowds of Easter and Passover, these worshippers arrived quietly and lay down their prayer rugs in tidy rows. From the air we could see only patterns filling the courtyard. At one point the Israeli pilot said to me, "Are those all Muslims down there?" When I nodded, he said quietly, "You have no idea how much that frightens me."

Gaining permission to photograph the end of Ramadan, marked by dawn prayer inside the Dome of the Rock, was a greater challenge. I made my way to the home of the Palestinian Mufti of Jerusalem. His home was crowded with important men waiting to speak to him, so I wandered into the kitchen where his wife and daughters were preparing dinner. I rolled up my sleeves and joined them, chopping vegetables and chatting, and they asked me to stay for dinner. I asked the Mufti for permission to join the women at the Dome of the Rock the following morning. He smiled, but shook his head. No way.

But the next morning, at around 4 a.m., a veiled stranger came to my apartment. She told me to dress modestly, hide my camera, and come with her. The Mufti had said no, but his wife had said yes. We joined a shadowy stream of worshippers making their way to the Dome in the dark. My friend created a small diversion to distract the guards. The Dome was filled with women, illuminated by the faint glow of the mosque's gold-plated walls. I nestled among them on the floor, disappearing into a comforting sea of bodies and maternal touches. As sunrise bathed the women in light, they began their welcoming prayer. I believe I am the only photographer who has ever witnessed this event.

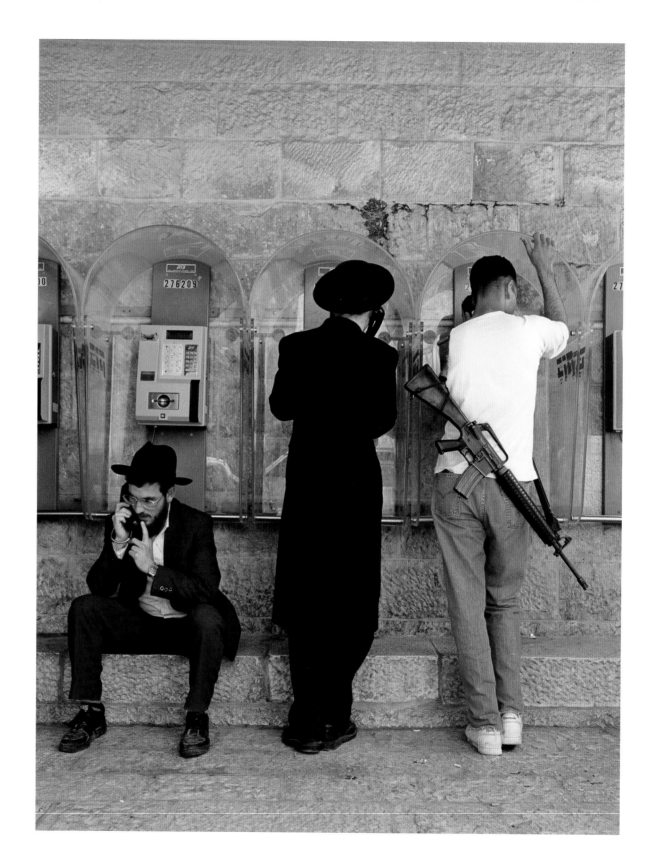

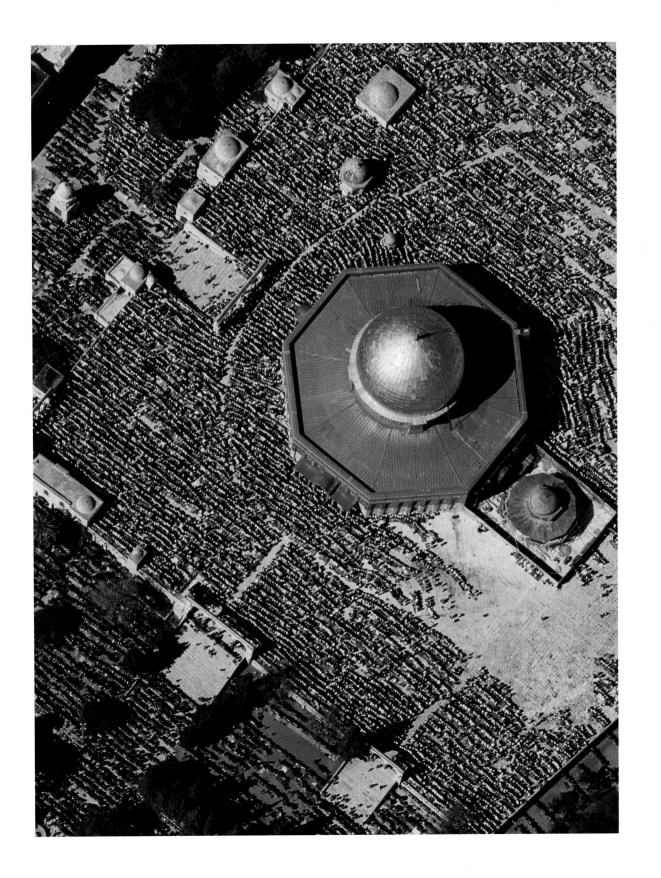

JERUSALEM, ISRAEL
Aerial of Friday prayer during
Ramadan at the Dome of the Rock

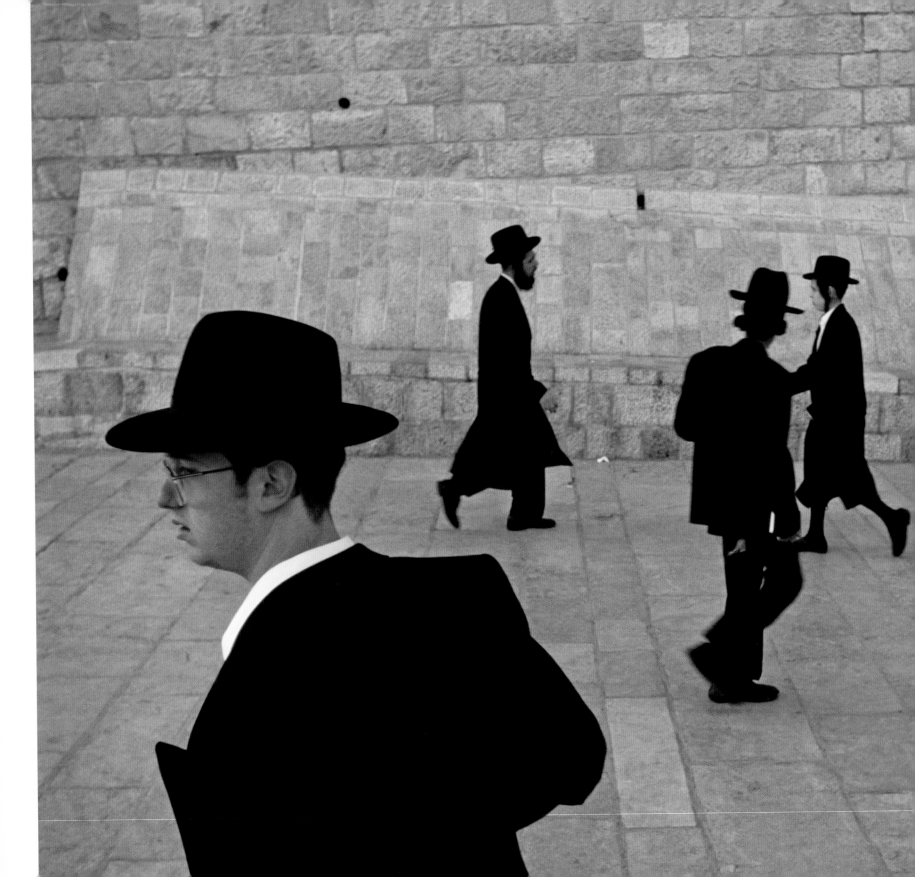

119

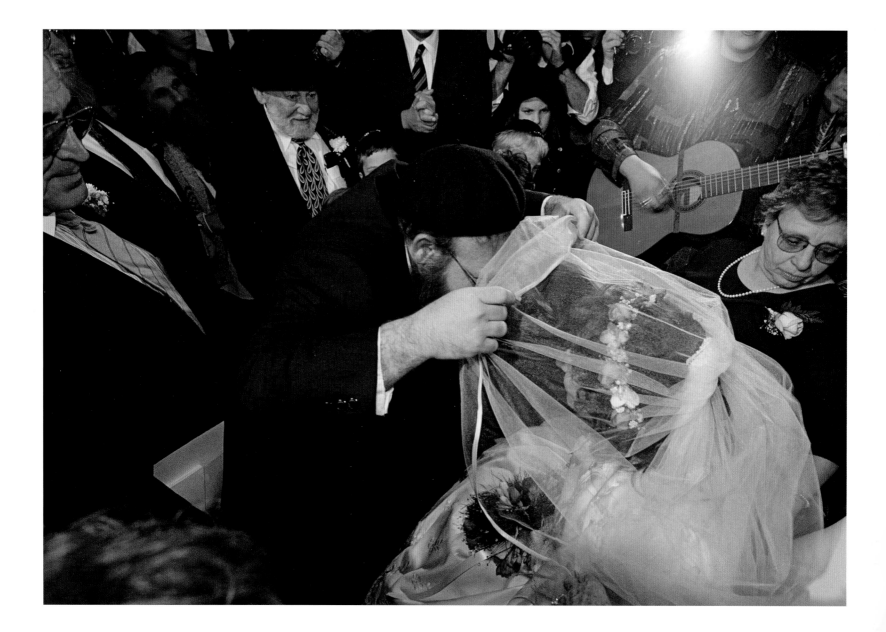

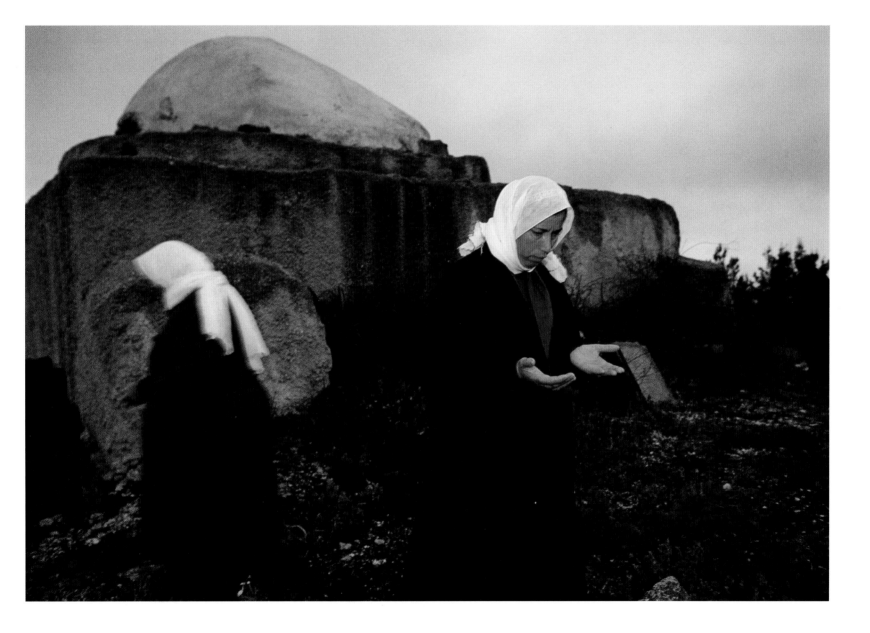

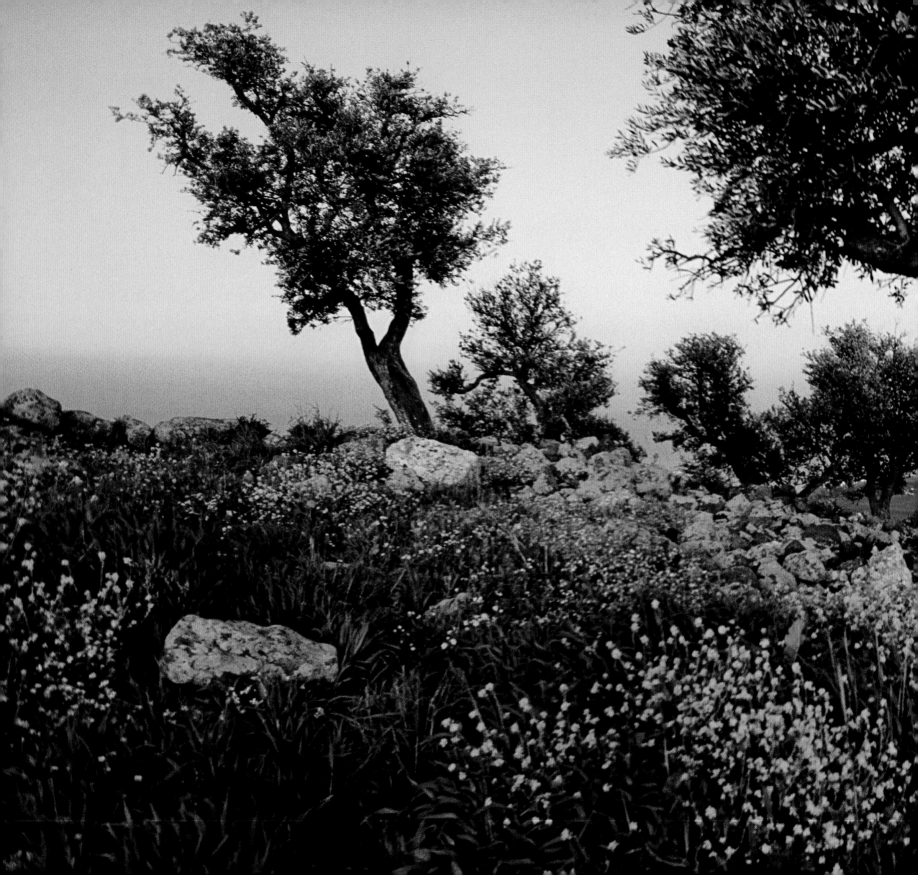

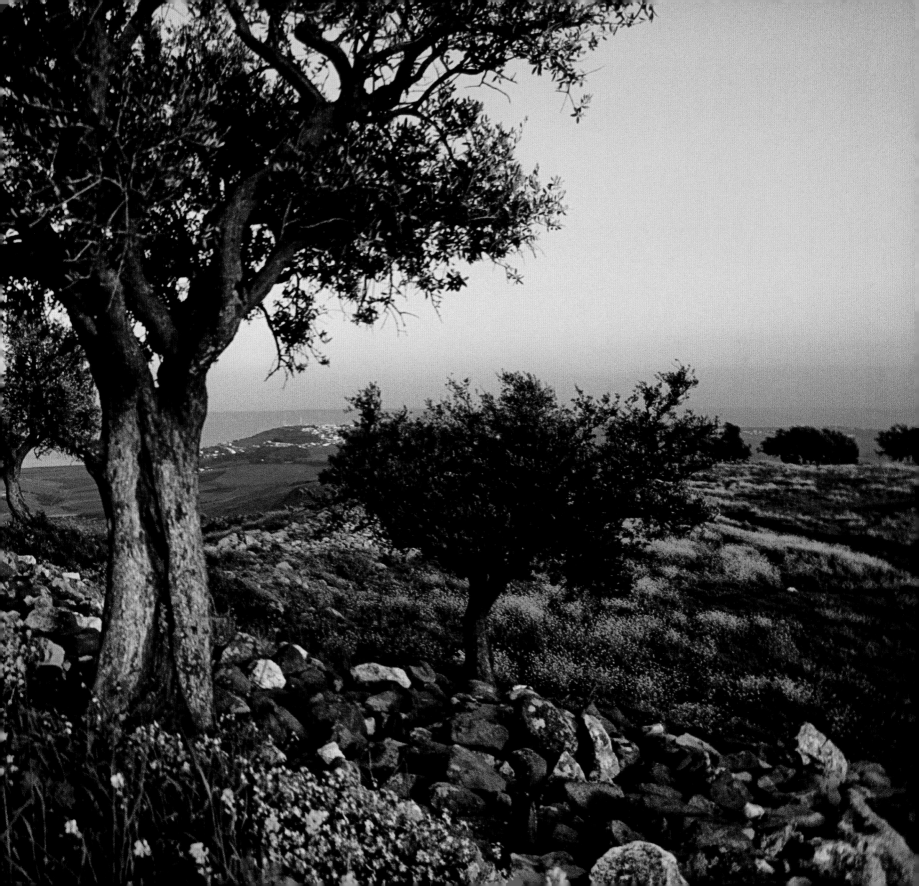

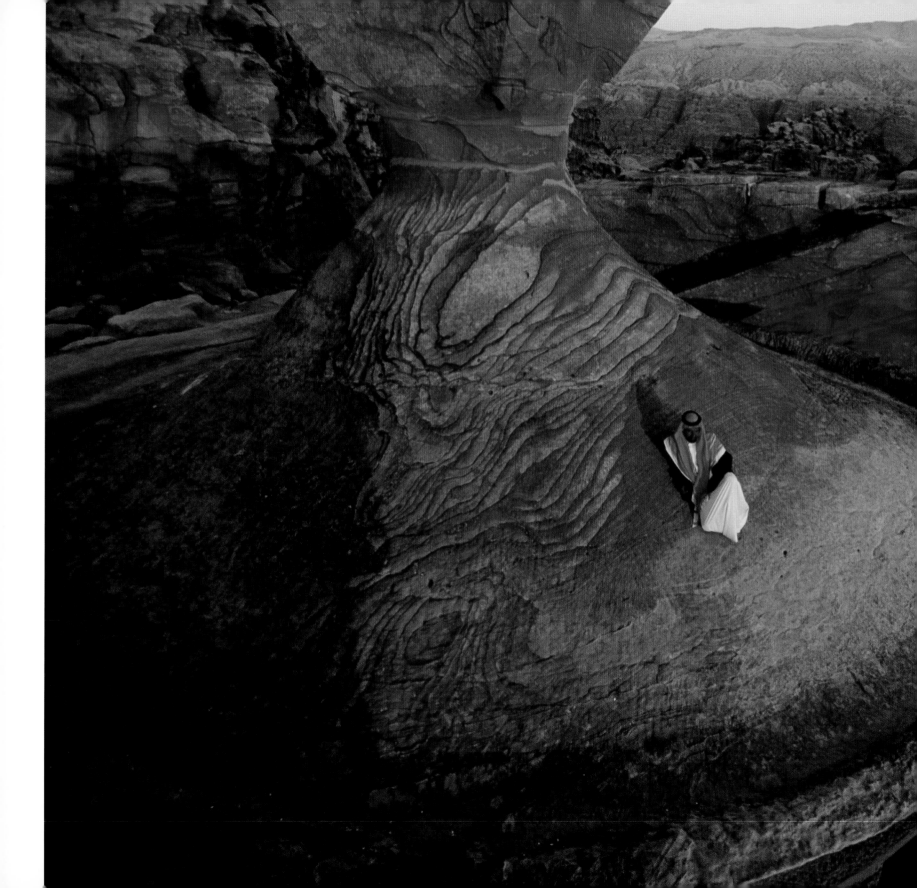

PETRA, JORDAN
Bedouin man atop Al Deir,
the Monastery

FIORDLAND, NEW ZEALAND
Don Belt and Charlie, age six,
hiking the rain forest

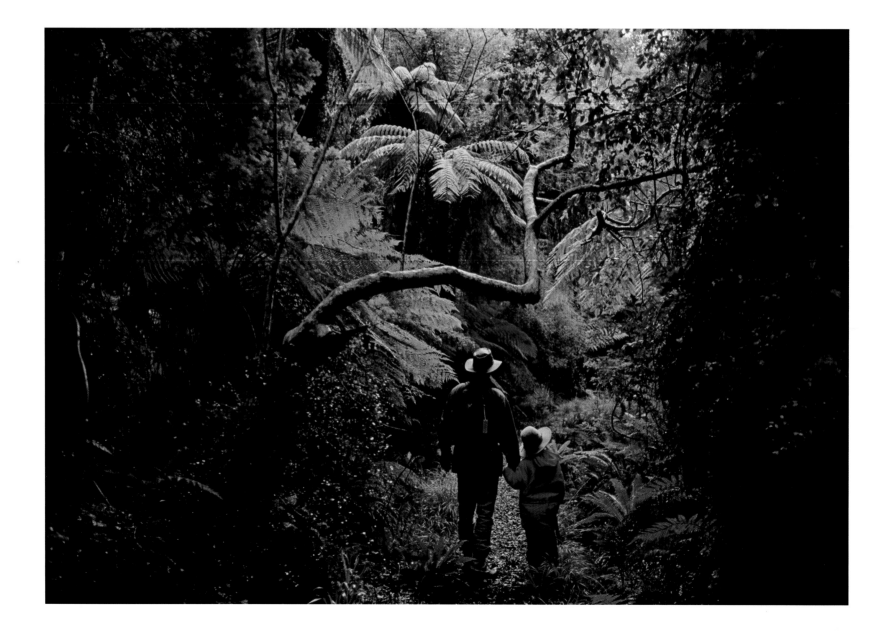

Shifting Continents

After years working throughout North America and the Middle East, I was fortunate in the 1990s to move on to other continents and other cultures, kids in tow. For the next decade we found ourselves hopscotching around the globe on a dizzying variety of assignments. We trekked the rainforests

of New Zealand and celebrated the millenium in Australia, photographing the most spectacular fireworks display ever seen in Sydney Harbor. We spent a magical summer in the Lake District of northern England—and a less magical November in the damp and dark of Oxford. We followed the Moorish route from Morocco to Spain across the Strait of Gibraltar. We had assignments on every continent but Antarctica.

Along the way we had our share of adventures and calamities. The kids learned to shear sheep in Cumbria, to luge in New Zealand, and to body surf in Australia. Don twisted a knee and went to a traditional healer in Fez, who knelt over him for half an hour with herbs and incantations. It did no good, but was definitely amusing. I broke my back in a nasty car accident in New Zealand. Charlie and I swam with sea turtles in the Galapagos Islands. Lily became fluent in Spanish during a summer in Spain. My mother joined me on assignment in South Africa and Victoria Falls in Zambia. Don and I paddled alongside Gray whales in Baja California and encountered one female who was so friendly that she slid under our rubber raft and took us for a ride. We have learned to navigate impossible roads and adapt to bizarre driving

customs. We now understand that STOP on a red sign in many languages roughly translates as "Driver is encouraged to honk as he blows past this sign." We've been stung and scraped and sickened, sunburned and jetlagged in nearly every time zone.

Yet we are traveling still—this year to Australia, Europe, South America, Africa, India, and Pakistan. Sometimes we split up, and Don takes one of the kids and I take the other. Or I take both. Or, best of all, we all go together. The great thing is that we are still diggin' it, poring over maps and planning our next project. The kids are old enough now that we can tell they are travelers for life. Don and I have always harbored a secret fear that they would eventually grow tired of our vagabond life—that the prom or New Year's Eve or pizza or showering regularly would suddenly appeal to them more than drifting around the planet with their aging parents. But each adventure and each culture seems to captivate them as well. We find that the hardest thing is deciding whether to reach for a new experience or return to a place we love. So we try to do both.

This year I returned to Africa for the 14th and 15th times, yet had entirely different experiences from previous trips.

I saw my first Southern Right whale off the coast of South Africa. On that same trip, Charlie jumped into a cage in the Indian Ocean and shot a picture right down the throat of a great white shark. We visited townships and schools and met children who taught us a soothing, traditional song that we still can't get out of our heads. After we got home, in the strange, cyber way that the world connects these days, Charlie was able to go online, find a haunting version of the same song and download it, transporting us back to Africa whenever we listen.

How to explain the allure of Africa? Whenever my plane touches down in Maputo or Marrakech or Mombasa, I feel a rush of energy and privilege. Over the years I've seen Africa at her worst and best. I've snorkled along the glorious coral reefs of Mozambique, stood among the towering temples of Egypt, and lingered in the markets of Fez. I've also trudged through the slums of Nairobi and the crushing refugee camps of the Sudan. I have visited the simple homes of families who survived unspeakable horrors in Rwanda and Somalia. But no matter how dismal the circumstance, there is a spirit in Africa that I find to be both humbling and uplifting. Somehow, I always come away hopeful. Africans understand survival on a level I've not witnessed anywhere else on Earth. Who needs to be told that human life began in Africa? It is confirmed every moment you're there. Africans were the first to come and, I believe, will be the last to go.

Last winter I traveled to places I had never been in South America. I visited remote corners of Bolivia to photograph indigenous tribes who are trying to reclaim their native lands and witnessed what a hundred years of the *patrone* system had done to an ancient culture. I worked in Argentina and learned to dance the Tango in Buenos Aires. I visited the state of Bahia in northern Brazil and made portraits of some of the spiritual leaders of the Afro-Brazilian religion called *Candomblé*. I did some dancing there, as well!

This summer, Lily and I took a ship along the Kimberley Coast of northern Australia and photographed pearl farming and rock art. We arrived on her 18th birthday, so this was our first trip together as adults. Once again we rode camels, but this time we were a world away from the Middle East—on the beaches of Broome, Australia. I have been lucky enough to visit Australia a dozen times and am looking forward to an assignment in Tasmania next year. It's easy to forget how enormous Australia is, with a landmass the size of the United States and a desert interior as forbidding as the Sahara. The continent is harsh, unforgiving, and breathtakingly beautiful.

I've always found that visiting Australia is like attending a carnival that has more bizarre, feisty, and fantastical creatures than any place on Earth—and that doesn't include the wildlife! Nobody knows how to have a better time than the Aussies. Life in Oz is hard work, strong drink, and song. Sport is king. Straight talk is required and social graces are a distant concern.

When I first visited in 1985, the Aussie culture was pretty crude—racist and macho and fiercely defensive about its convict heritage. Standard fare was meat pies and beer. But in the past 25 years, Australia has exploded onto the Pacific Rim scene and has been transformed. Sydney and Melbourne are two of the

world's great cities—not only physically beautiful, but culturally, artistically, and gastronomically exciting as well.

Last month I returned to Scotland after years of being away, and found it delightfully *unchanged*. Britain has somehow always felt like home to me. My ancestry is mixed, but mostly British, so perhaps that explains the connection. All I know is that the smells and sounds and humor in Britain comfort me. I find extraordinary peace as I drive the roads of Ireland, Scotland, or northern England. I probably shouldn't admit this, but I even like the food.

❧

One of the best things about my work is that no two days are alike. One day I might photograph an elaborate wedding, the next day a cockfight, the next a Salsa competition. I often work very long days, and when I'm busy shooting I forget to eat, sleep, or even use the bathroom. I climb fences and lie on my belly and sweat and drive like a maniac—and I love it. The only bad days are those spent on the phone or the computer or buried in expense accounts. The best days are those when I can get lost in a culture or village or extended family that carries on as though I weren't even there. I have a lot of those days. I've grown comfortable in this chameleon-like career. Changing colors to disappear into each culture is remarkably easy. I love that the camera has become my passport to other realities—an excuse to go behind the scenes, arrive early, stay late, or simply follow someone home.

Years ago the kids and I used to play a game in which we debated which superpower would be the best to possess. I always chose invisibility—a way to explore the world quietly, to see things and people as they really are, without intruding. It's the perfect superpower for a hungry and curious soul. My backpack full of Nikons is probably the closest I will ever get to an invisibility cloak. And as long as I keep my head down and my heart open, I get to places few people are lucky enough to see.

Meanwhile, these first 30 years at National Geographic have been an enormous privilege. Although there may have been days when all the togetherness got a bit claustrophobic, Don and I were able to forge a loving partnership to accomodate the multiple needs of work and family. As parents we have graduated from diapers and car seats to driver's ed and college visits. Lily and Charlie have unique perspectives on the world. They are multilingual, open-minded, and kind. Somehow all of our assignments have been successful and continue to appear in wonderful publications. The children did not flunk out of school, and Don was able to achieve his personal goal of organizing a soccer game on every continent except Antarctica. Penguins beware!

So where to next? I have no idea. People assume that I have been everywhere, but I always see the giant holes on the map where I haven't traveled. I almost taste the names as I count them off: Mongolia, Patagonia, Siberia, Istanbul, Mikonos, Jakarta, Bangalore, Prague. Recently someone gave me a list of all the countries in the world, and for the first time in my life, I checked them off. It amazed me to discover that I've visited nearly a hundred countries. Which leaves more than a hundred to go. It kind of makes me want to to throw on my backpack and head out the door.

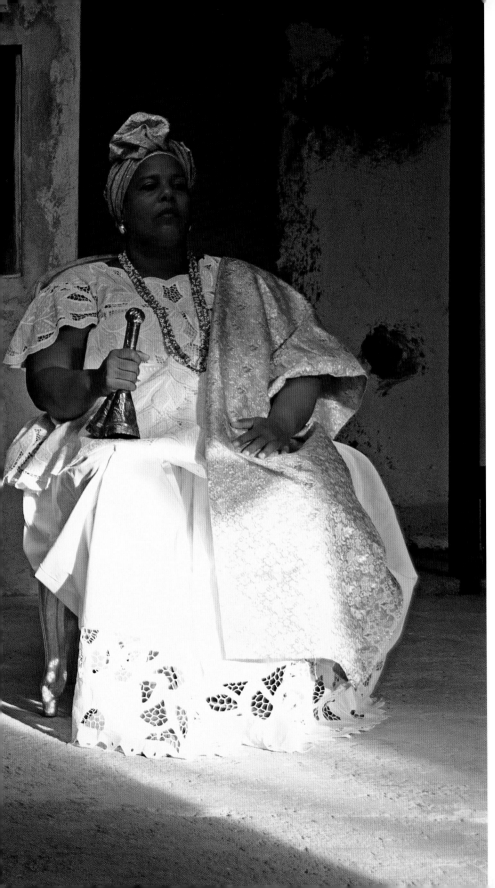

SALVADOR, BRAZIL
Candomblé priestess waiting
for church members to arrive

NAMIBIA
Petrified trees among dunes of
the Namib Desert

HONG KONG, CHINA
Opera star putting on makeup
SYDNEY, AUSTRALIA
Film screen on floats in the harbor

133

SYDNEY BRIDES

After five years of working in the Middle East, I was assigned to photograph Sydney, Australia. Changing gears from the intensity of global conflict to the carefree, raucus world Down Under nearly gave me whiplash—from harsh desert to beach parties, from daily politics to nightly revelry.

The story was a look at Sydney's banner year, when it hosted both the world's first millennium celebration and the 2000 Summer Olympic games. The city had never been so energized. Over the previous 20 years, Australia had loosened its immigration policy, creating a more diverse society and allowing the country to take its economic place among the Pacific Rim nations. Sport has always been huge in Australia, so the chance to host the Olympics and showcase their country filled the Aussies with pride.

Sydney, one of the most beautiful cities in the world, was the site of the venues. Here, everything happens on the water. Nothing symbolizes Sydney more than its exquisite winged Opera House, which juts out into the water at the edge of the city center. For years, wedding photographers have staked out views at different locations to place couples in this classic Sydney setting.

One Saturday I was wandering near the Sydney hub, called Circular Quay, when I came upon a wedding party just stepping out of their limos. Their dress was classic Western—tuxedos and billowy white dresses—but the language everyone was speaking was Arabic. The newlyweds were Lebanese. Suddenly my two recent worlds, the Arab Middle East and multicultural Australia, came together. It turned out that it was a double wedding. A sister and brother from one family were marrying a sister and brother from another. They had just arrived to have wedding pictures taken and were astonished that I greeted them in Arabic. When I asked permission, their very generous Lebanese photographers allowed me to shoot alongside them.

It was a magnificent stormy day, which added to the chaos of two families on a wedding day. Everything was a riot of veils, elaborate hairdos, kisses, curses, and a bevy of little bridesmaids. Throughout it all, the two couples seemed almost oblivious. These were clearly love marriages between young people who had their feet firmly planted in two cultures: from Beirut to Sydney.

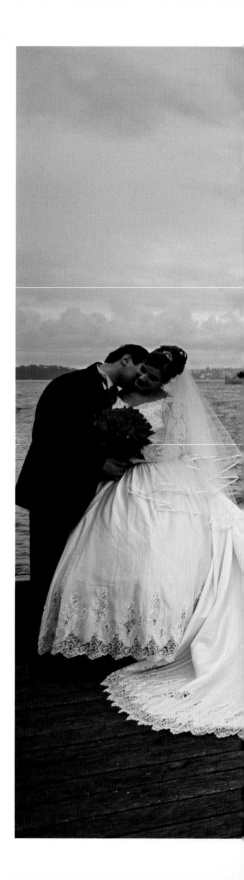

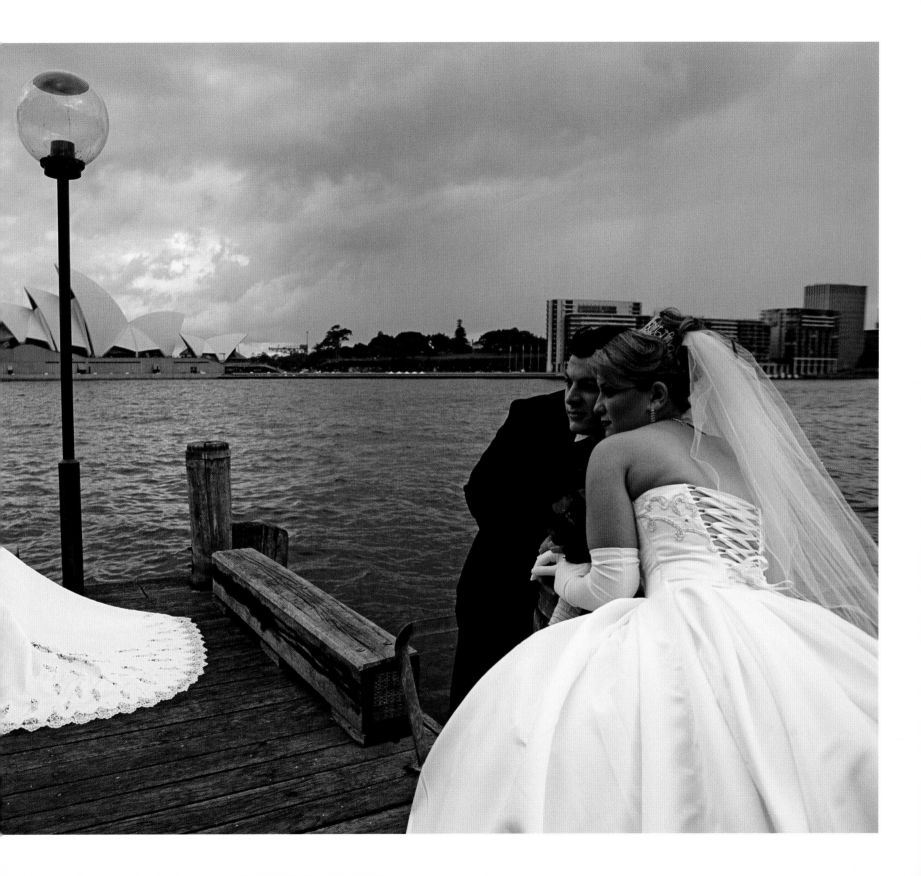

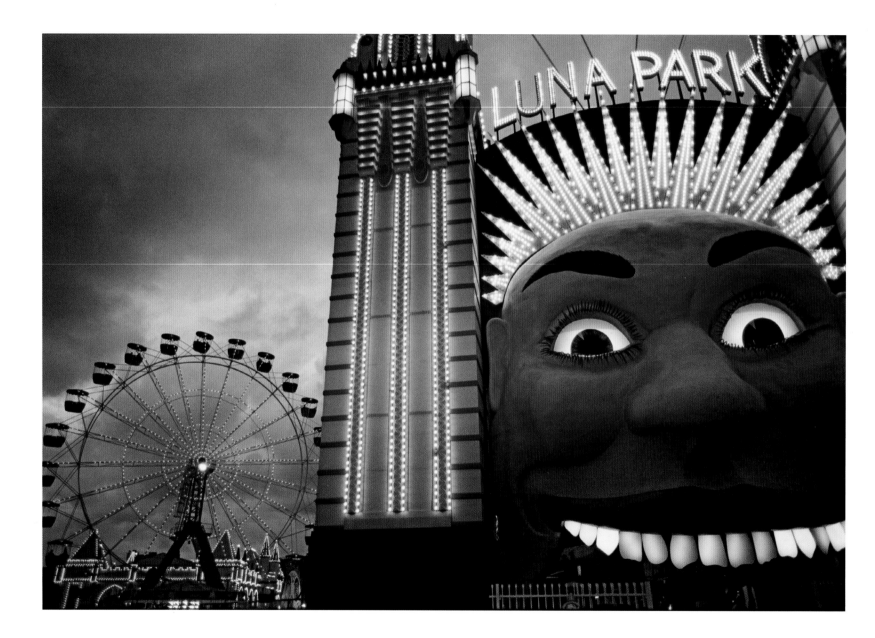

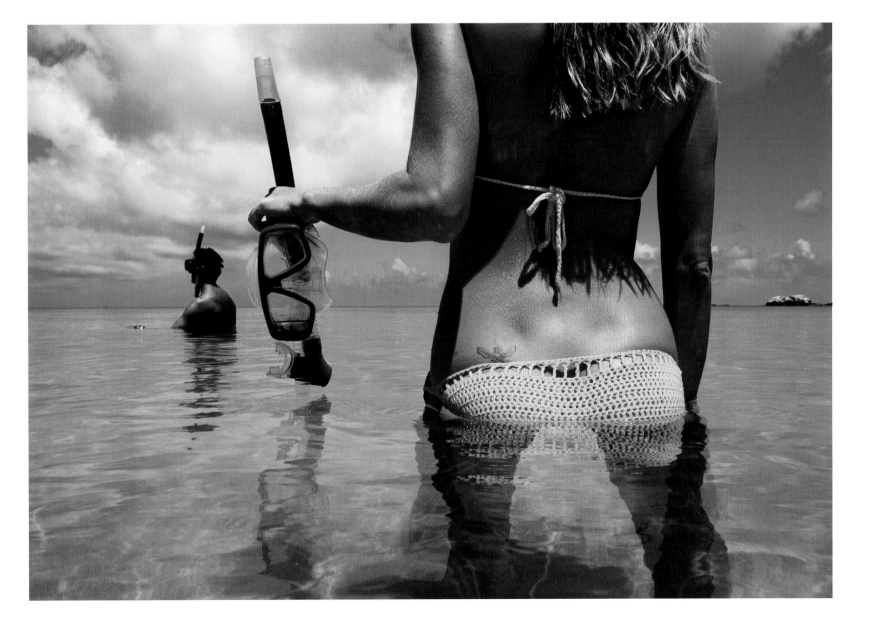

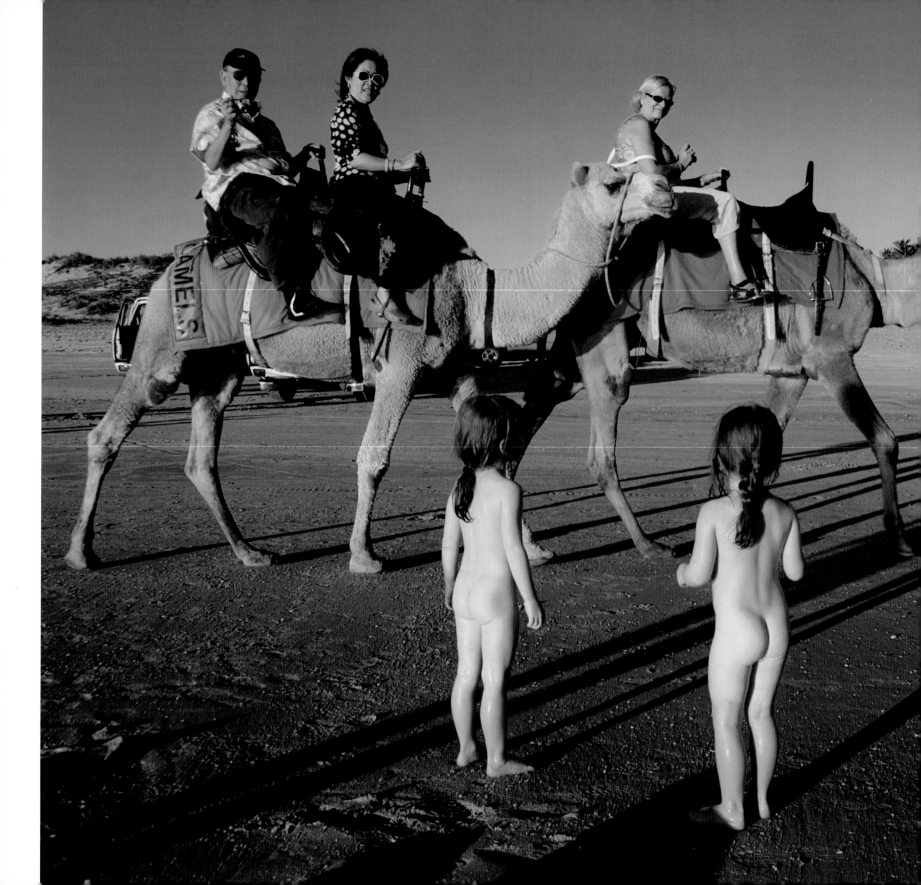

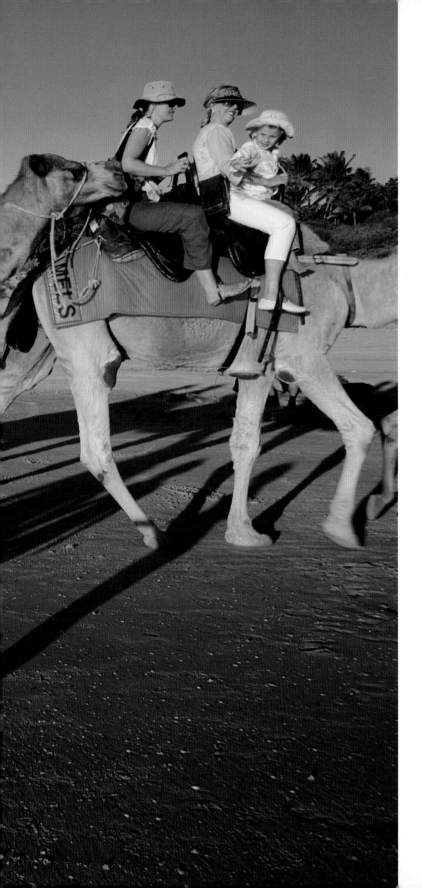

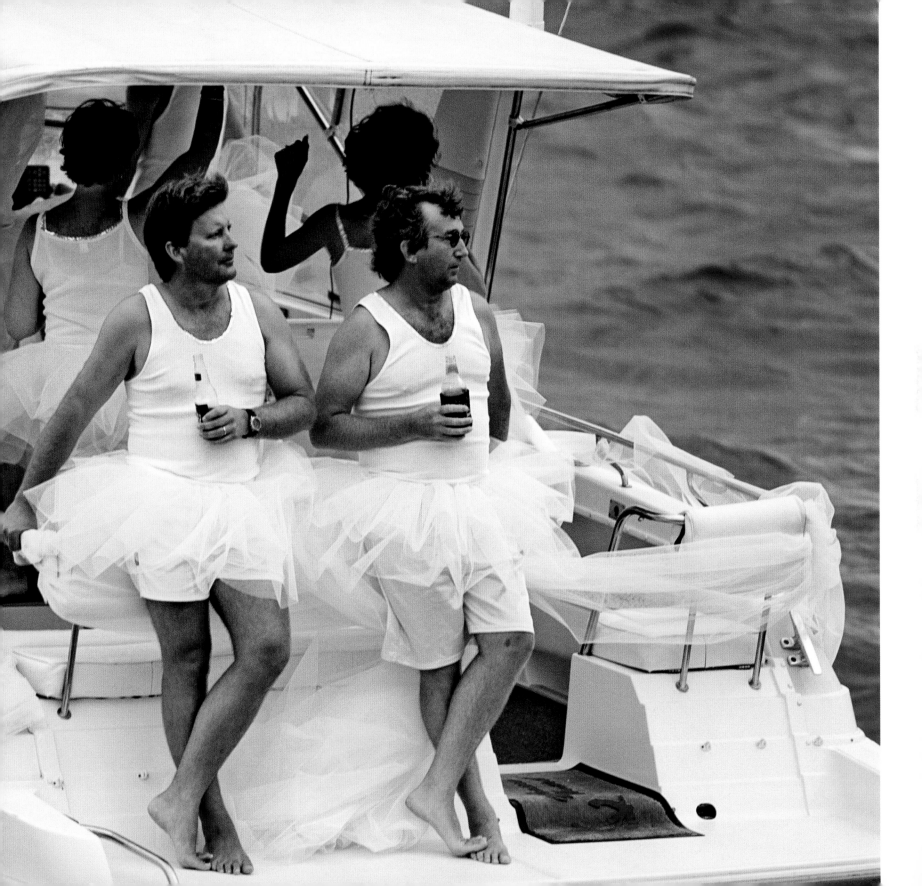

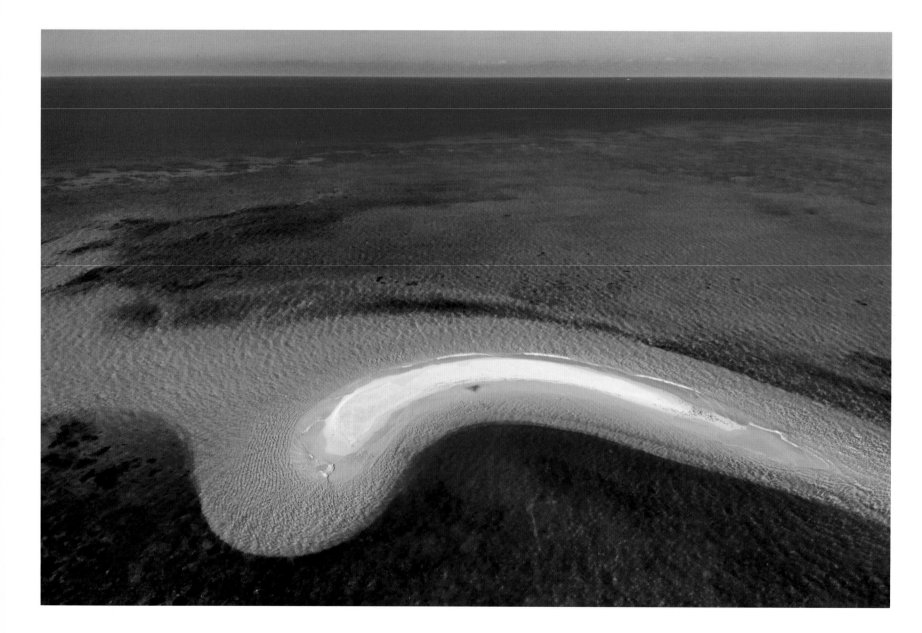

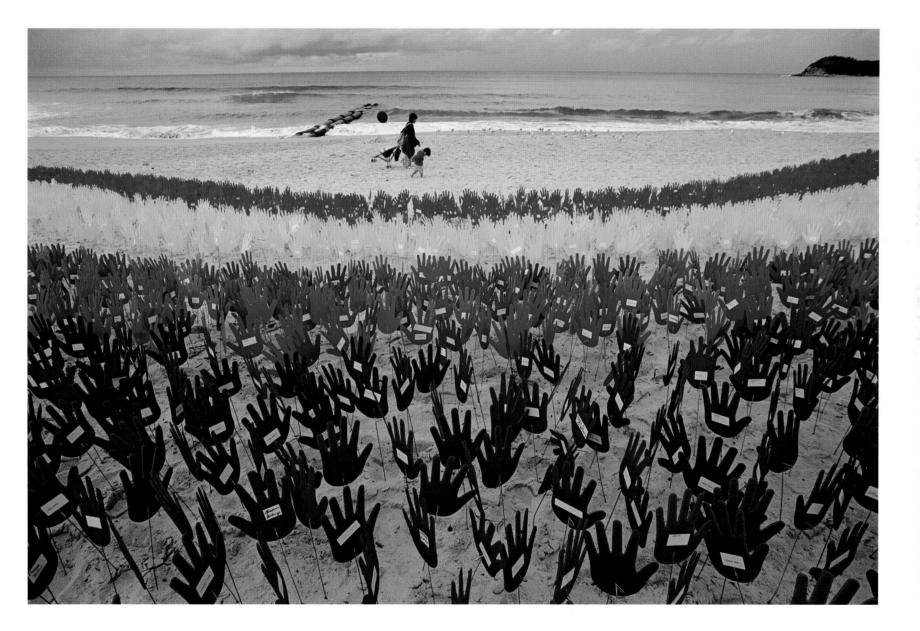

DOUBTFUL SOUND, NEW ZEALAND
Dolphins playing at dawn in the fjord

SOUTH ISLAND, NEW ZEALAND
Detail of plumage of the kea,
a native parrot

PAPUA NEW GUINEA
Child along the Sepik River
DENTDALE, ENGLAND
Steam train *(following pages)*

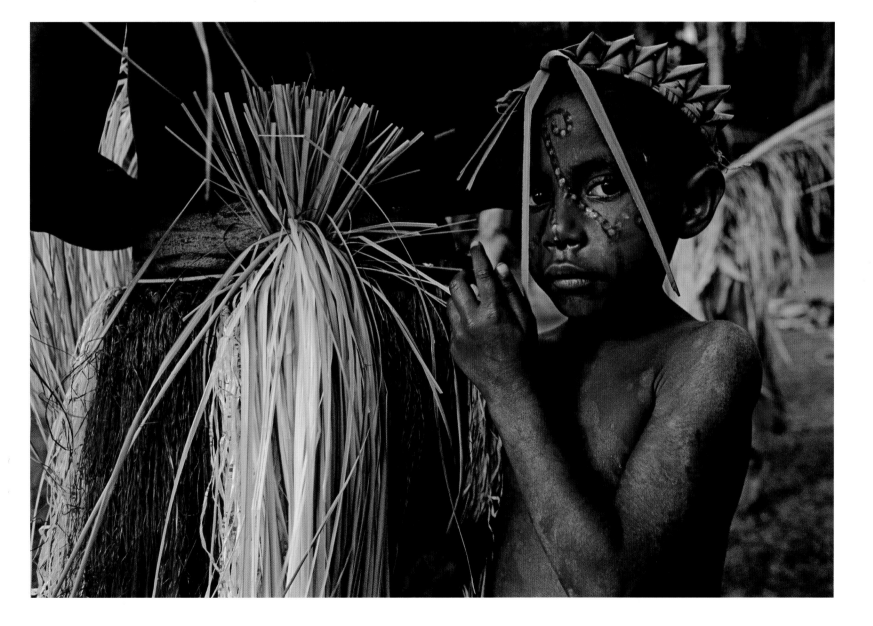

BRITISH MEN

I have a thing for British men. It began with my first assignment in North Yorkshire and followed me to the altar in Virginia. I'm drawn to the shepherd who walks his land at night during lambing season, looking for struggling ewes. I love the dairyman whose devotion to his cows has kept him in the same little dell he where he was born—except for the soldiering chapter of his life when he abandoned his milk cans and shouldered a gun during World War II. I love that British men are monosyllabic by day and songsters by night, when they visit the pub. I love the humor in their eyes, and the strength. I admire the work ethic that has twisted their hands like tree roots. I am touched by the way they treat their animals.

When the kids and I were posted to England's Lake District, we spent our best days in the company of Cumbrian farmers, who taught us the nearly lost arts of traditional sheep shearing and cheese making. My favorite farmer was a spirited stump of a man named Joe Benn. I was with Joe on the day he attended the auction of his best friend Billy Taylor's farm. Billy needed to retire, and there was no family member interested in taking over the hard work of farming his land. So I watched as neighbors, who loved and admired the Taylor family, clapped Billy across the shoulders and stepped up to bid against one another for pieces of his life, to ensure that the auction was a success.

On another assignment in England, I stopped at a little café for lunch. Fluttering off the edge of the café bulletin board was a recipe card with a neatly printed announcement: "There will be a meeting of the Calder Valley Mouse Club on Wednesday at 10 a.m." I drove to the bungalow listed on the recipe card and sure enough, there was a group of Mouse Fanciers—mostly retired men in their 70s and 80s—who lovingly raised the creatures we think of as vermin. They introduced me to the back garden joys of raising quality mice, explaining, for example, that length of tail and color of spots separated a champion from an ordinary mouse. As we were chatting in the garden, I could see two concerned faces popping up at the kitchen window. Mouse club members confided to me that their wives did *not* fancy mice and were concerned that they *stay* in the back garden and never find their way to the tidy bungalow across the yard. How could I not be crazy about British men?

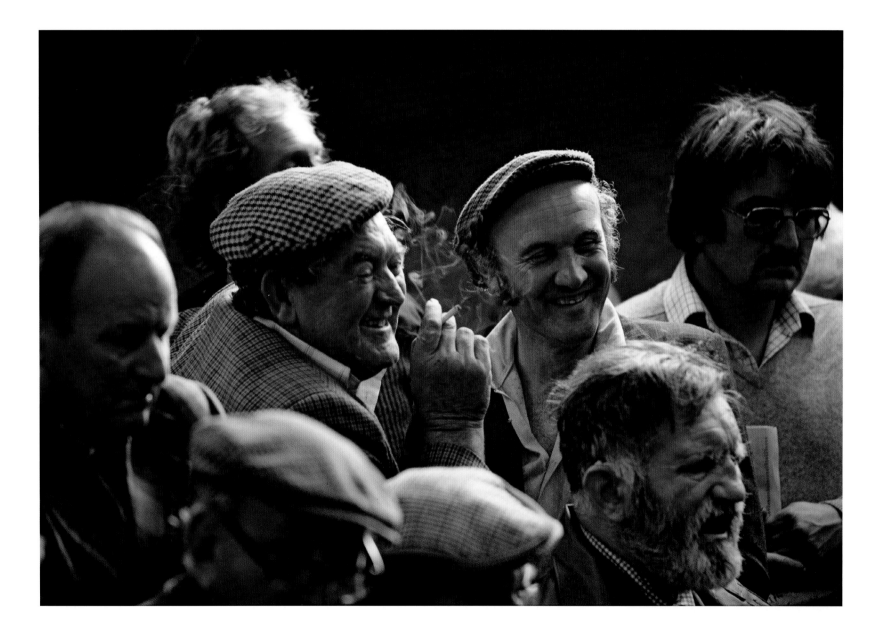

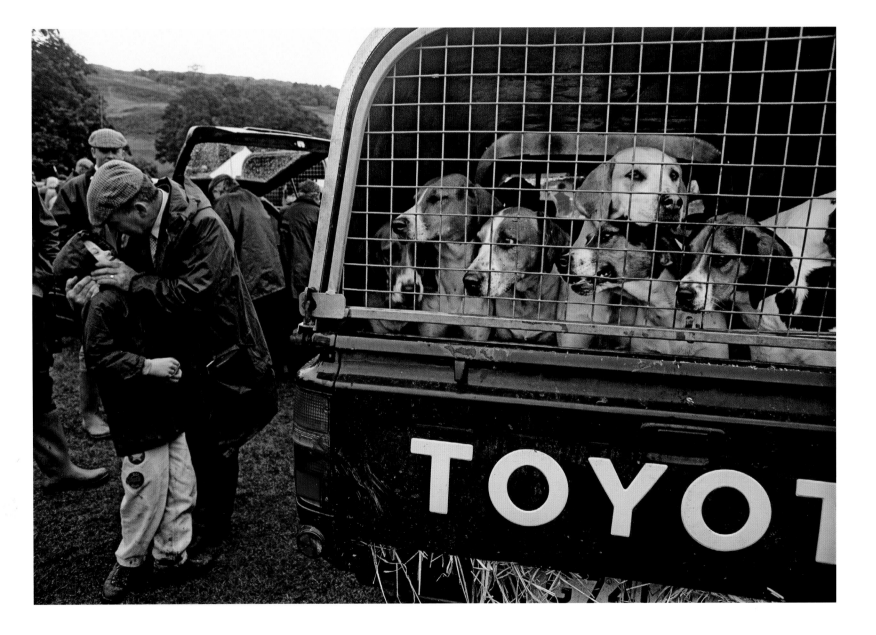

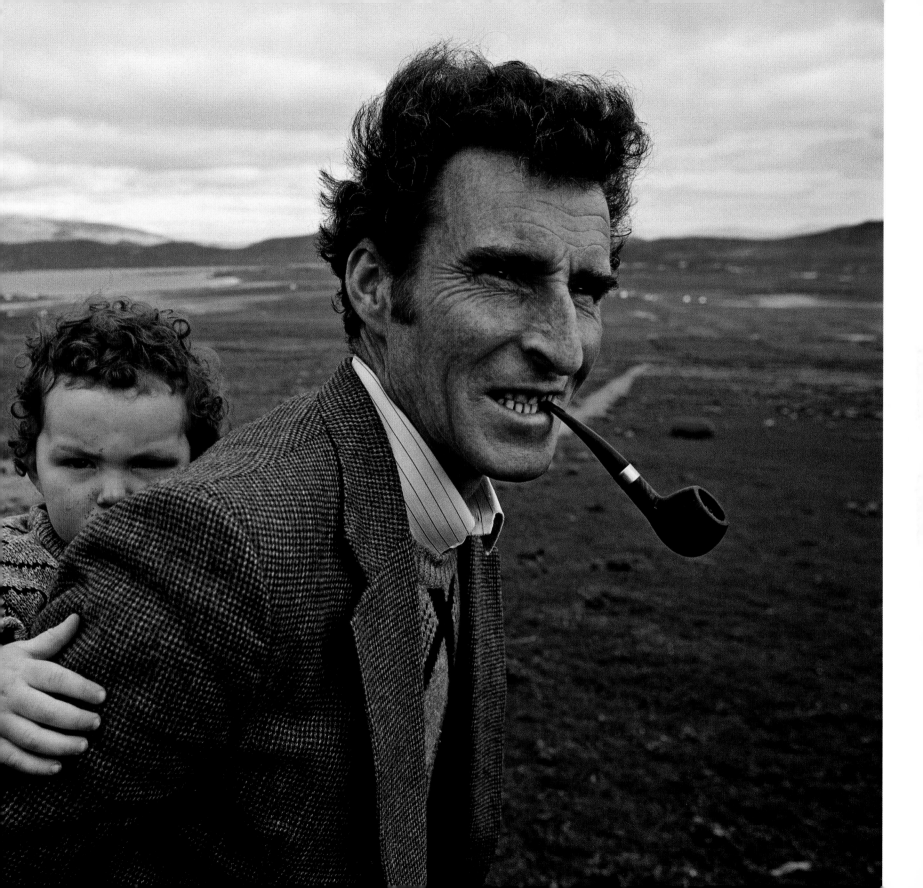

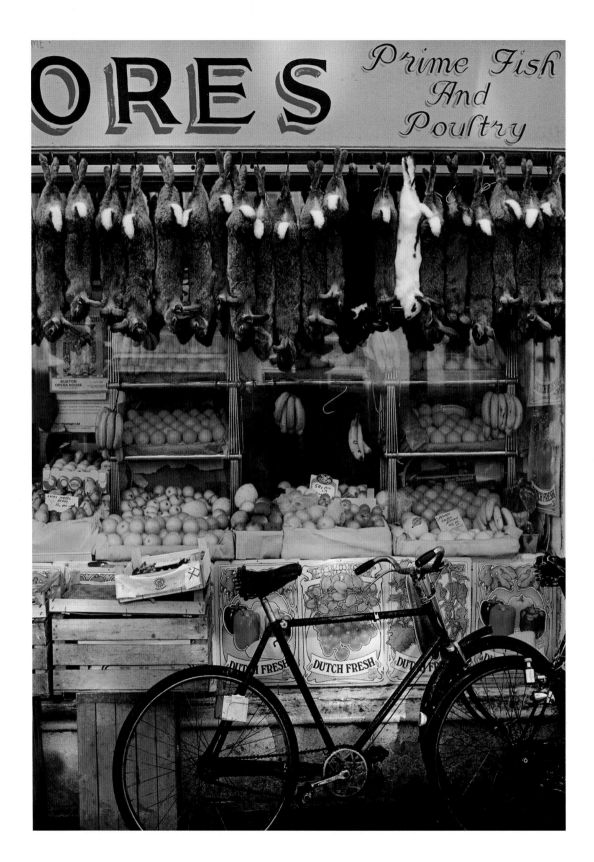

BAKEWELL, ENGLAND
Fresh rabbits hanging outside a traditional grocery

158

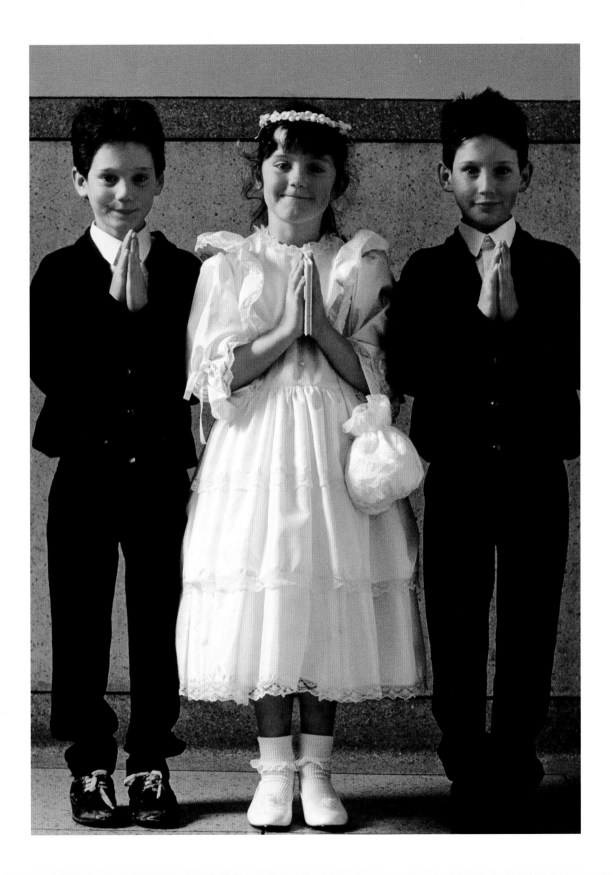

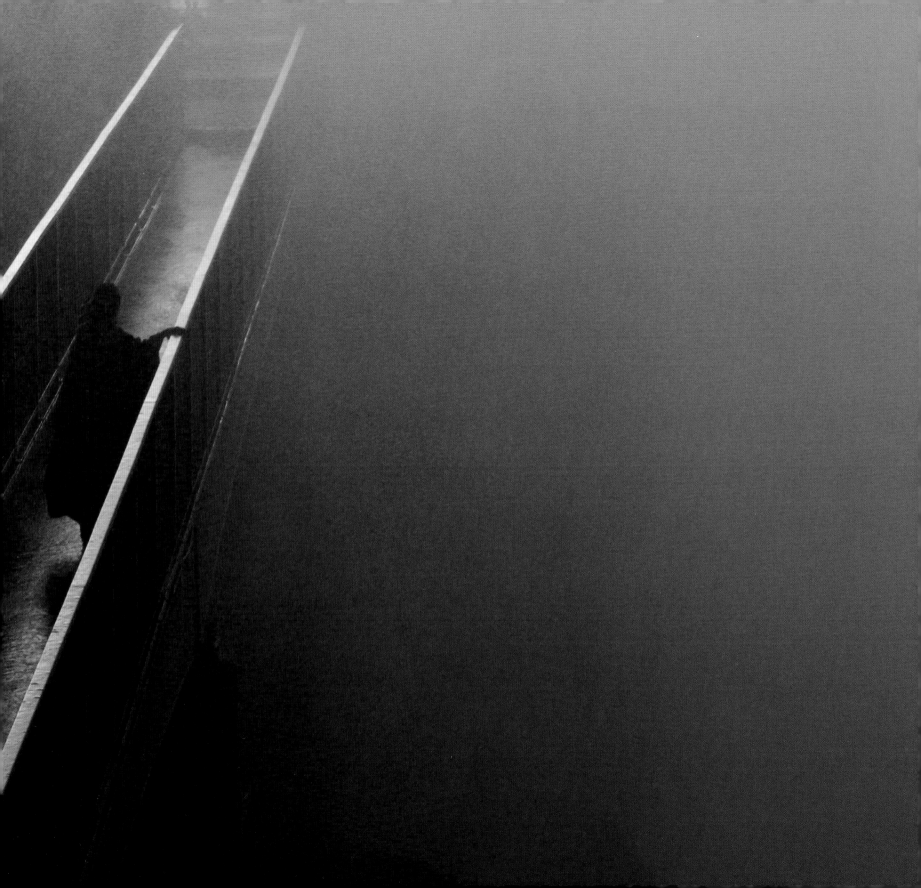

ITALY

Italy has long been my favorite country in Europe. I remember the first time I crossed the Alps from flawless Switzerland into the chaos and charm of Italy. I fell hard for her aging grace and bipolar culture. It seemed that everyone in Italy was either agitated or tender—shouting or kissing—embracing or throwing things at each other. It was exhausting, but also exhilarating. Since that first visit, whether I am driving the snow-covered roads of the Dolomites or sharing pasta with friends in Rome or looking out over the endless vineyards of Tuscany, I am happy. Every time I'm in Italy I end up walking around with a stupid grin on my face. I would love to live there someday.

Several years ago, I was assigned to work on a book called *A Day in the Life of Italy.* I was asked to photograph, among other things, a cemetery in the Veneto region. What might sound like an unappealing job to some photographers was actually a treat for me. Since childhood, I have loved wandering through cemeteries and thinking about the lives and stories of the people buried there. In this cemetery, I was fascinated that, in addition to the traditional graves, there was a wall where people were buried in drawers. Most of the graves along the wall had photographs as well as the normal burial inscriptions, giving faces to the people buried there. I loved that.

After a while I noticed a little old lady, dressed in black, who was roaming the graveyard carrying a blue detergent bottle filled with fresh water. She stopped at graves along the way and lovingly pruned the flowers, then gave each plant a drink. At some graves she lingered and spoke. I couldn't tell whether she was praying or having a little conversation with an old friend.

As the old woman came closer, I smiled and tried out my dreadful Italian. I asked if I could take her picture. She nodded and walked over to a spot along the wall where there were two empty drawers. She set down her detergent bottle, and simply assumed this pose. I couldn't believe how peaceful and sweet she looked standing there among her departed friends and family.

When I had finished the portrait, she took my hand and began to speak softly in Italian. At first I couldn't understand the words, but finally I realized that she was asking if I could send her the photograph to put on her grave when she died. And that explained her pose. She wanted to look like an angel.

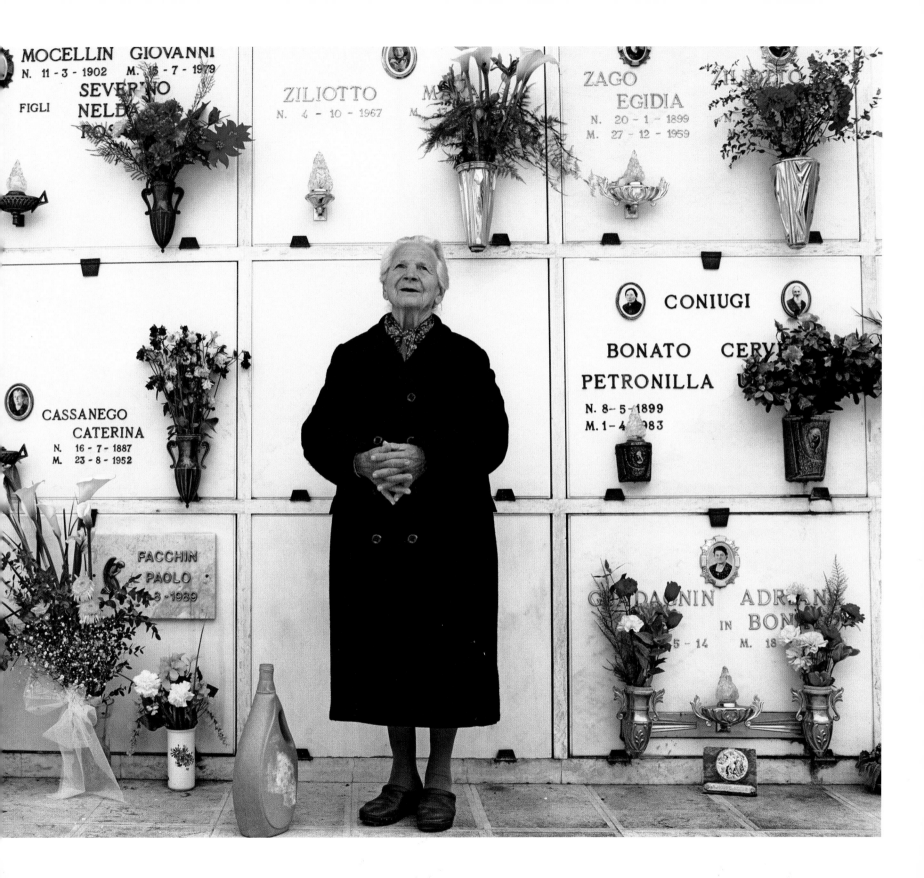

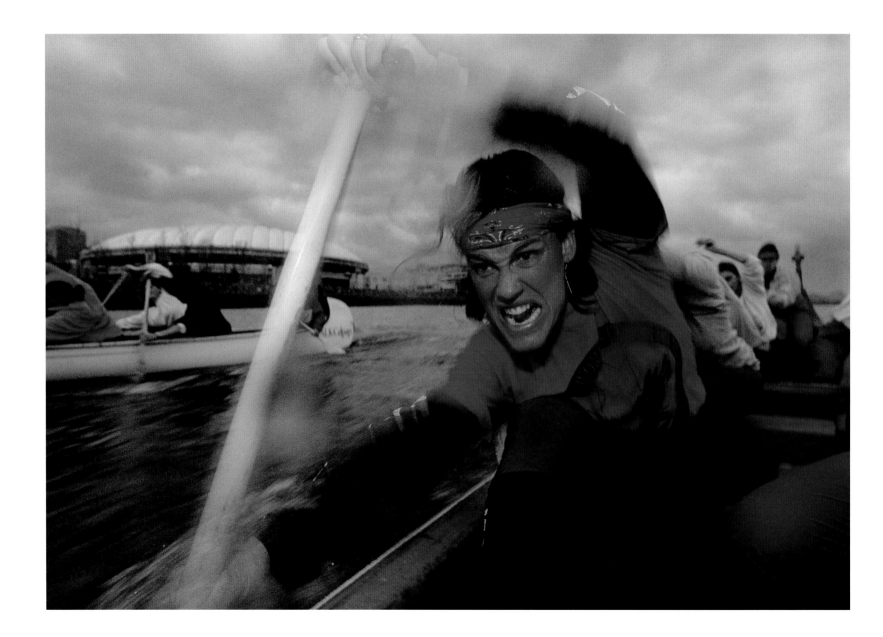

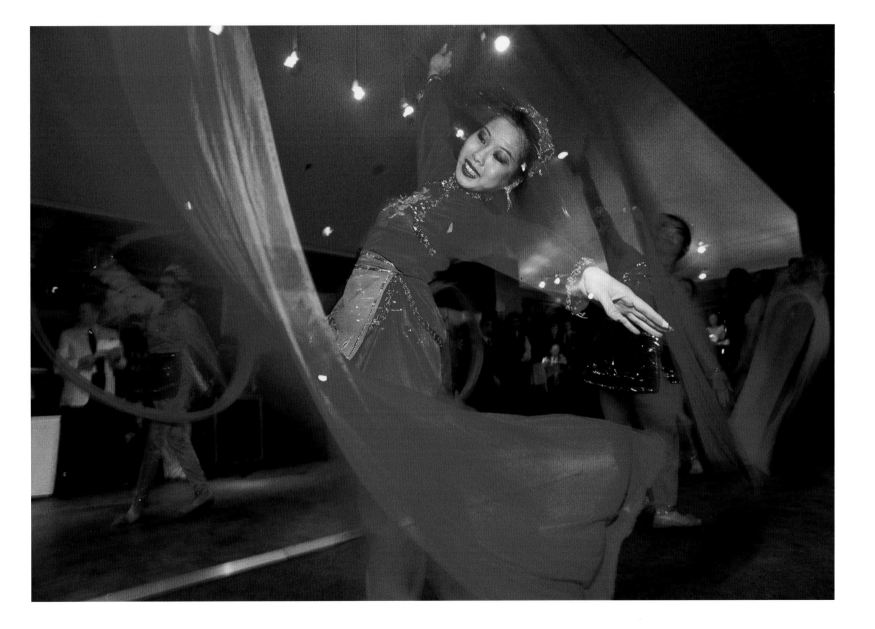

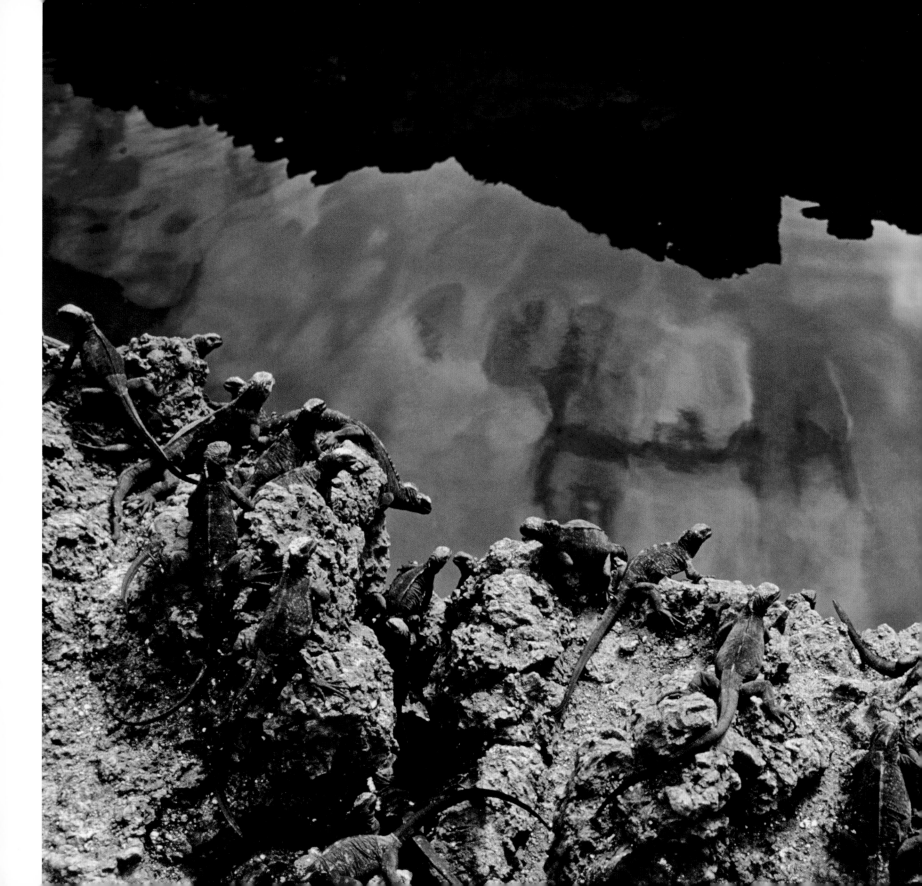

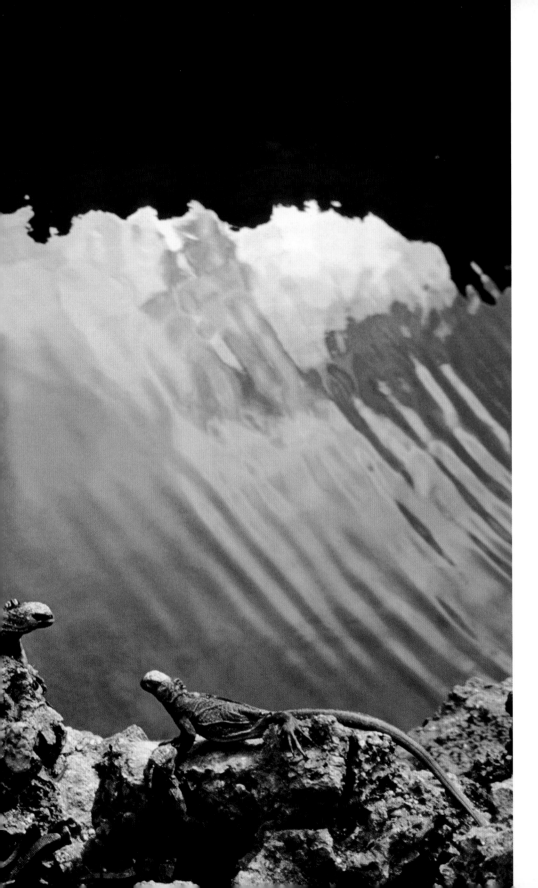

BAJA WOMAN AND CHILD

Among the favorite assignments that Don and I have had was a story in Baja California, Mexico. Although the two ends of this thousand-mile peninsula—Cabo San Lucas and Tijuana—are widely visited by tourists, the whole of central Baja remains quite wild. It was this part of Baja that drew us.

We knew that there were scattered oases throughout the mountainous desert of central Baja, where families had lived for generations, isolated and completely self-sufficient. We hired a surly American guide named Glenn, who knew the backcountry well and agreed to take us, by mule, to meet three remote families that he'd visited in the past. It took more than a week in the saddle to travel from one remote outpost to the next. Nine days on a mule along precarious trails is a long time, but I would have gladly spent a month on a mule to meet the extraordinary people who lived in the deep canyons of this remote part of Mexico.

Water in the desert is a wonder. It is astonishing to emerge from days of endless brown and suddenly encounter green. The families here had fruit trees and gardens. Unlike the emaciated goats and cows usually seen plodding through the Sonoran Desert, their livestock were fat, lively, and productive.

We camped for several days on the land of Señor Francisco Arce. The Arces may be the most self-sufficient people I have ever met in North America. Francisco is an accomplished saddle maker and we watched as he took leather tanned from one of his own cows and crafted a hand-tooled saddle that any American cowboy would admire. All of his children wore sombreros made by their father and shoes from leather so thick that their feet were safe from the toughest cactus thorns.

I took this photograph of a young woman, Sofia Altamirano, inside her simple kitchen. The baby was her niece. Sofia asked if I would take a picture of the two of them. As I took this photograph, I was struck by Sofia's dignity. Even the baby seemed dignified. To Americans, this family might appear poor. In truth, they have a beautiful life. They have food and shelter. Their children are safe and happy. They have pride and confidence. As Sofia told Don, "Life is good here in San Pedro. There is water in the well."

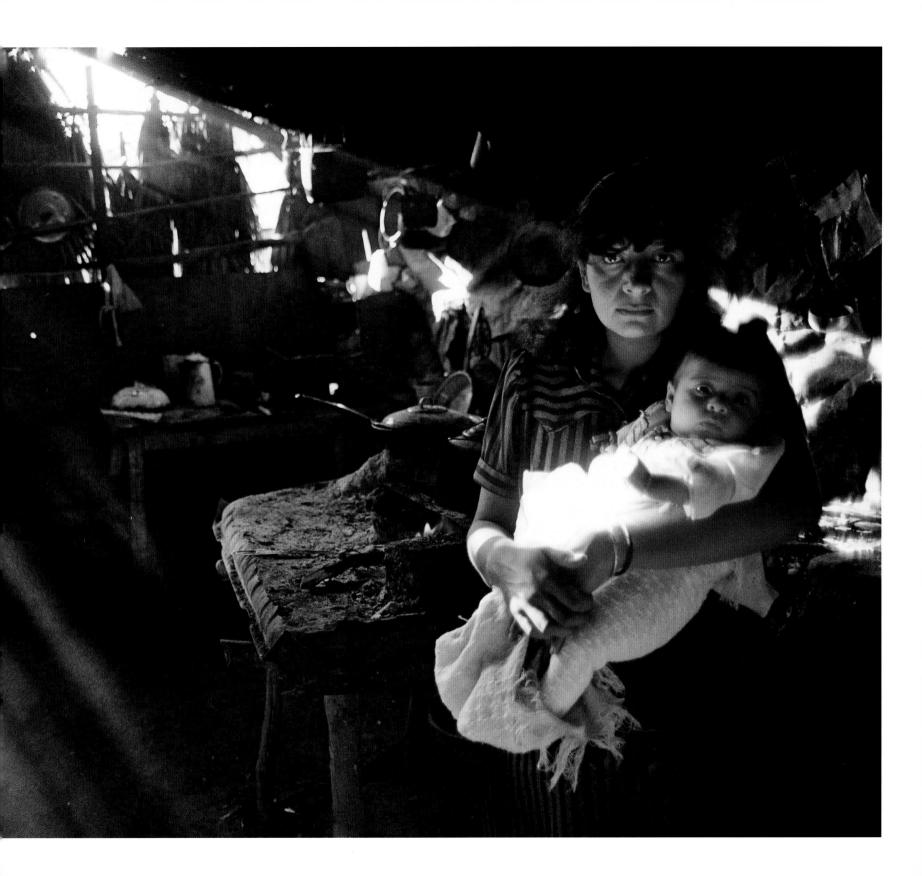

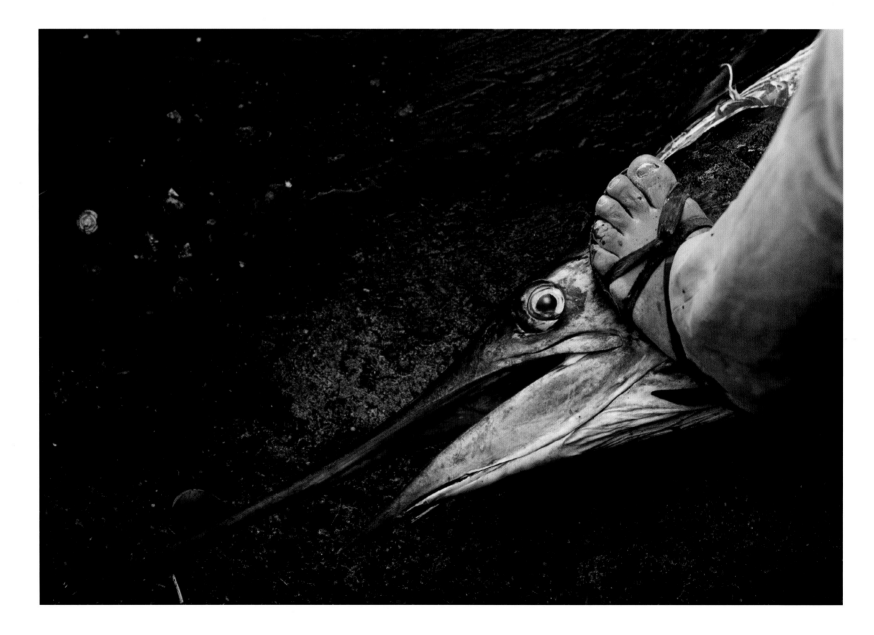

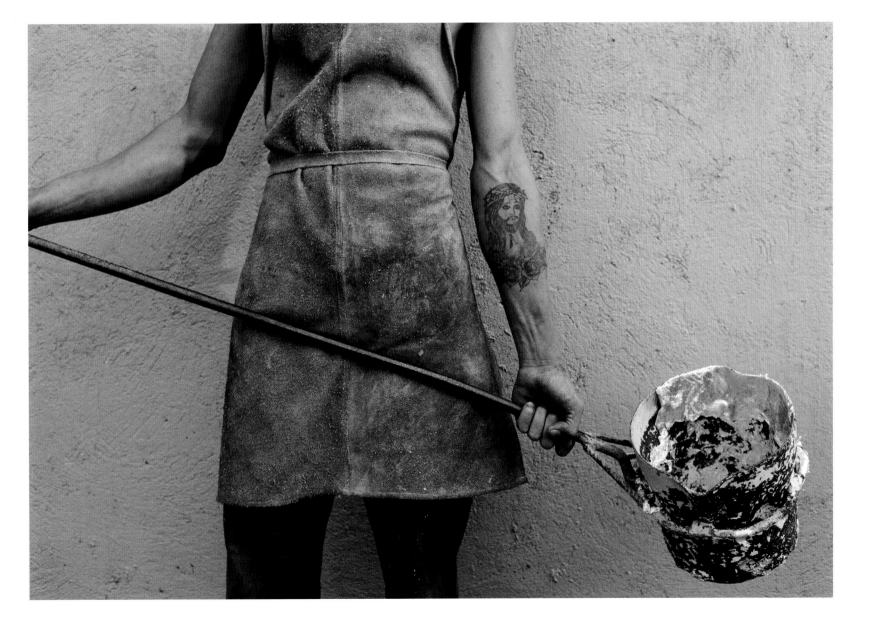

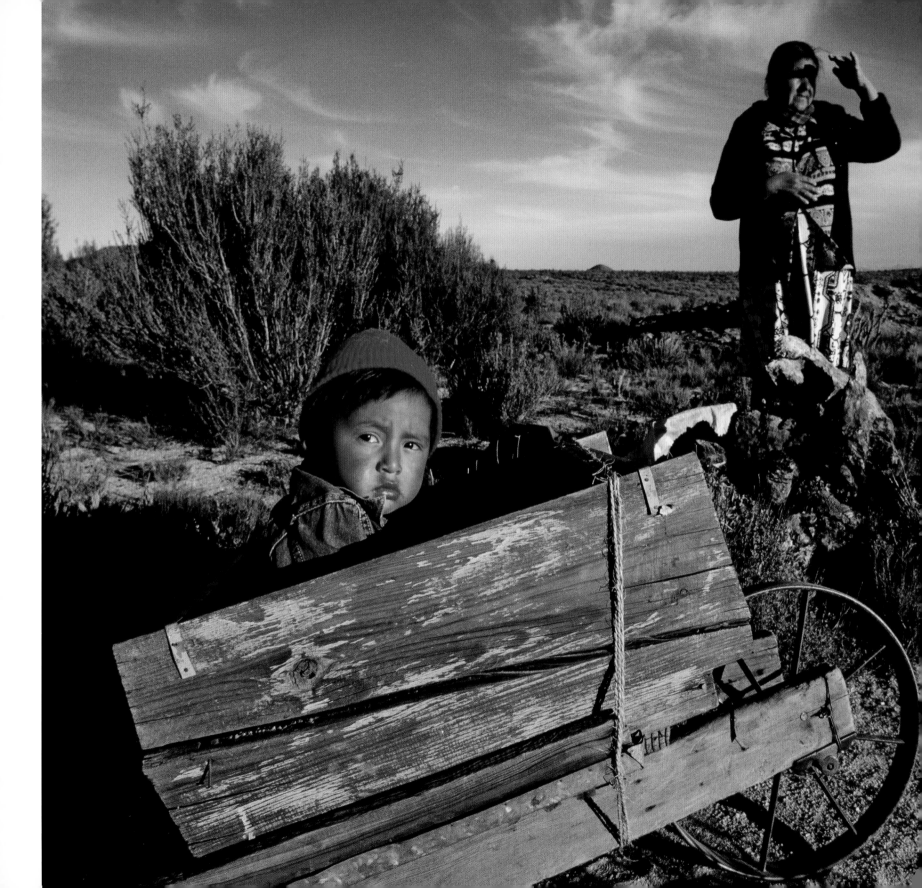

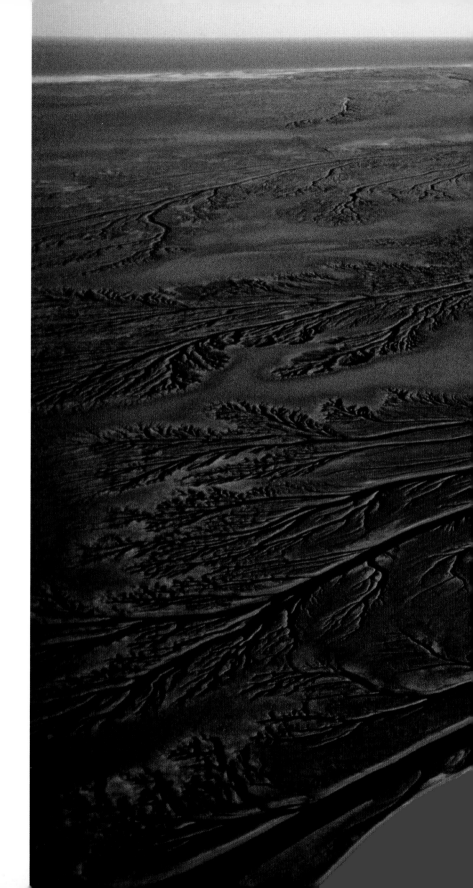

SEA OF CORTEZ, MEXICO
Mudflat remains of the Colorado River Delta

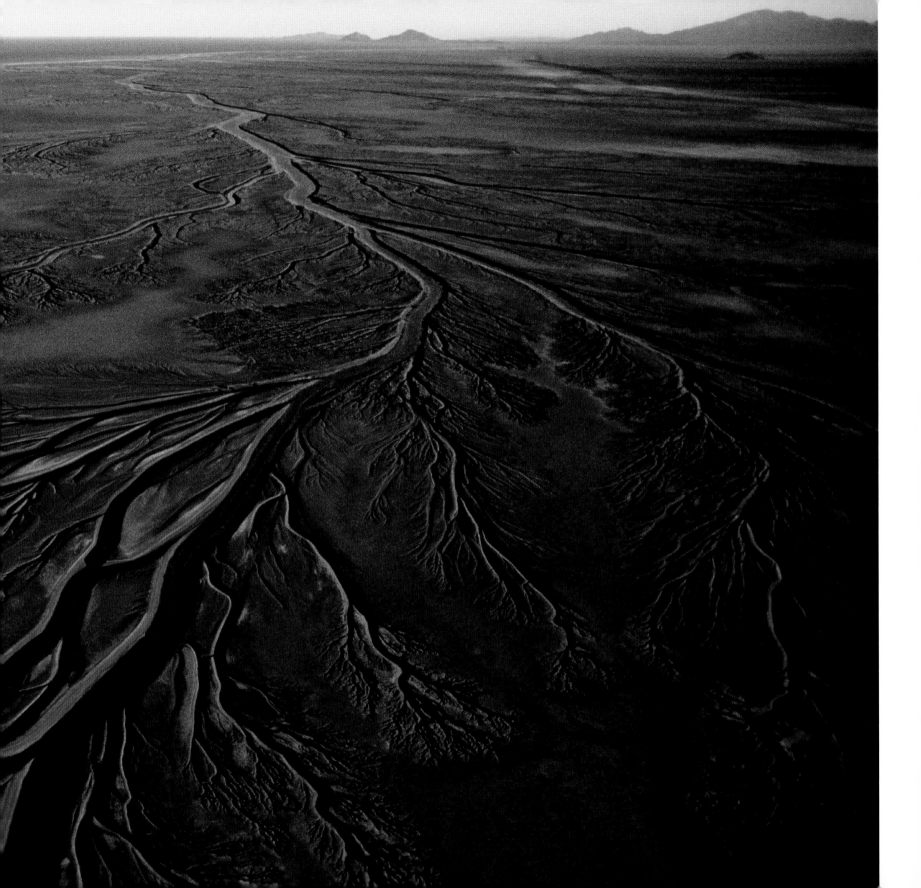

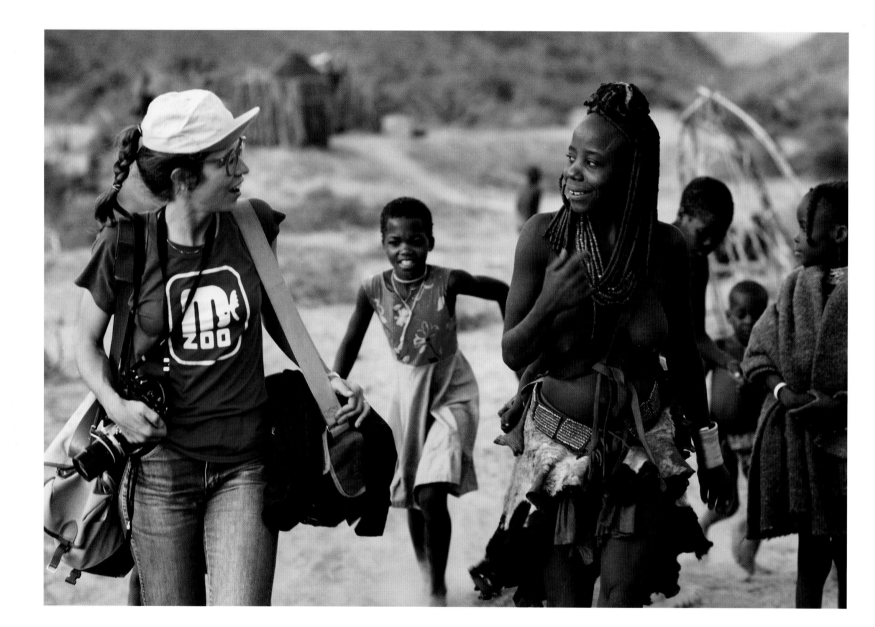

Giving Back

After years of traveling the world together, our family has lately entered a new phase. Our daughter, Lily, is consumed by the pursuit of college and career. Our son, Charlie, just wants to make the high school soccer team. And Don and I have reached a new, proactive point in our careers where we want

our work to be, above all, meaningful. As our children wax, we refuse to wane. Don has become an expert on the Middle East and is working on a variety of projects in that region to expand understanding of a complex, pivotal part of the world. And I've realized that I want my pictures to be used to raise awareness as well as to tell stories. I had been privileged to see magnificent sights in my travels, but other things I saw made me feel sad and helpless—and I resolved to do something about it. I'd resisted helplessness all my life and certainly did not want to model apathy for my children. When faced with the sheer magnitude of global need, I think that most of us feel overwhelmed. How can we possibly make a difference? But if each of us can search inside ourselves for a little acorn of time or passion or ability, and find creative ways to offer that gift, a forest begins to grow. My personal acorn is photography, so I decided to seek out ways that my pictures could help others.

In 1997 I began a photographic project for Habitat for Humanity. It was the brainchild of my brother Bobby, who specializes in finding creative ways for nonprofit organizations to gain visibility. The theme of that first project was "Shelter," and

our goal was to photograph families whose lives were changed because Habitat had helped them build a home. The pictures were then used for a calendar and a variety of fundraising activities.

The Habitat philosophy boils down to a very simple idea: All people deserve to have access to safe, affordable housing. In most countries of the world, including our own, the majority of families live on the edge of economic survival, where one cruel twist of fate—an illness, a divorce, a handicapped child, a drought, a civil war—can push them over that edge into poverty and homelessness. Perhaps most devastating of all is the crushing loss of dignity and self-confidence that poverty can bring.

This is particularly true in single-parent homes. The load on a single, working parent is crushing. Trying to do right by the children and carrying the financial burden alone is often overwhelming. I have photographed families where mothers or fathers work two or three jobs and also raise their children alone. The thought of owning an affordable home was not even on the radar screen for most of these Habitat families.

What touched me about every Habitat family that I have photographed was the empowerment that came when

families were given the tools to build and own their own homes. Inside new Habitat homes, children were getting better grades, mothers were freed from mind-numbing safety worries, fathers stood taller. Where groups of Habitat houses were built, communities were suddenly inspired to build a playground, to grow a garden, to insist on electricity, clean water, or bus service for their community.

The actual photography on the Habitat projects was a little daunting because, working on a very tight budget, I usually had less than an hour to photograph each family. Yet I was keenly aware that every photo needed to be compelling enough to inspire for a month in the calendar. It is a tribute to the generosity and gratitude of these families that the pictures worked so well. For nearly a decade I helped create the Habitat for Humanity calendar. It became one of my favorite annual projects.

After the 2000 Presidential election, my friend novelist Barbara Kingsolver and I became aware that the environment was in for a rough ride. Determined to do something about it, we began a book project for National Geographic called *Last Stand, America's Virgin Lands.* Barbara contributed her vast knowledge of the natural world, as well as her exquisite prose, and I set about photographing some of the last remaining wilderness in our country.

Our goal was to create a body of work that could be used in a variety of ways to remind Americans that only one percent of the United States remains as pristine wilderness—and that it must be protected. I chose to photograph using an old technique: shooting black-and-white infrared film and hand-color-ing the resulting prints. The technique helped the images to look as wilderness should, timeless and pristine.

The project seemed blessed from the beginning. Encouraged by National Geographic Senior Vice President Nina Hoffman, and with expense funding from the Society's Expedition Council, Barbara and I were able to create a book, an exhibit, and a Last Stand Fund to give grants in support of grassroots conservation efforts. In the past few years Last Stand Fund monies have supported work for a variety of projects, ranging from river cleanups, to endangered species protection, to the documentation of glacial retreat and climate change.

❧

For more than a decade now, I have also done work for a charitable organization called Church World Service (CWS). A nondenominational consortium of religions, CWS was founded in 1944 by a group of churches in the Midwest that worked with local farmers to ship desperately needed food to war survivors in Europe. CWS evolved to become a global force, raising money and partnering with aid organizations around the world. But they needed compelling photographs to help them raise funds and public consciousness. Again, in partnership with my brother Bobby, we set out to put a human face on the important work being supported.

Desperate people usually live in desperate places, and often the process of getting to them would be my biggest challenge. Every spring I set off, usually to three distressed locations around

the world, allowing myself three or four days per country. I would arrive in Bangkok or Mombasa or São Paulo, and be whisked away by some devoted aid worker who met me at the airport with a handmade sign bearing some version of my name—"Mis Ani," "American Annie," or, in one memorable case, "Lady Belt." Lady Belt would throw her gear in the back of a battered four-wheel drive vehicle, and off we'd go, driving for hours on unpaved roads to the part of the country where the need was greatest.

I learned on the very first trip to travel light (hand luggage only), carry my own food, and be prepared to sleep *anywhere*. I've also become keenly aware that my three or four days of discomfort are nothing compared to the months and years of dedication, empathy, and kindness routinely provided by aid workers around the world.

Despite crazy logistics, these journeys always ended up being worthwhile. Often we were greeted by a lively reception—not for me, but for the aid workers who were the community's only lifeline. The kids would peek at us with wide-eyed amusement. Women shyly touched my hair or took my hands. Men surrounded the aid workers with trust and fresh concerns. And I searched every face for a photograph that would somehow convey his or her reality to a wider audience.

One of my sweetest memories was traveling in Mozambique shortly after 20 years of civil war had ended. There were no aid workers available to help me, but I found a man who spoke passable English and asked him if he could drive me to an orphanage that I hoped to photograph. He was delightful and willing, but he had a major problem. The battery for his truck was dying, and anytime he stopped the truck he needed to recruit a group of volunteers to push-start the engine. We struck a bargain: I would buy him a new battery, and he would be my driver for the day. We made it to the remote orphanage, where more than a hundred little girls, orphaned by the war, were waiting in matching pink-and-purple dresses. It was all I could do not to tuck a couple of them into my backpack and take them home to a better life.

The most touching aspect of my work has always been how quickly people open up to me and my camera. I do try to appear as non-threatening as possible. I travel light, never wear a photo vest or camera bag, and work very simply. I believe that it's far better to look like somebody's mother than like a photographer. But despite my efforts to connect with people of other cultures, I know that I remain an aberration in their world. I arrive in my jeans and T-shirt, a middle-age white woman in a baseball cap, speaking a strange language and wielding a big fat camera. And yet the openness and generosity of the people I encounter always takes my breath away.

Whenever possible, I try to communicate without an interpreter, because it's so easy for an interpreter to actually become an unwitting wall between me and the people I'm trying to photograph. I'd rather make an idiot out of myself pantomiming and using whatever few words of the local language I possess than to rely on an interpreter. And I have learned that even without a shared language, it's easy to let people know that their children are beautiful, their homes are lovely, their tea is delicious, and their stories are worth sharing with the world.

PARAIBA DO SUL, BRAZIL
Young boys play with papaya leaves

AMELIA ISLAND, FLORIDA
Habitat for Humanity volunteer
with children he has helped
(following pages)

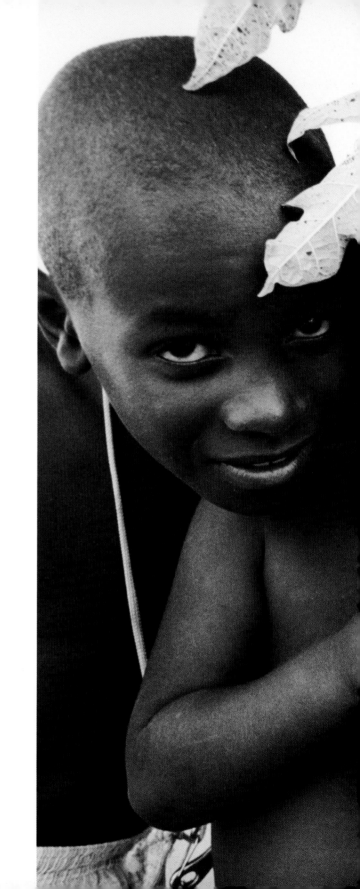

180

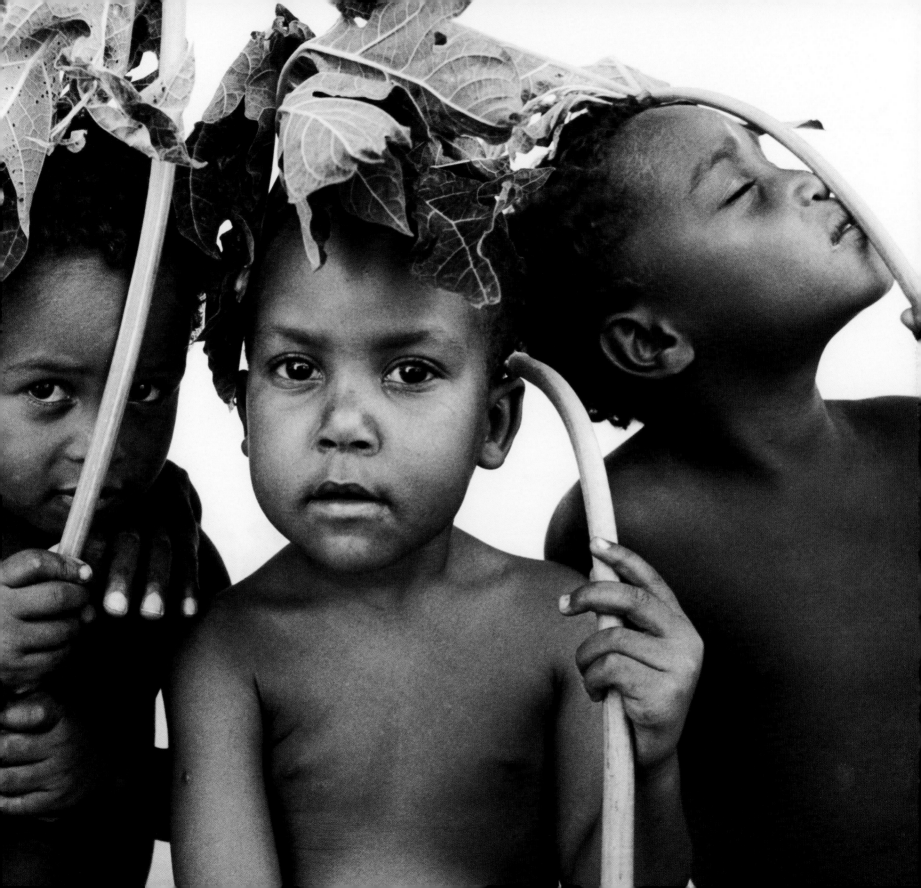

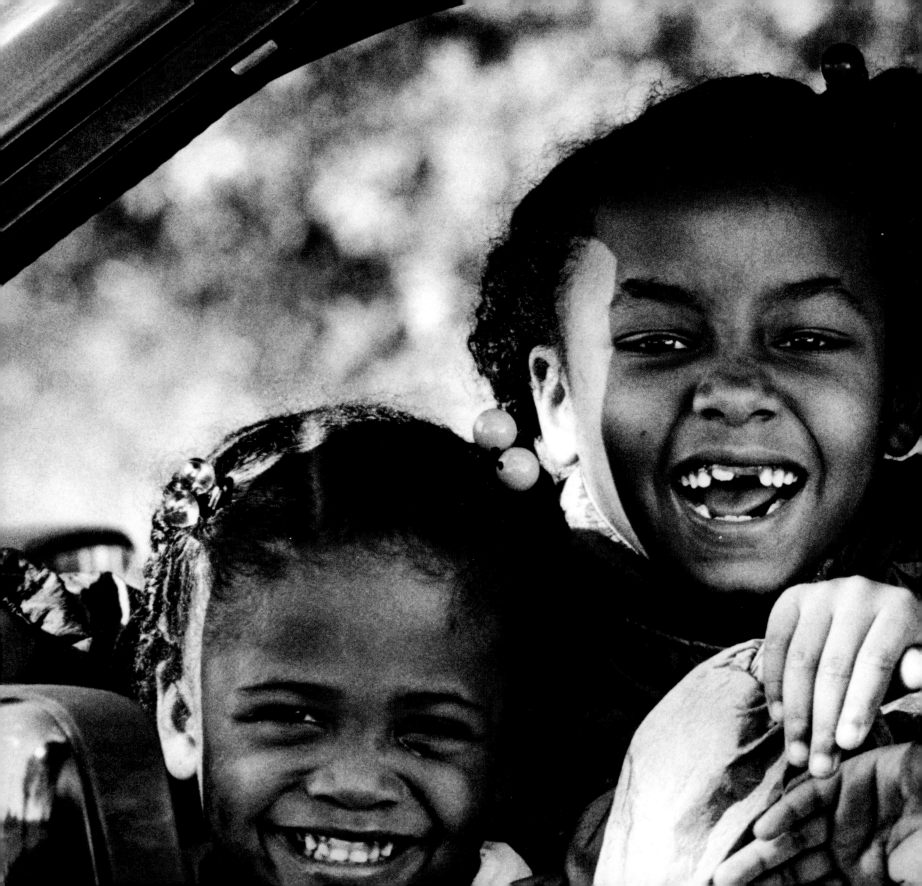

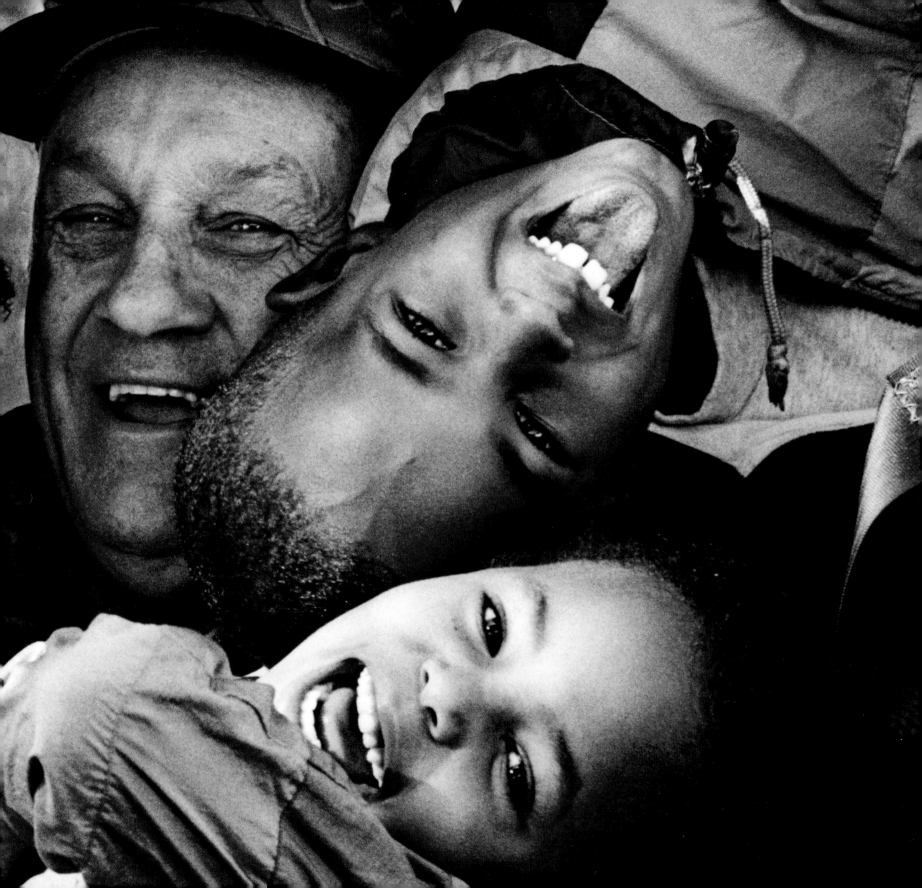

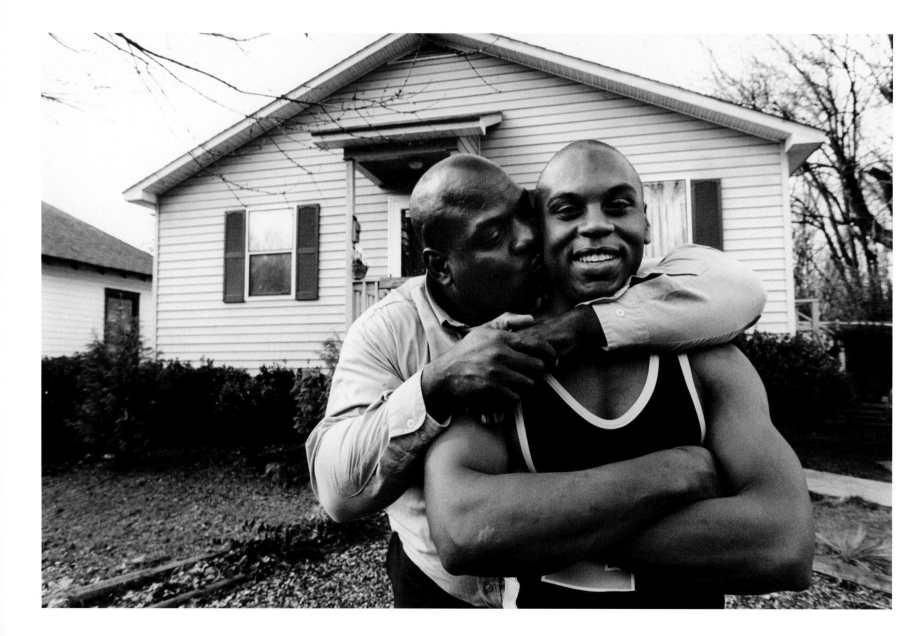

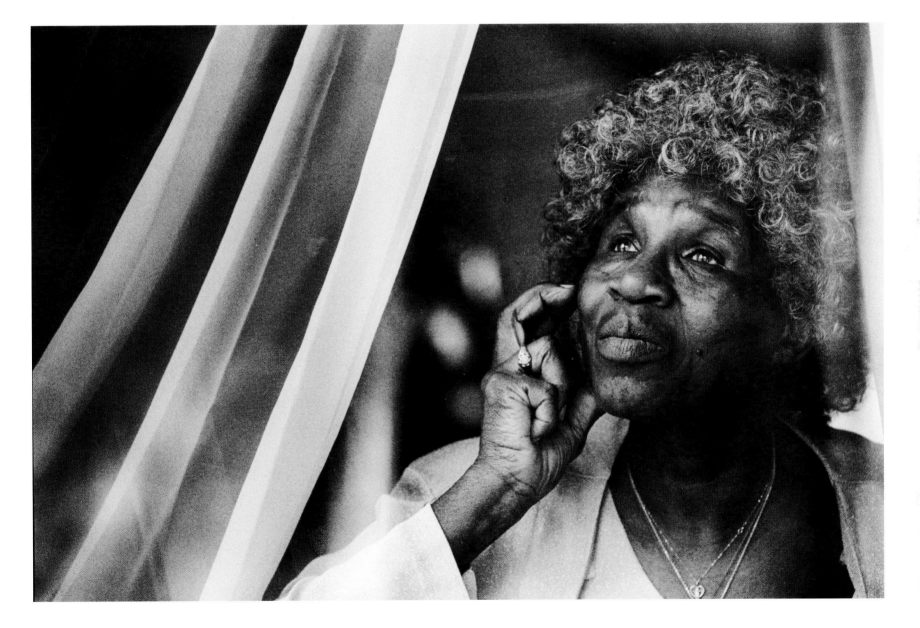

185

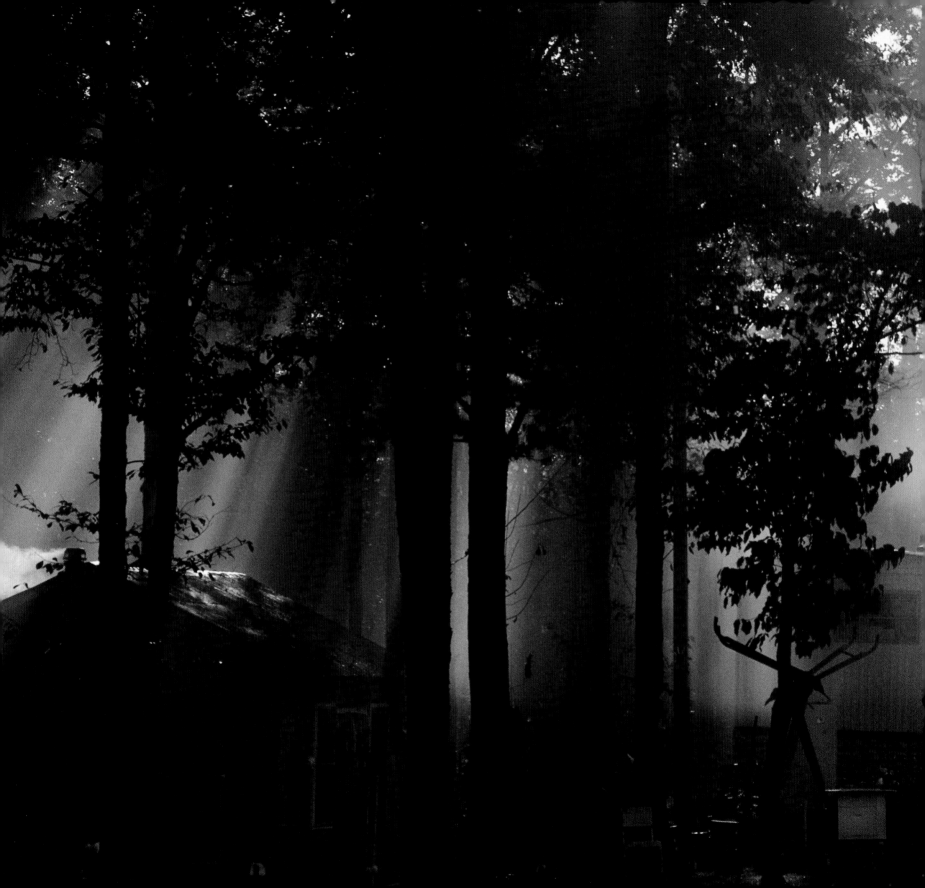

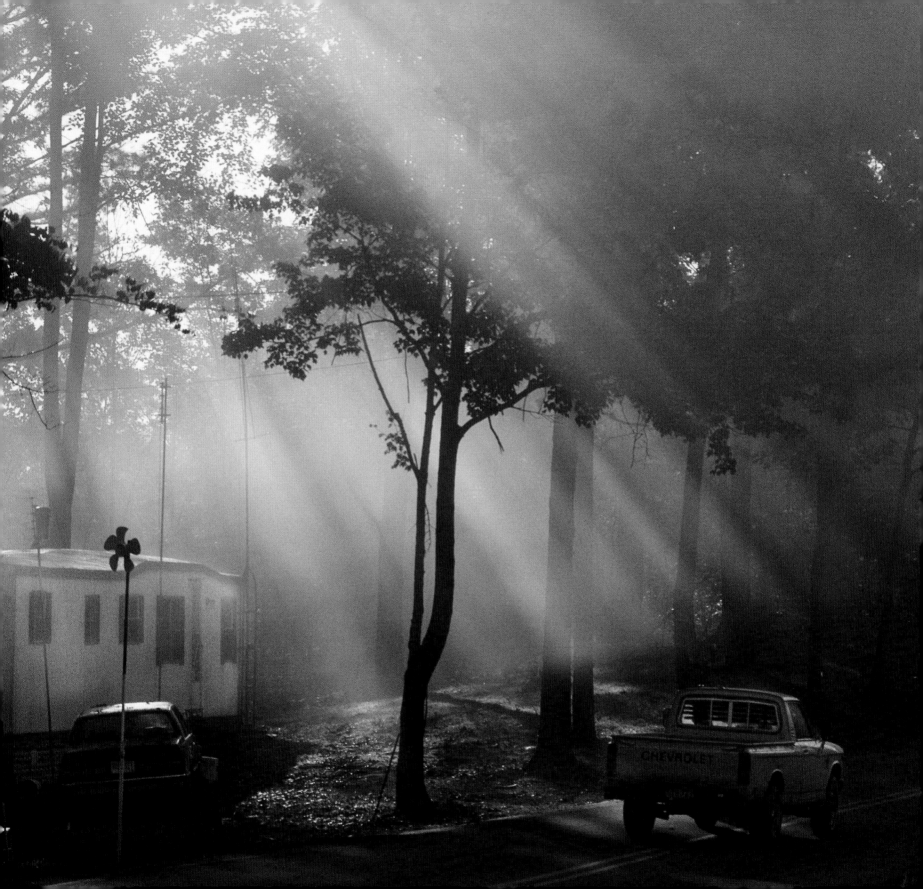

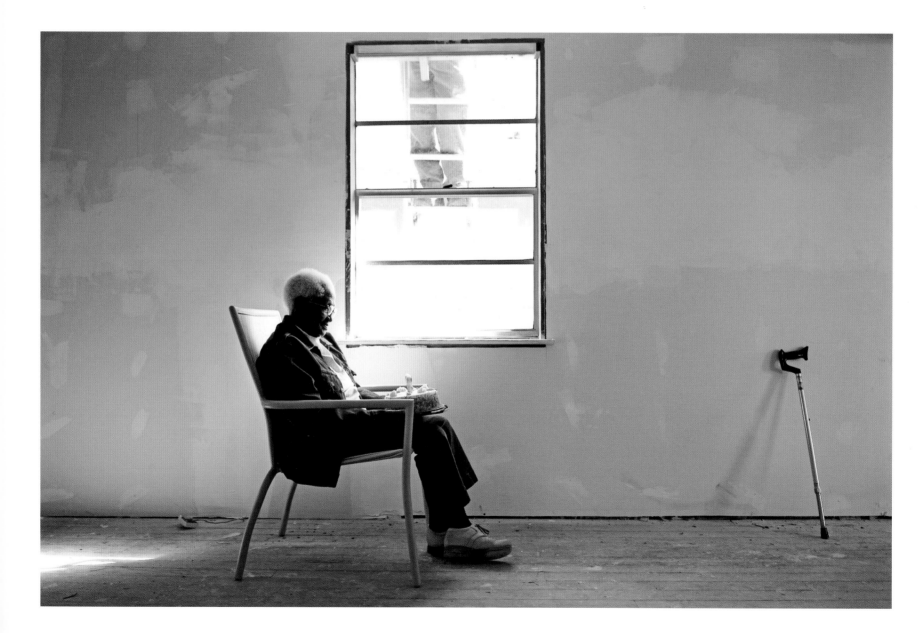

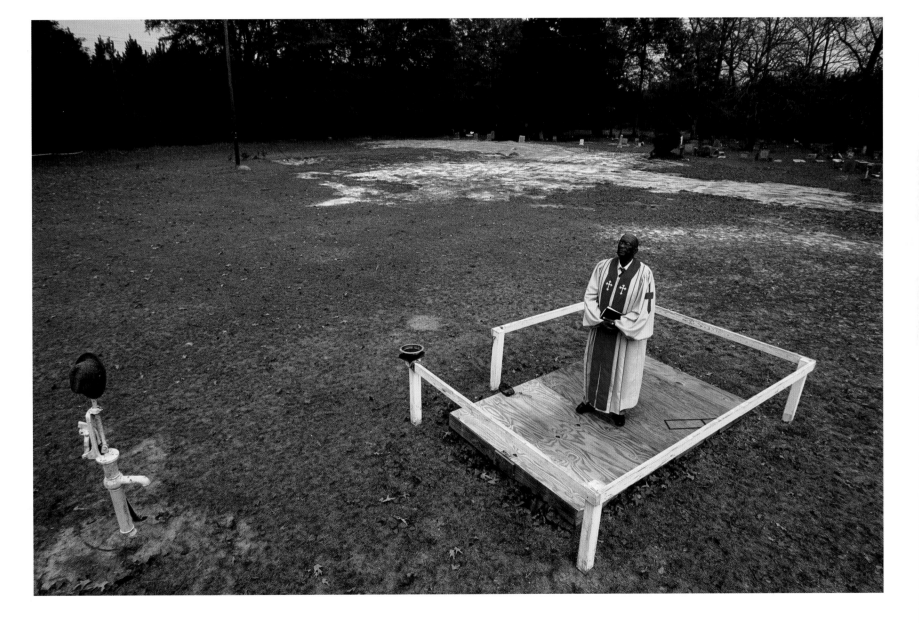

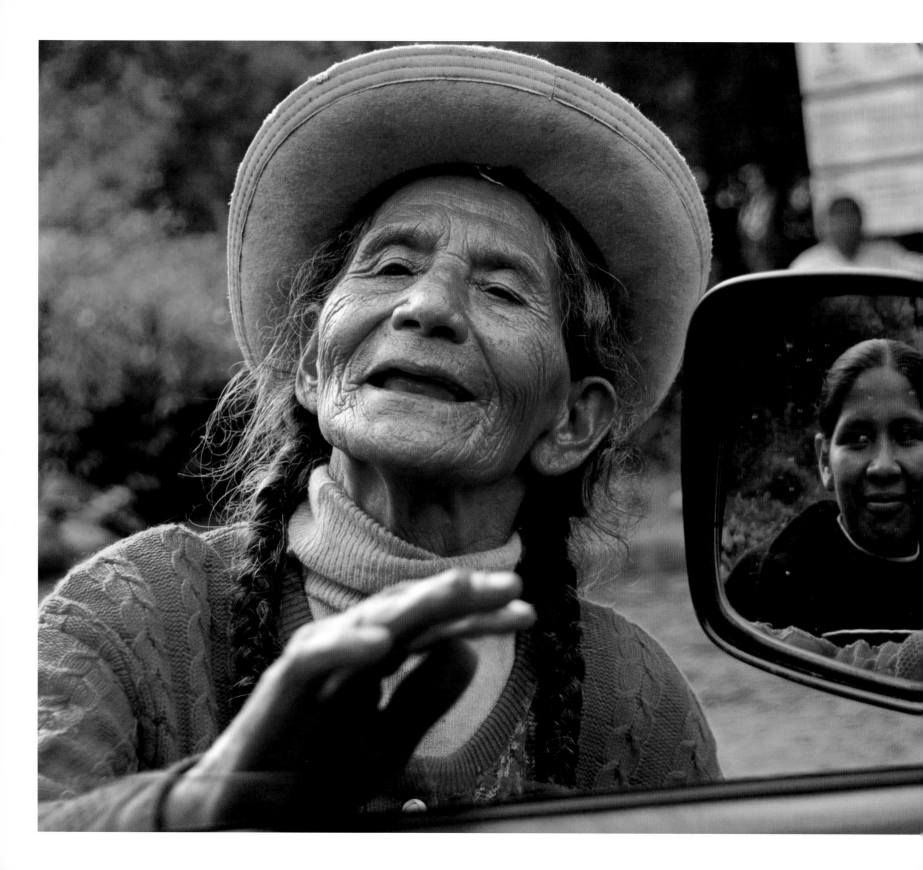

BOLIVIA

On many of my assignments, logistics are a nightmare—far more challenging at times than the photography itself. Recently I traveled to the western mountains of Bolivia to photograph the indigenous Guarani people. Roads there are treacherous and marked regularly by roadside crosses, in memory of travelers who died. Because few Bolivians can afford to travel alone, the crosses mostly huddle in twos and threes and sixes along the side of the road. The trip was difficult in many ways: impenetrable local dialects, a shortage of food and water, and dreadful sleeping quarters. But the toughest challenge of all came when I tried to leave Bolivia for my next assignment in Argentina.

The driver and I set out on a day when the impoverished local *campesinos* had decided to protest against corrupt local politicians. They were out in force wielding the only weapon available to them—time. They dragged boulders and trees across every road in or out of Tarija. Cars and trucks and buses and taxis were lined up on both sides of each barricade. People abandoned their buses and began walking in the blistering sun, seeking shade. At one point, I counted seven people crouching in the small patch of shade cast by our battered pickup. The farmers, their cheeks wadded with coca leaves, felt briefly empowered and stood a little taller. I was especially intrigued by the women who, despite the heat, were adorned in endless layers of shawls and skirts. The most astonishing thing of all were the little black, porkpie hats that clung, inexplicably, to the tops of their heads.

As evening came, we fell asleep to the sounds of farmers talking and sticks crackling on small fires. At 3 a.m. we awoke to silence. With the cold setting in and the world asleep, the *campesinos* had headed home. We crept out and rolled away boulders in a path wide enough to pass. Elated, we sped on for five miles until we came upon another roadblock. The farmers here were more resolute—or perhaps just farther from their homes. They were sleeping in colorful bundles on top of the roadblock. Thwarted, I reluctantly abandoned my pickup and driver and dragged my belongings over the boulders. On the other side, I hired a driver to transport me to the next roadblock, where I again repeated the process. And so I made my way, taxi by taxi, to the Argentine border. It took 17 hours to travel 30 miles.

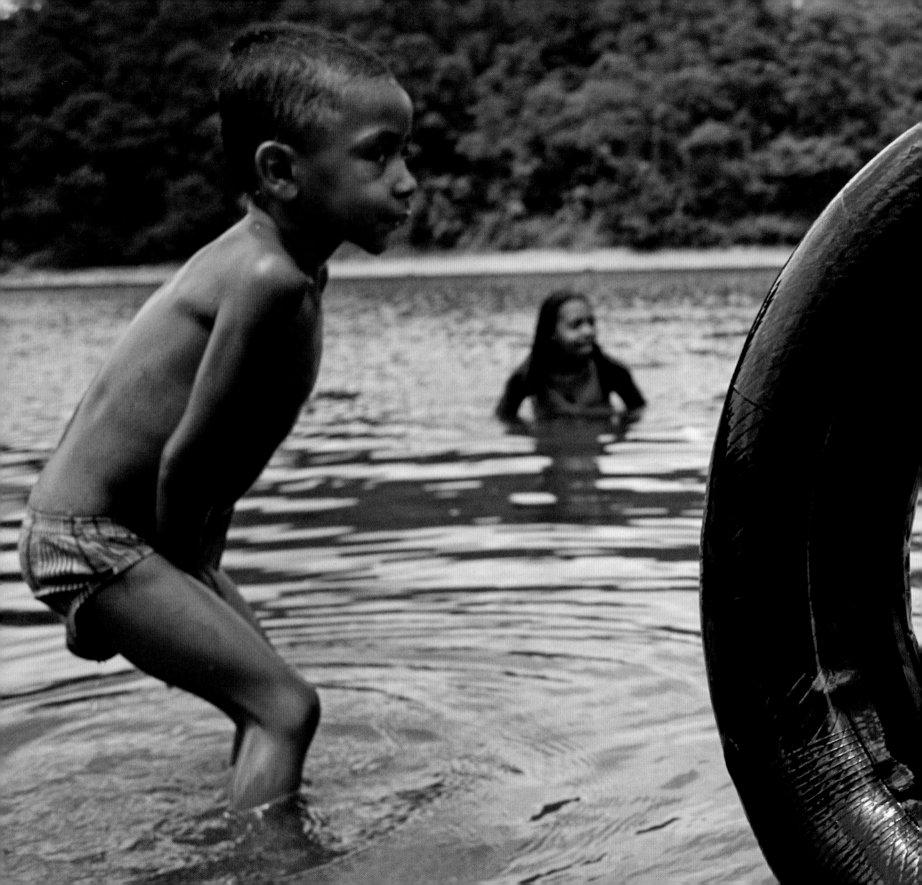

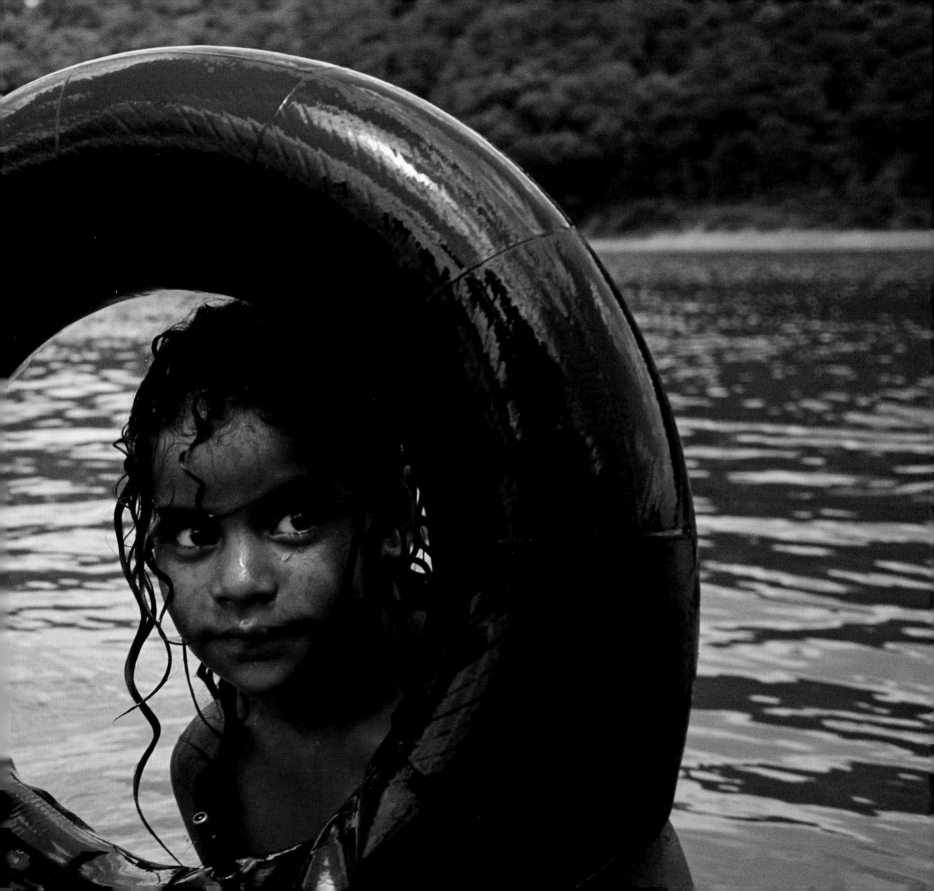

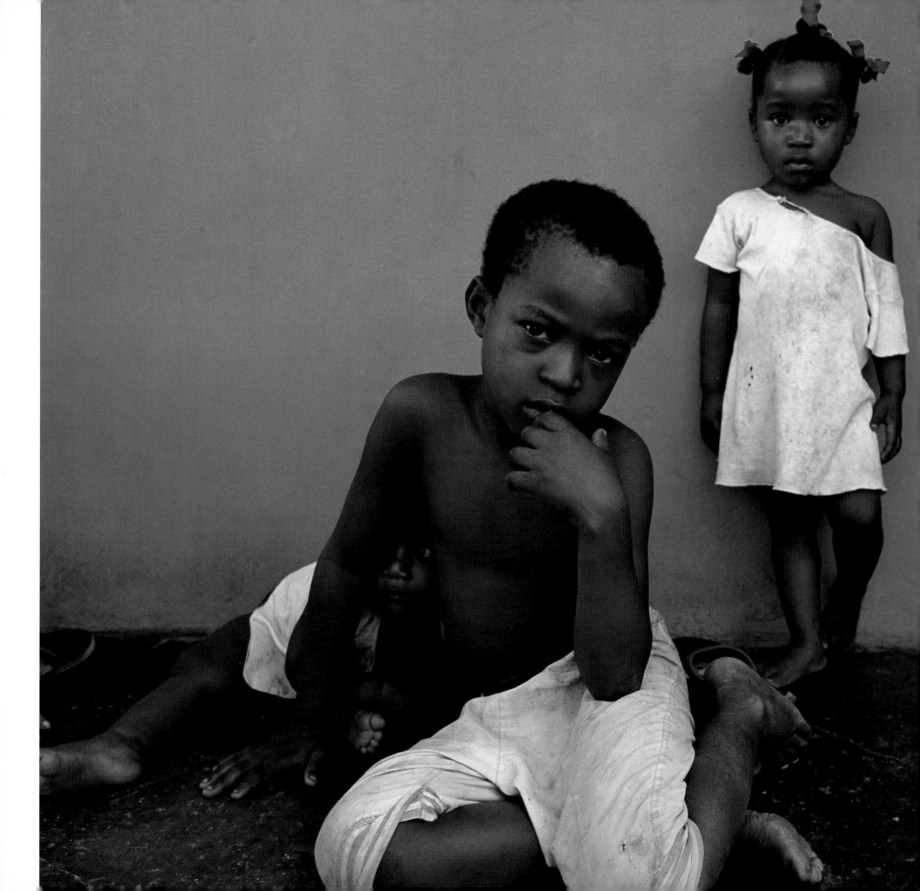

DOMINICAN REPUBLIC
Children of a cane worker in a rural *bataye*

RURAL HAITI
Refugee child, after rescue from
a stranded boat

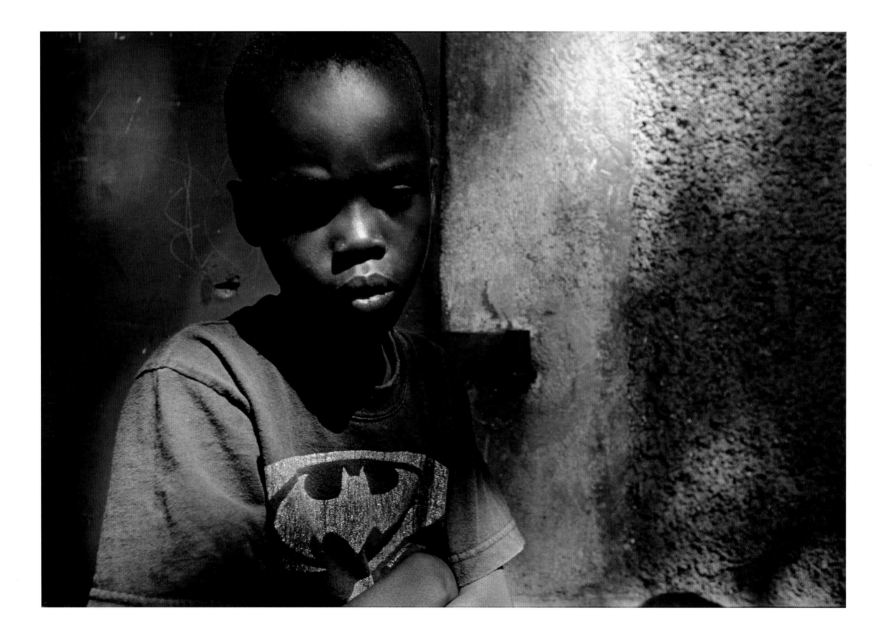

NORTHERN THAILAND
Opium addiction survivor
KENYA
The Rift Valley (*following pages*)

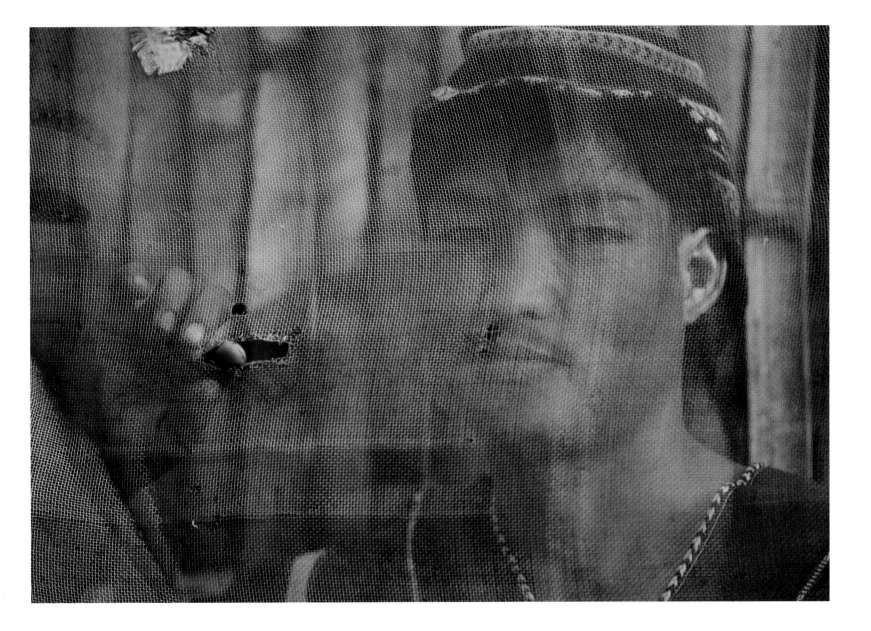

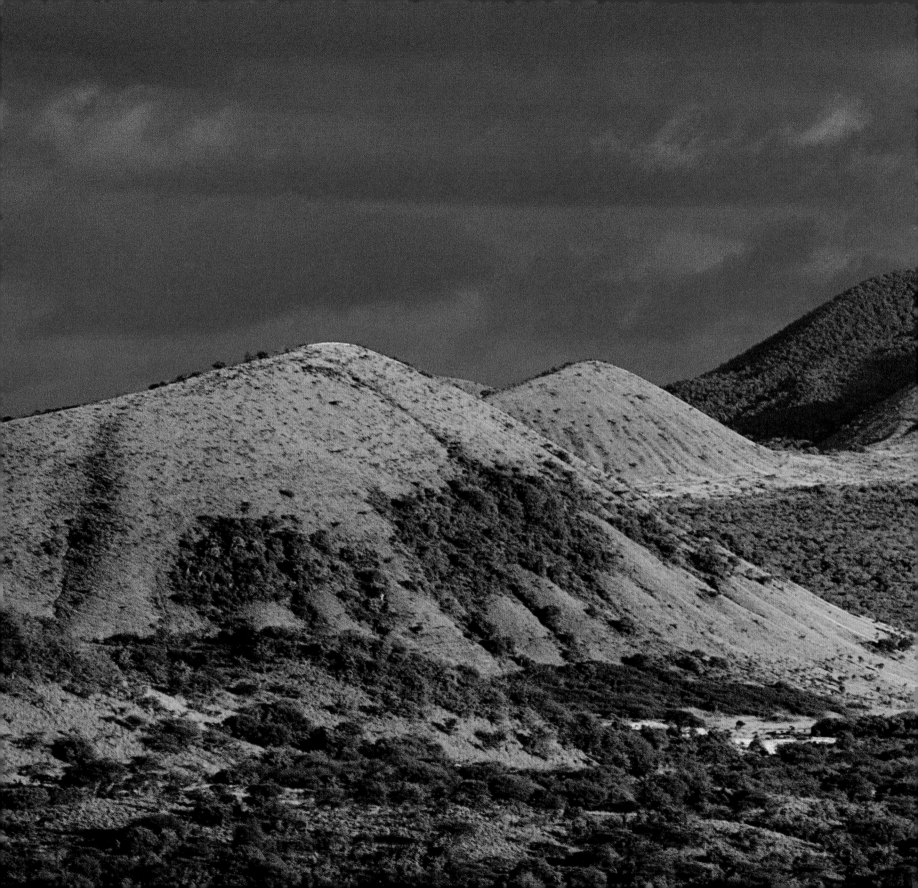

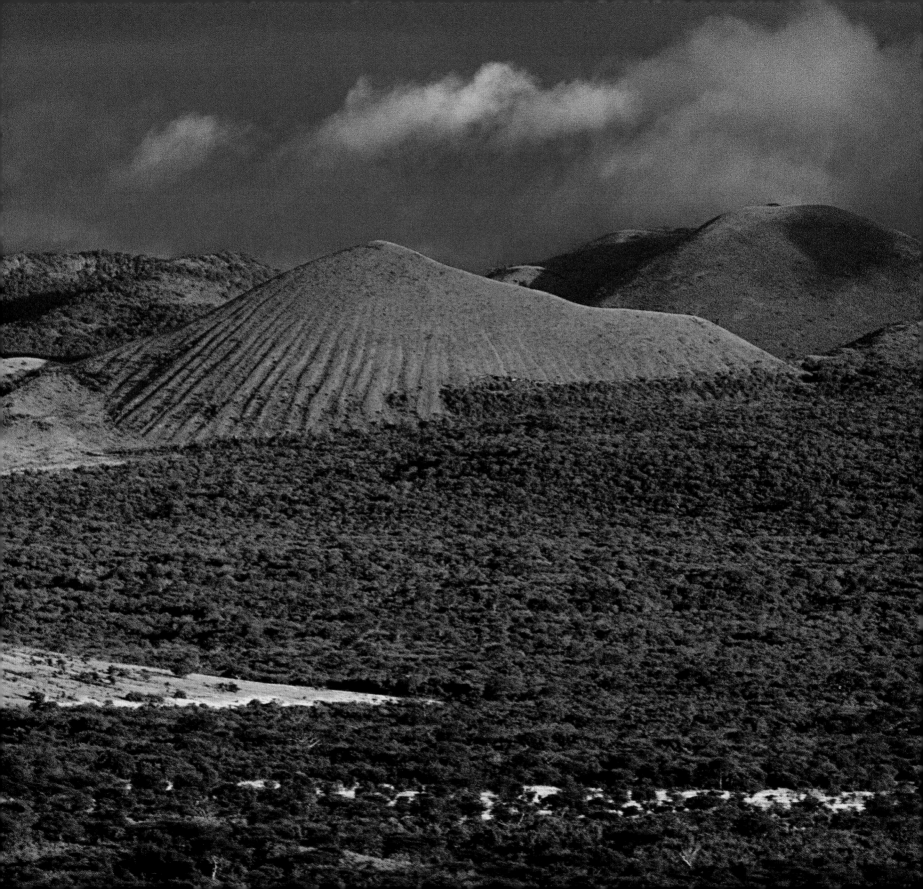

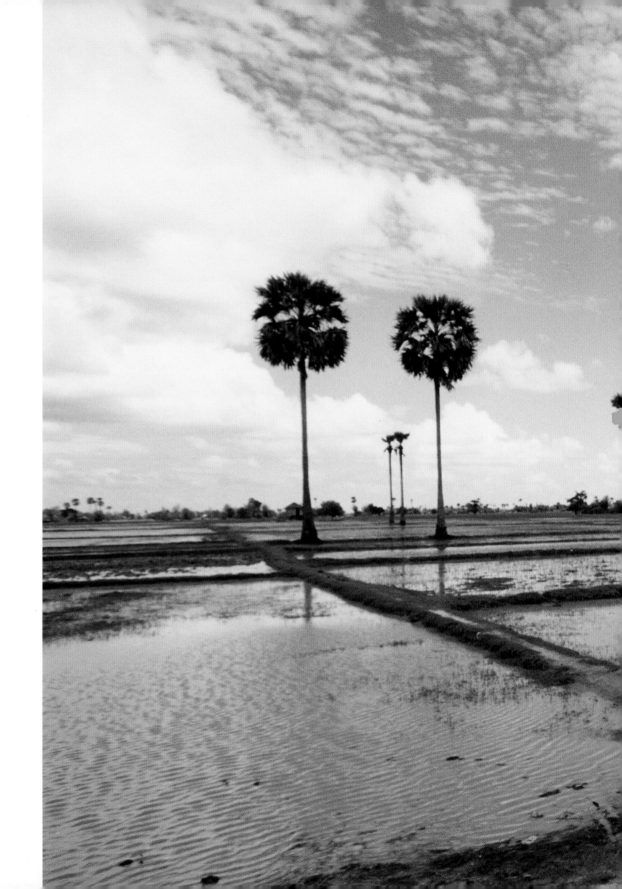

NORTHERN CAMBODIA
Man bathing at a new community well

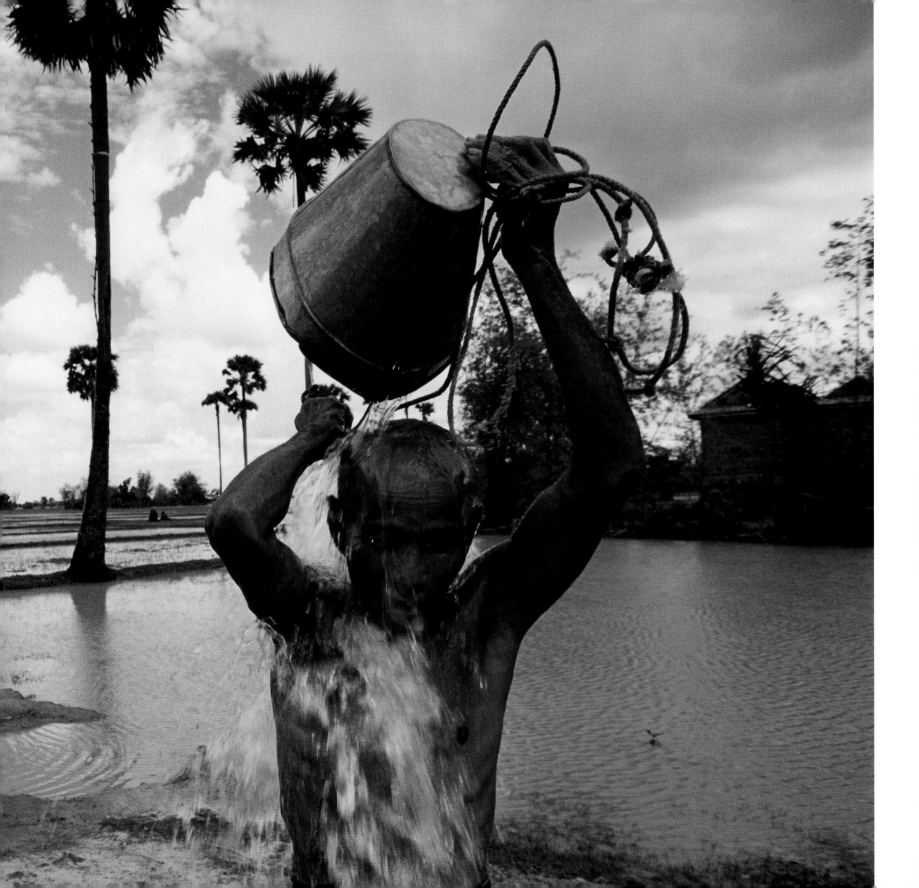

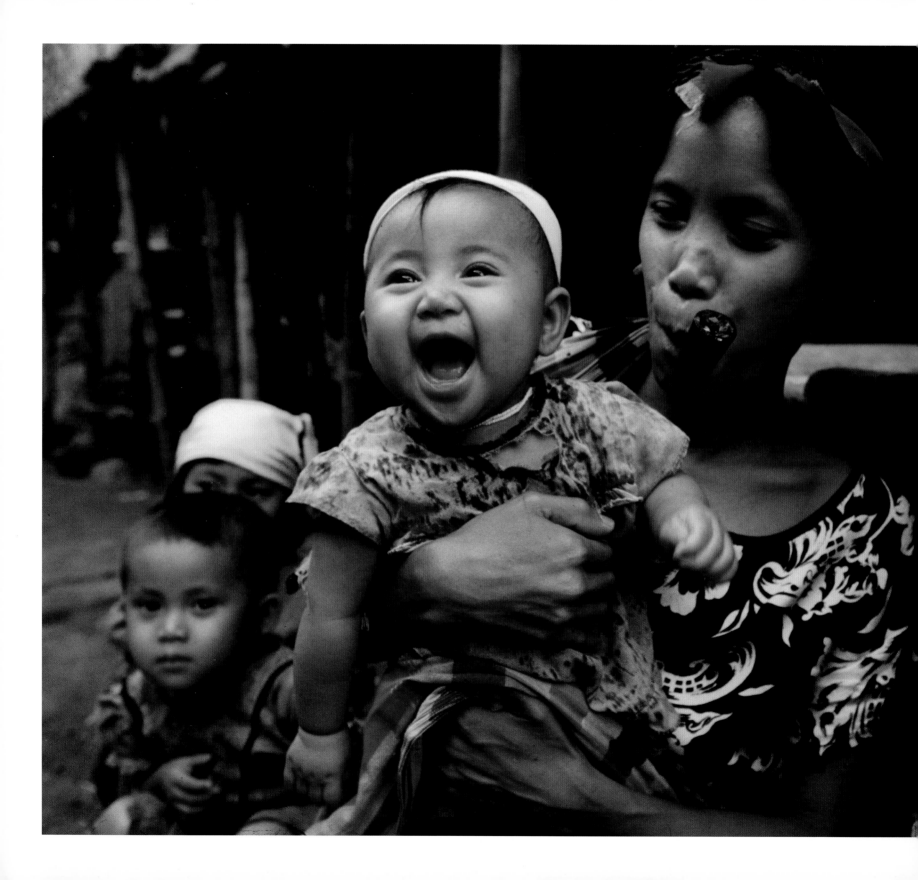

MAE KONG KHA, THAILAND
Burmese mother and child
at refugee camp

REFUGEE CAMPS

Over the years I've spent a lot of time in refugee camps, mostly photographing for aid organizations in conflict zones and regions devastated by drought and other natural disasters. These camps come in all shapes and sizes, ranging from fenced-in hellholes to humane camps where people in the community care for one another. The most dignified camp I ever visited was in northern Thailand, along the Burmese border. Here the Kerala people had been fleeing Burmese persecution for years, in what may have become the longest civil war in history. On the Thai side of the border was a refugee camp that looked more like a series of well-kept villages. Each village had a chief who presided over all activities. And although the refugees depended on aid organizations for food, they were self-sufficient in every other way. Villagers saw to it that any arriving family had a home built for them by the community within 48 hours. The spirit in this camp, where people felt empowered and confident, was inspiring.

I was in Bosnia a year after the Dayton Accords ended the Balkan wars. In one of the camps I visited, the adults were close-knit, but beaten down by unemployment and humiliation. Not so the children. The kids were like a pirate crew, noisy and happy in their freewheeling hierarchy. The self-proclaimed king of the camp was a charismatic 12-year-old named Ari, who'd managed to procure not only a bicycle, but a pair of sunglasses. He was beyond cool. When he learned I was an American, he gathered all the young girls of the camp to perform a loosely choreographed version of a Britney Spears song.

The most depressing camp I ever photographed was in Kenya, along the Sudanese border, where 70,000 refugees from civil wars in Uganda and Sudan crowded into a desolate camp. It was surrounded by barbed wire and guards armed with AK-47s to protect the refugees from attack by neighboring tribes, who resented their presence. Some people had been in this monstrous place for more than a decade. An entire generation had been born there. A few were finding a way out, usually through refugee programs. One day I watched a ragtag group of about a hundred people make their way, like a mirage, through the desert heat toward a transport plane. I'm sure they were terrified. But they were the lucky ones, the ones who had somehow found an exit from hell on Earth.

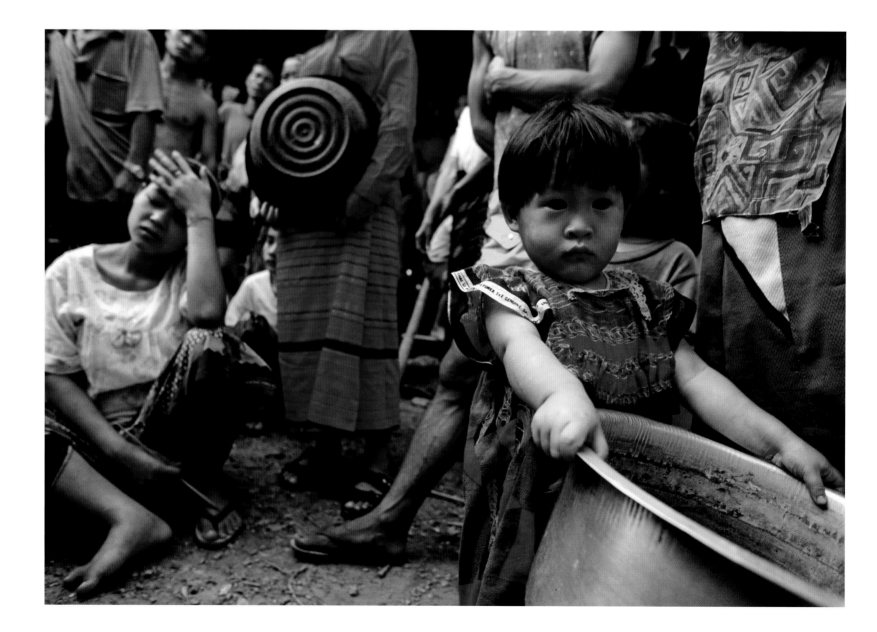

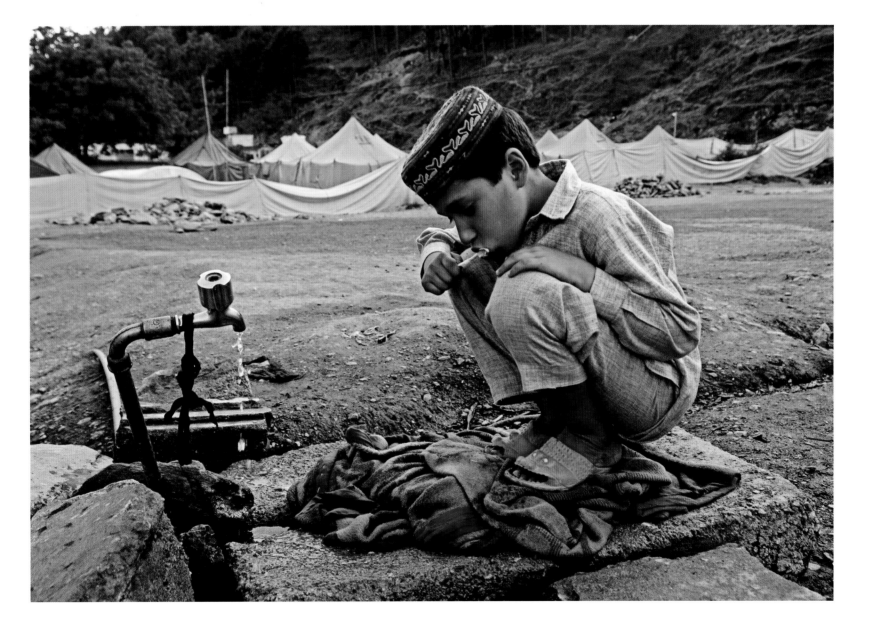

SARAJEVO, BOSNIA
Ari, self-appointed king of the
refugee camp

KAKUMA, KENYA
Somali mother and child await evacuation

SERENGETI PARK, TANZANIA
Migrating wildebeest *(following pages)*

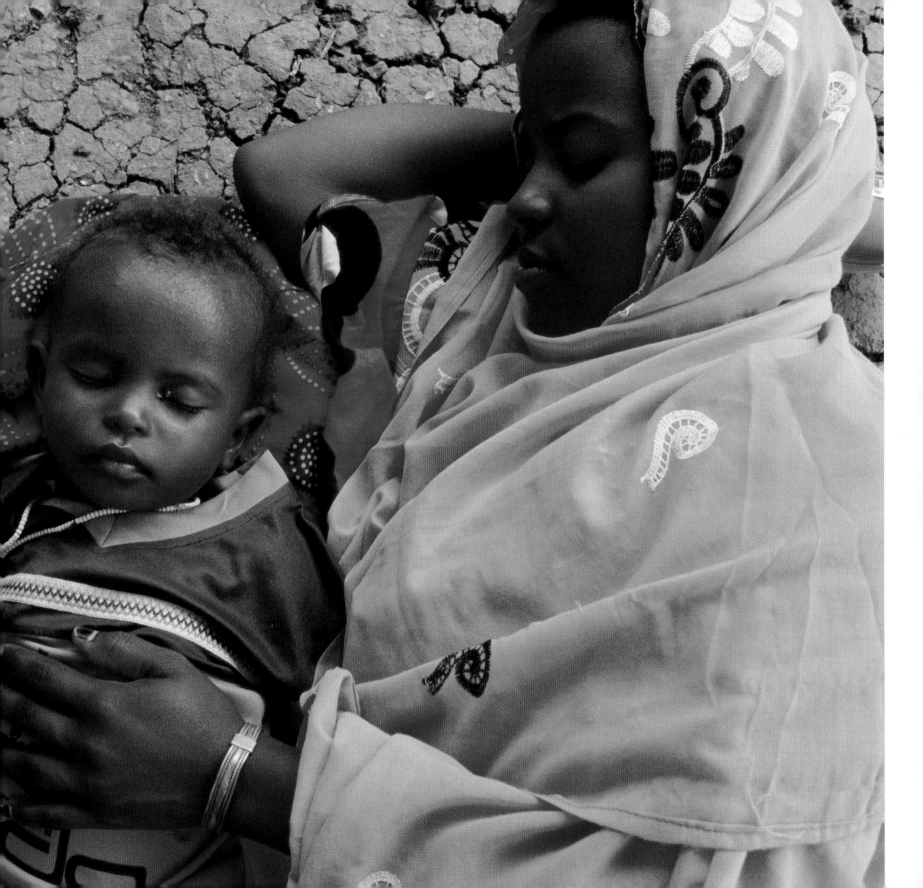

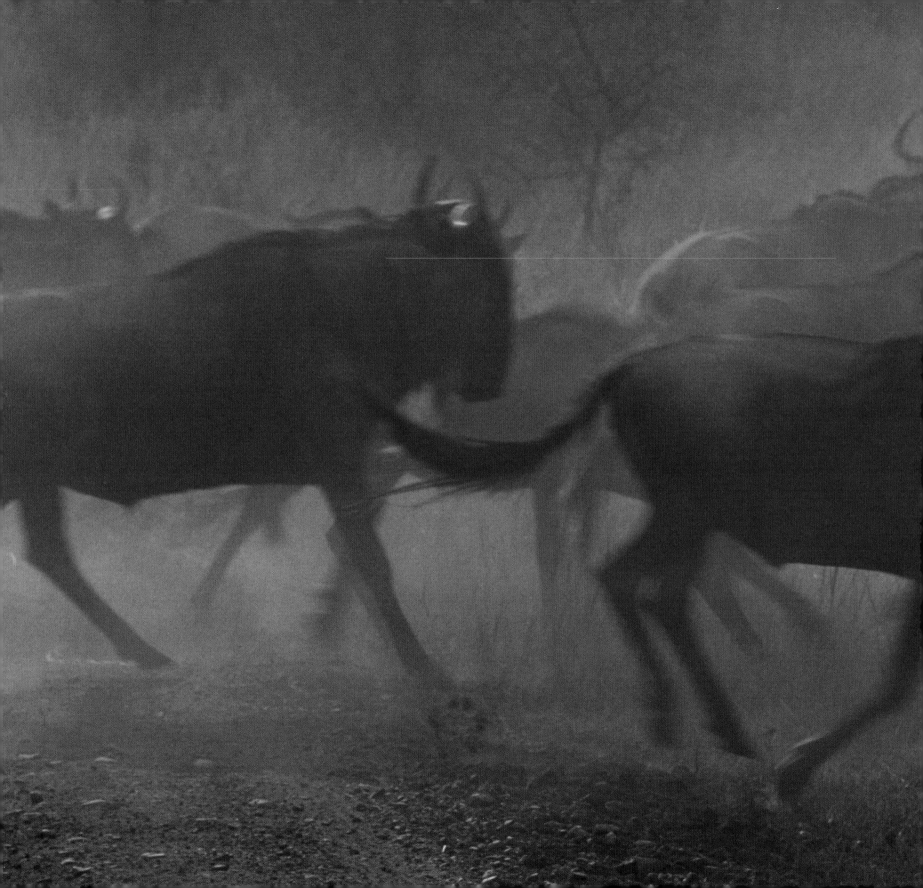

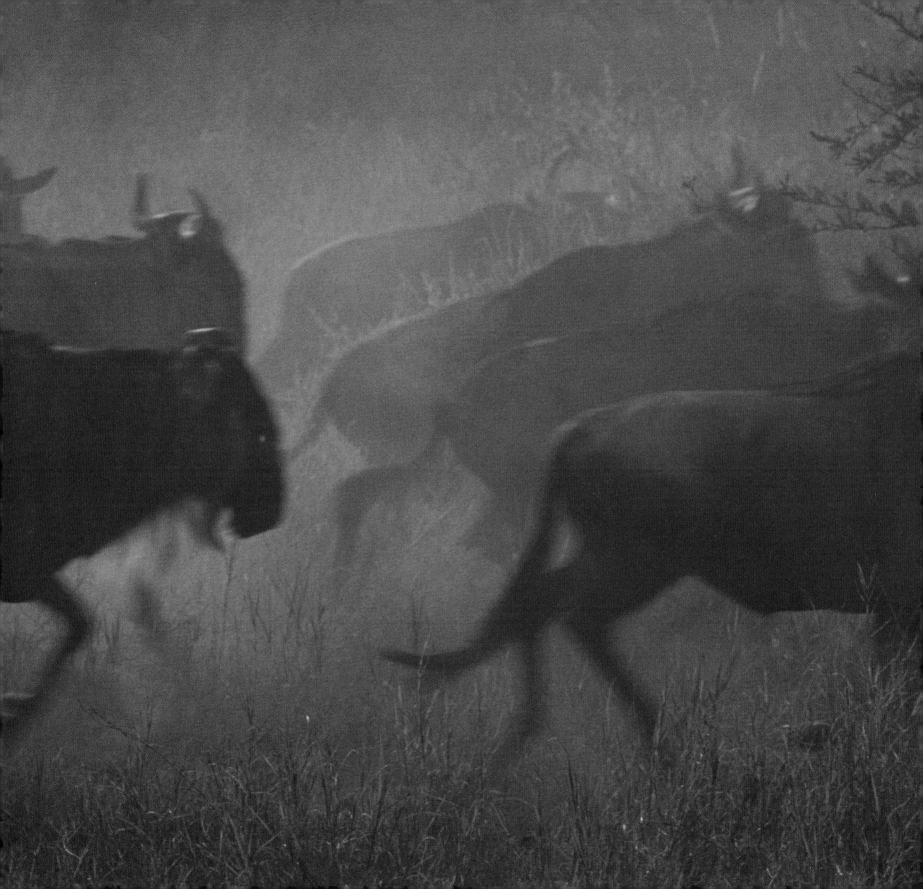

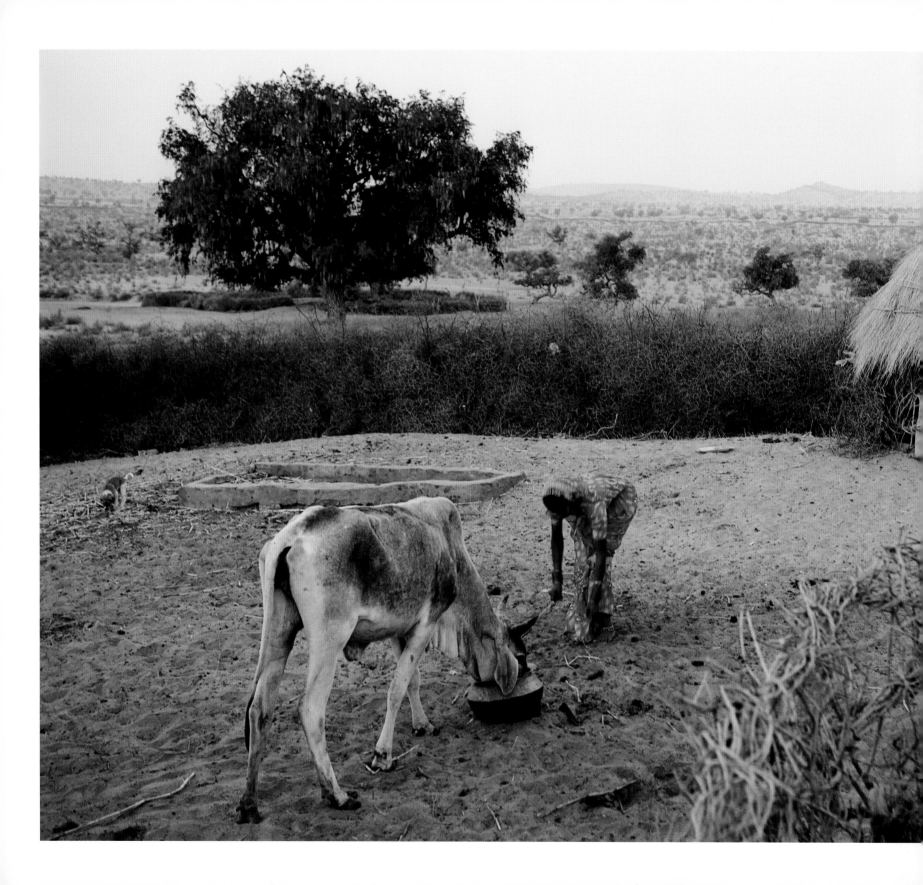

PAKISTAN

On a recent trip to Pakistan, I traveled to a remote desert region in the south called Cholistan, a land of semi-nomadic tribes where there were no roads at all. The day was a scorcher, well above 100°F. We arrived at a desperate little enclave—a village of sorts. It was midday, so the sun was unbearable. Everyone was tucked away into any patch of shade they could find. My guide, Raania, and I joined a group of women who were doing embroidery work inside a mud hut. It was family time, mouths and hands moving in the quiet industry of weaving and embroidering.

I have never felt homelier than on that day. Although they were incredibly poor, these women were dressed in the flowing tunics and delicate shawls of their culture. The colors were vivid oranges and yellows and greens that only silk can hold. I sat in khaki pants, a long-sleeve cotton t-shirt, and a really bad scarf. As we passed the midday hours laughing and pantomiming, one of the women finally asked if I was a woman or a man. I grabbed my breasts as proof, which caused peals of laughter. When I told them I had two children, they really hooted, surprised that any man would have me.

As evening approached, children emerged and moved off in search of firewood. Raania and I were so far from any town that we knew we would need to sleep in the desert. The villagers asked us to stay with them. The teenage daughter of the village elder began to cook a simple meal. It has always touched me that throughout the world, people who have nothing seem to give everything—the nicest tea cup, the biggest piece of bread, the seat closest to the fire. Meanwhile, her brothers moved the two best beds in the house out into the courtyard. The little ones piled blankets and pillows atop the beds, and then climbed up beside us, watching, transfixed, as we ate our soup and bread.

When it was time to sleep, the village elder asked if we would like some music. When we nodded yes, a small group of men with handmade stringed instruments and drums filed into the courtyard, sat in a semicircle around us, and began to play soft and mysterious songs. Peacocks gathered on the thatch roofs. Overhead the constellations pulsed across the desert night. The harshness of the day melted away and we slept.

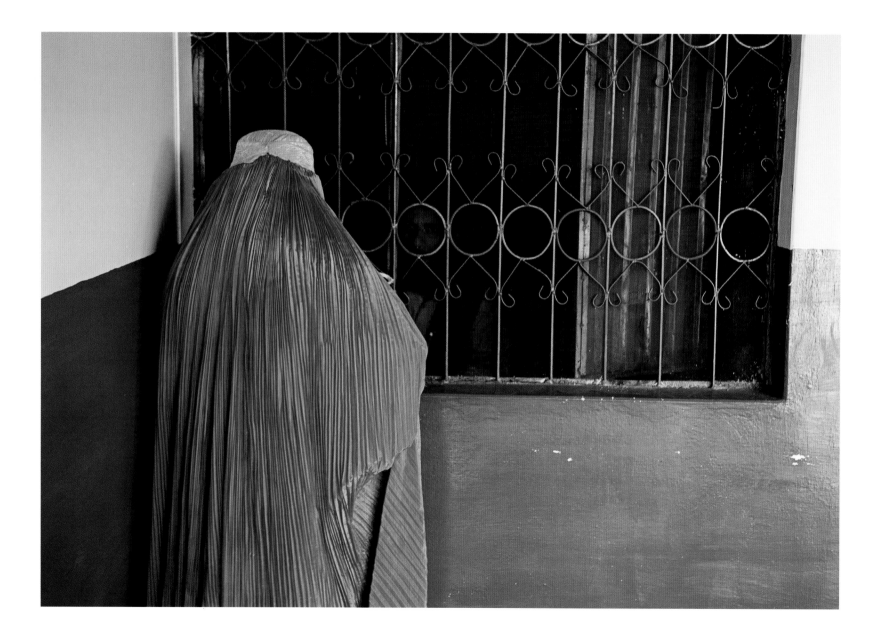

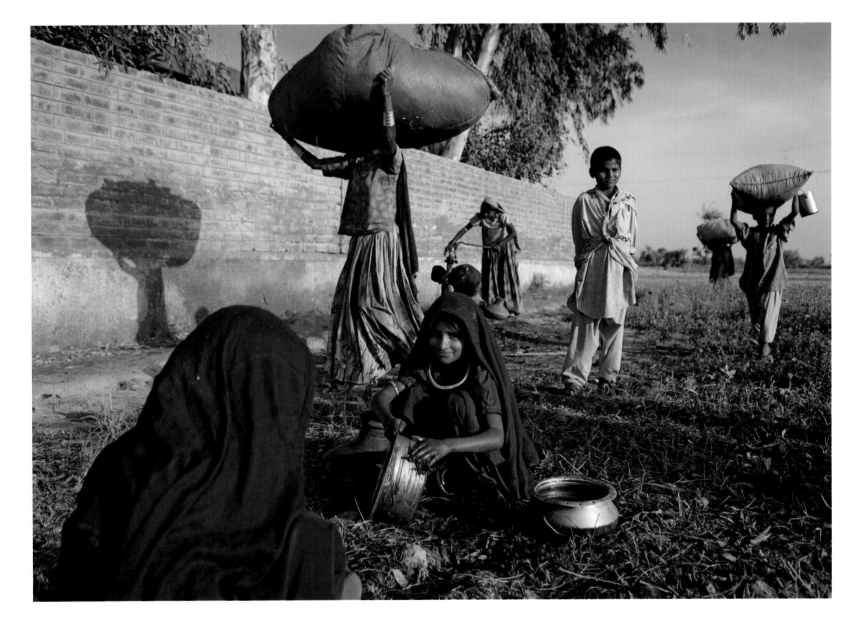

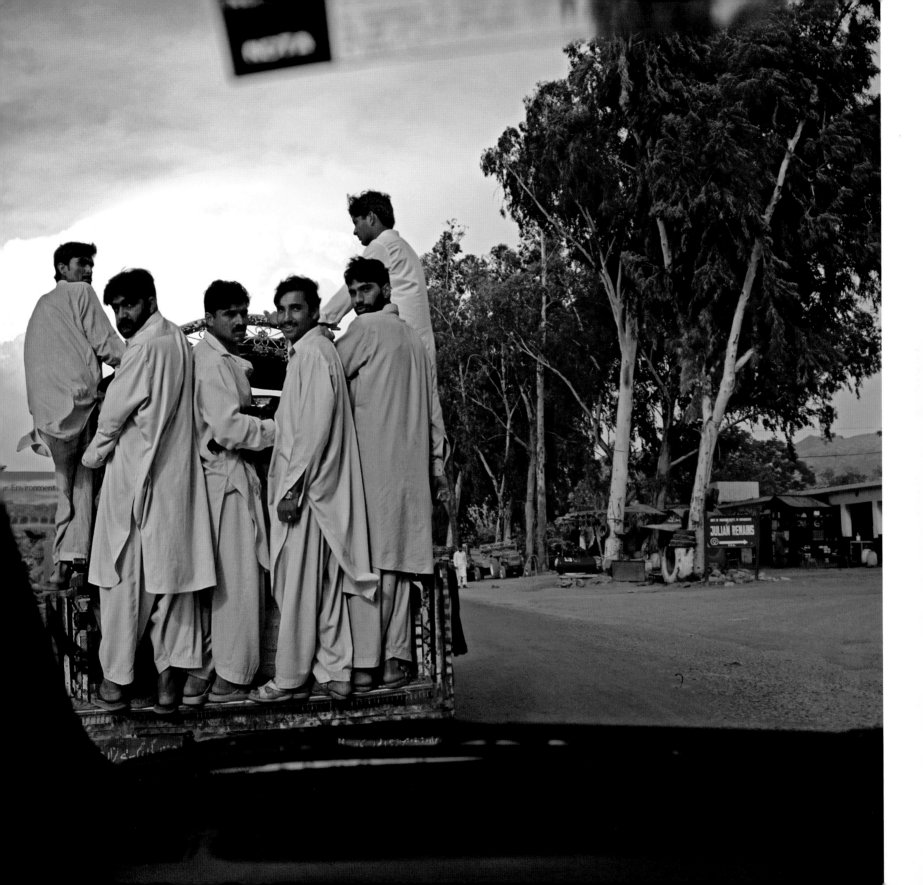

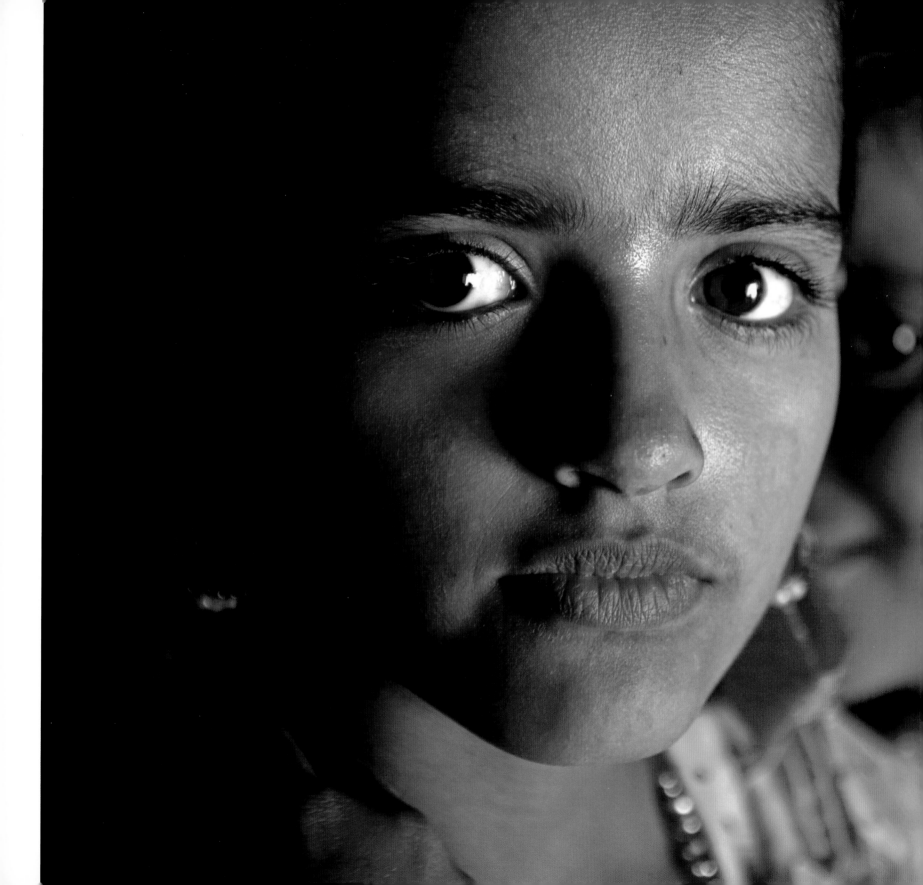

Afterword

This photograph was taken the day I became a photographer. I was 21 years old, determined to be a novelist, and a bit lost. By a fluke, I stumbled into a Beginning Photography course at the University of Minnesota. Our first assignment was to take a picture of "available light." I stewed for days about what to photograph. Finally I decided to stop worrying and get moving. Somehow I found myself at dawn on a golf course in St. Paul, Minnesota. It was autumn and chilly. Fog steamed from the cold, wet grass as the sun rose behind a lone tree that fractured the light into a hundred rays.

As I lay on my belly in the soaking grass, intently photographing the tree, two guys came by in a golf cart. They stopped and watched me, more than a little amused at the soggy college student taking pictures of... what, a *tree*? But I was in heaven, mesmerized by the dancing light, trying to capture it before it evaporated. As the golfers drove away, I vaguely remember hearing laughter coming from their cart. Thirty seconds later, the golf course's sprinkler system went off, drenching me. They had known, as I had not, that I had been lying on one of the spigots.

I took a bus back to campus and never stopped grinning. I was dripping and dirty and ridiculous, but all I wanted to do was to get back to the darkroom with my film. That morning changed my life. I felt the transformative power of photography and how the creative intensity of making a picture could dissolve any discomfort or self-consciousness I might feel. It was the first of a lifetime of days when time stood still, and I became far less important than what I saw in the camera's viewfinder. I marched to the admissions office and changed my major.

The great lesson of light, I learned, is that it is more beautiful when it is less perfect. The full and unforgiving light of high noon rarely inspires. But light that is mottled, broken, fractured, or incomplete takes your breath away. For a perfectionist like me to glory in imperfect light was truly a revelation. There was no controlling the outcome, no plan, no magic formula for success. There were only surprises and revelations, accidents and miracles. I learned that serendipitous, divine light can make anything beautiful—even something as ordinary as a golf course. My happiest moments are still like that: intensely focused and lost in the light before me.

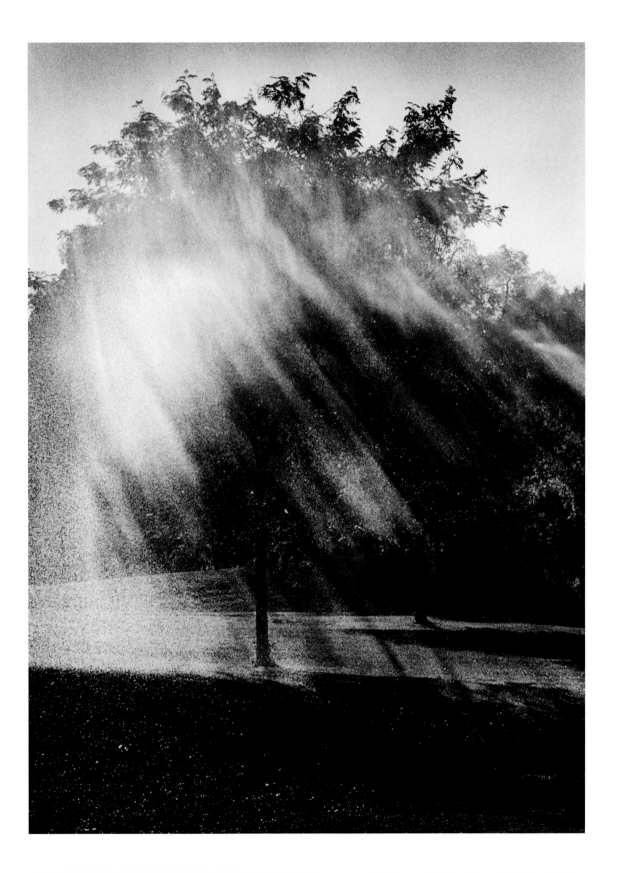

Acknowledgments

First and foremost, I thank Nina Hoffman, President of the National Geographic Book Pubishing Group, who came to me with the idea for this book and has shepherded it past all the obstacles of bringing it to print. Heartfelt thanks to Marianne Koszorus, designer extraordinaire, who worked nights and weekends to birth this baby.

Thanks to my sorority of readers—Becky Lescaze, Melina Bellows, Barbara Kingsolver, Karen Kostyal, and Bette Ashcroft. And profound gratitude to my patient picture advisors—Kathy Moran, Leah Painter Roberts, Cristina Mittermeier, and Ed Kashi. Each of these friends took time from very busy lives to look at pictures and offer suggestions on the text. Your feedback was invaluable.

The most important feedback of all came from my best friend and husband, Don Belt, who is the real writer in our family. Thanks, my love, for all your patience and insight.

My career would never have happened without the generosity of early mentors Bob and Jan Gilka, Lilian Davidson, Bill and Lucy Garrett, Tom Kennedy, Tom and Lynn Abercrombie, John Agnone, Kent Peterson, and Frank Cooley.

To Gary Colbert, John Dunn, Nicole Elliott, Clay Burneston, Melissa Farris, Cameron Zotter, Nicole DiPatrizio, and all the folks in the National Geographic Book Division who gave pieces of their art and their heart to this book. I am forever grateful. And to my friend and assistant, Linda Johansson, who added her artistry to the photographs.

Loving thanks to Lynn Cooley, Bette Ashcroft, and Linda Tiernan, who have kept my feet firmly planted in Midwestern soil for more than 40 years. Thank you for your friendship, wisdom, and humor.

How do I begin to thank my children, Lily and Charlie, who have lovingly put up with their mom's crazy career all their lives? I am deeply proud of you guys, and you will *always* be my favorite traveling companions.

Thanks to my brothers, David and Bobby, and my sister, Sally. Finally, love and gratitude to my parents, Bob and Mary Griffiths, who have encouraged and supported each of the Griffiths kids as we chose very different paths in life. There is no greater gift.

A Camera, Two Kids, and a Camel

Annie Griffiths Belt

Published by the National Geographic Society
John M. Fahey, Jr., President and Chief Executive Officer
Gilbert M. Grosvenor, Chairman of the Board
Nina D. Hoffman, Executive Vice President;
 President, Book Publishing Group

Prepared by the Book Division
Kevin Mulroy, Senior Vice President and Publisher
Leah Bendavid-Val, Director of Photography Publishing
 and Illustrations
Marianne R. Koszorus, Director of Design
Barbara Brownell Grogan, Executive Editor
Elizabeth Newhouse, Director of Travel Publishing
Carl Mehler, Director of Maps

Staff for This Book
Rebecca Lescaze, Text Editor
Marianne Koszorus, Art Director
Gary Colbert, Production Project Manager
Marshall Kiker, Illustrations Specialist
Cameron Zotter, Design Assistant
Nicole DiPatrizio, Design Assistant
Melissa Farris, Design Consultant

Jennifer A. Thornton, Managing Editor
Gary Colbert, Production Director

Manufacturing and Quality Management
Christopher A. Liedel, Chief Financial Officer
Phillip L. Schlosser, Vice President
John T. Dunn, Technical Director
Chris Brown, Director
Maryclare Tracy, Manager
Nicole Elliott, Manager

Founded in 1888, the National Geographic Society is one of the largest nonprofit scientific and educational organizations in the world. It reaches more than 285 million people worldwide each month through its official journal, National Geographic, and its four other magazines; the National Geographic Channel; television documentaries; radio programs; films; books; videos and DVDs; maps; and interactive media. National Geographic has funded more than 8,000 scientific research projects and supports an education program combating geographic illiteracy.

For more information, please call
1-800-NGS LINE (647-5463)
or write to the following address:

National Geographic Society
1145 17th Street N.W.
Washington, D.C. 20036-4688 U.S.A.

Visit us online at www.nationalgeographic.com/books

For information about special discounts
for bulk purchases, please contact
National Geographic Books Special Sales:
ngspecsales@ngs.org

For rights or permissions inquiries,
please contact National Geographic Books Subsidiary Rights:
ngbookrights@ngs.org

Printed in Italy

Library of Congress Cataloging-in-Publication Data
Belt, Annie Griffiths, 1953-
 A camera, two kids, and a camel : my journey in photographs / by Annie Griffiths Belt.
 p. cm.
 ISBN 978-1-4262-0245-2
 1. Travel photography. 2. Belt, Annie Griffiths, 1953---Travel.
 3. Voyages around the world--Pictorial works. I. Title
TR790.B45 2008
779.092--dc22